The Artist's Mount Desert

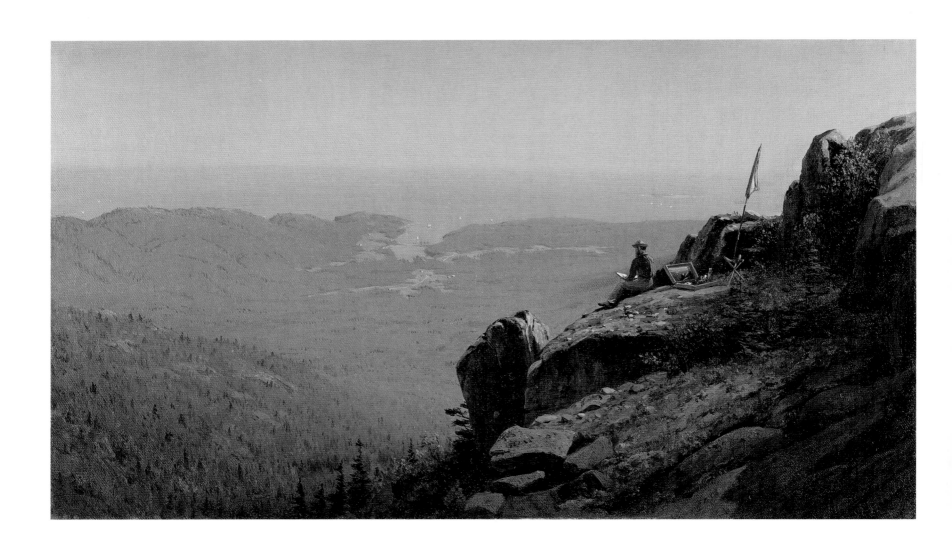

The Artist's Mount Desert

American Painters on the Maine Coast

JOHN WILMERDING

PRINCETON UNIVERSITY PRESS

PRINCETON, NEW JERSEY

Library of Congress Cataloging-in-Publication Data

Wilmerding, John.
 The artist's Mount Desert : American painters on the Maine Coast/
 John Wilmerding.
 p. cm.
 Includes bibliographical references and index.
 ISBN 0-691-03458-3 :
 1. Mount Desert (Me.) in art. 2. Landscape painting, American.
 3. Landscape painting—19th century—United States. 4. Landscape
 painting—20th century—United States. I. Title.
 ND1351.5.W56 1994
 758′.174145—dc20 93-43453
 CIP

This book has been composed in Linotron Bodoni

Princeton University Press books are printed on acid-free paper
and meet the guidelines for permanence and durability of the
Committee on Production Guidelines for Book Longevity of the
Council on Library Resources

10 9 8 7 6 5 4 3 2 1
10 9 8 7 6 5 4 3 2 1
(Pbk.)

Designed by Bruce Campbell

Frontispiece: Sanford R. Gifford, *The Artist Sketching at Mount Desert*, 1864–65

For Jo Ann and Julian Ganz
who also love the light

For assistance in the preparation and publication of this book, warm thanks go to Susan Lehre, Elizabeth Powers, Jane Lincoln Taylor, and Margaret Vendreyes; and to the Spears Fund of the Department of Art and Archaeology, Princeton University.

For help with site photography, thanks also to the friends of *Cressida* and the August captain.

Contents

The Artist's Mount Desert

I.

The Timeless Place

AMERICAN GEOGRAPHY has always seized the national imagination. From America's earliest years, nature and nation have helped define each other. The consciousness of a virgin wilderness of great and variable wonders was significant in shaping a national identity distinct from the Old World of Europe, by definition newer and by conviction better. This was to be a landscape for democracy, where many of the country's great wilderness sites would be designated national parks for the people. As settlement moved westward, Americans celebrated a multiplicity of natural wonders, some focal like the Natural Bridge in Virginia, others spatial like the Great Plains, some seemingly frozen in time like the Grand Canyon, others endlessly charged in motion like Niagara Falls. Rising in unique configuration from the sea, and containing America's only national park in the Northeast, is Mount Desert Island on the Maine coast. Peculiar to its topography are the conjunctions of sheer cliffs and ocean plane, and of evergreen, pink granite, and northern light.

By virtue of its location off the easterly running coastline, extending south some twenty miles into the open Gulf of Maine, Mount Desert seems—and is—isolated. Because its mountain summits slope off almost directly into the sea, forming a unique geological junction on the east coast of the North American continent, there is an additional visual drama to the island's silhouette against the horizon (see figs. 1, 75, and 171). From almost all vantage points the intersecting lines of land and water appear clean and sharp, a characteristic that would have continuing appeal for American artists recording the island region over almost two centuries.

1. Mount Desert from Baker's Island

Another factor contributing to the island's singular presence is its relative inaccessibility. Situated on a rugged part of the northeastern coast, Mount Desert lies approximately two-thirds of the way along the Maine shore from New Hampshire to the Canadian border. Nearly three hundred miles from Boston, it is reached even today by a long overland trip from New England's largest cities. The most common early approach was by water, and as Samuel de Champlain was among the first to learn in the seventeenth century, coastal travel was constantly endangered by sudden fogs, strong seas and tides, and treacherous, unmarked ledges. Coming upon a place of such bold beauty after a long journey and often arduous effort only heightened the visitor's feeling of reaching a New World island of Cythera.

In nineteenth-century America the wilderness frontier held a special allure. As westward expansion moved that frontier across the continent, adventurers and artists alike sought increasingly distant horizons to find solace and solitude. Steamboat and then rail travel reached the farthest sections of the New England coast. Mount Desert was one of several natural sites at once pure and wild, and yet accessible for commerce and enjoyment. It seemed inevitable that the island should evolve as both a national park and a summer resort.

Given Mount Desert's visual prominence on the edge of the coast, it has always afforded superb views of two types: focal and panoramic. Like the other solitary summits to the island's west, the Camden Hills and Blue Hill, and that of Mount Katahdin in central northern Maine—or for that matter like other singular peaks in New England such as Chocorua, Washington, and Mansfield—Mount Desert looms up as a single commanding form from a good distance away. Indeed, from the open sea its

2. Schoodic Point from
Great Head

combined summits are readily visible for twenty miles or more, making it one of the most distinctive landfalls in North America.

As trails made their way up its hills, and later in the nineteenth century when a carriage road and then a tram railway were built to the top of Green (now Cadillac) Mountain, the island's highest point, viewers were rewarded with unsurpassed vistas. To the north lie the Gouldsboro Hills and Tunk Mountains; to the east the islands of Frenchman Bay and Schoodic Point (see figs. 2, 37, 90); to the south open ocean, then more small islands marking the entrances to Northeast and Southwest harbors (see fig. 65); finally to the west larger islands again at the lower end of Blue Hill Bay and Blue Hill itself (see fig. 96). On the clearest days, one can also make out the Camden Hills beyond, and a sharp eye can find the lonely rockpile of the lighthouse at Mount Desert Rock twenty miles offshore due south (see figs. 3, 47). When American artists turned their attention to landscape at the beginning of the nineteenth century, these natural vantage points of and from Mount Desert provided views that would remain continually vivid.

One salient characteristic of the island is its fundamental contrasts, the first and most obvious being the balance of water and rock. In artistic terms this terrain has also served the opposing conventions of the picturesque and the sublime. On the one hand, the island's inner harbors, meadows, and valleys well suited the romantic sensibilities of the picturesque formulas, which stressed modulation and balance, meditative calm in both subdued sound and motion, and overall feelings of gentle accommodation and well-being (see figs. 31, 157). By contrast, the outer shores perfectly embodied the features of the sublime: they were rugged and threatening, and nature's forces were visible, its noise palpable. The human presence here was precarious and the juxtaposition of forms intimidating. Altogether, the scenery inspired feelings of awe, wonder, and exhilaration (see figs. 34, 119).

Arguably, the most indelible contrast is that of past and present; almost every experience of the moment is enhanced by the consciousness of the area's geological and historical past.

3. Mount Desert Rock

There are few places in the continental United States, especially in the East, where the surface of the earth so directly reveals the face of time. The bare mountaintops of Mount Desert not only evoked the precise observations of early explorers and later artists; they have also endured as the tangible record of their own creation and evolution. Even a rudimentary knowledge of geology indicates that these strikingly sloped hills were the result of prehistory's elemental polarities: fire and ice, volcano and glacier. Geologists tell us that most of what is now New England was covered by the sea around 450 million years ago.[1] Ever since, the forces of water and stone have engaged one another in shaping this landscape. The long settling of the earth's crust featured alternating periods of lifting and sinking of the land mass. Underneath the sea, ash and sediment stratified; then as pressures arose from within the earth, land formations protruded above sea level and in turn were subjected to different patterns of erosion. One sequence of volcanic eruptions produced the Cranberry Islands off the southern coast of Mount Desert, but they were covered again by the sea during a settling of the crust. Today one can readily see two basic rock types around the island: the rounded popplestones, formed by constant erosion from the movements of the sea, and the cubic blocks of rock walls, created by ages of layered deposits (see figs. 4, 70, 128).

Toward the end of this process (about sixty million years ago) the combination of volcanic eruption and resistance to erosion by the strongest granite produced a nearly continuous mountain range along this part of the coast. Its crest was almost even, and the ridge extended in an approximately straight line from east to west.[2] During another period of uplift in the earth's crust, what is now Mount Desert and the offshore islands were all joined to the mainland. Further upheaval resulted in the promontories and island formations we recognize today. The so-called Mount Desert mountain range was then subjected to a final great phase of geological action, that of the Ice Age beginning a million years ago.

Scientists believe that at least four major continental glaciers spread southward from the polar ice cap. The one that most

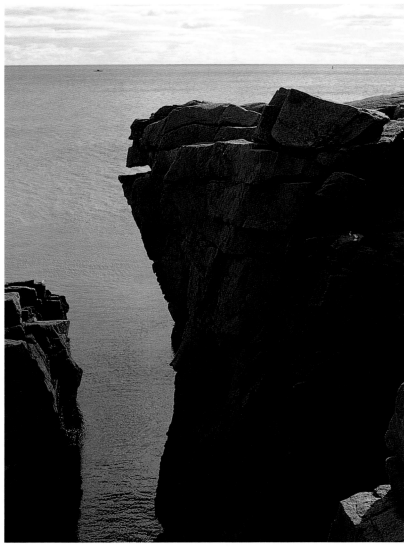

4. Thunder Hole

left behind some dozen separate peaks of varying heights. Several of the valleys between them became deep freshwater lakes within the island, while the central one, scoured deeper and longer than the rest, was flooded by the sea. This cut of Somes Sound now reached up the middle of Mount Desert as a coastal fjord. On the island's southern slopes the glacier abruptly broke off granite blocks and deposited random piles of stony debris, prominent today in the sharp cliffs and massive seawalls of the present ocean coastline. American artists from the early nineteenth century on have responded to those powerful primal formations (see figs. 11, 174).

The modern land formation that resulted after the cooling of the fire and the melting of the ice comprised about one hundred eight square miles; the island is an irregular circle, twelve miles across and fourteen miles long. Perhaps the most appropriate description of its outline comes from its earliest inhabitants, "the Indians, who called Mt. Desert 'Great Crab Island' in allusion to its shape."[4]

From evidence of arrowheads, shell heaps, and other relics, historians estimate that there were three phases of Indian life on the island. The first culture dates to around 4000 B.C. and a second to around A.D. 1000. Closer to A.D. 1500, the Penobscot and Passamaquoddy tribes of Abnacki Indians migrated to Mount Desert annually. These native Americans canoed down the northern rivers of Maine each summer to live off the local shellfish and wild berries, returning inland for the winter.[5]

The area's recorded history does not begin until the early sixteenth century. The first documented sighting of the island by Europeans occurred during the ambitious explorations of the New World by the Spanish and Portuguese, who were followed by the French and English. The Portuguese reached this part of North America in 1525 and made the first map of the area in 1529, one that served explorers for almost a century thereafter.[6] The most prominent European visitor and observer of this coast was Samuel de Champlain, whose extensive and distinguished career in North America began with his first voyage to Canada in 1603. Under the command of his countryman, Pierre du Gua, sieur de Monts, Champlain not only led expeditions along the coasts of Nova Scotia and New England, but, more importantly, kept written accounts and drew admirably accurate charts of the harbors and islands he passed.

recently covered New England began about a hundred thousand years ago and reached its maximum extent some eighteen thousand years ago. As it met the hard granite of the Mount Desert range, which extended across its path at right angles, the ice pack gradually ascended its ridges, which accounts for the gently curving rises of the island's north slopes today. Once reaching the summit, the glacier, whose thickness reached more than two thousand feet, pressed down on the resisting rock beneath. The moving ice gouged deep valleys running from north to south through the range.[3] When the glacier finally retreated, it

Champlain was given independent authority to undertake explorations along the Bay of Fundy and New Brunswick coastlines to consider sites for future settlements. He set forth in June 1604 and made his way to the south and west. Toward summer's end, he left Sainte-Croix and sailed by the high cliffs of Grand Manan Island, now a Canadian possession at the southern end of the Bay of Fundy. The next point of land he made for was Schoodic Point, where he evidently put in for the night, having sighted even more alluring land rising from the horizon beyond.

The following day, 6 September 1604, Champlain rounded the point of Schoodic (fig. 90) and sailed across Frenchman Bay for Mount Desert Island. Passing Great Head and Sand Beach on the southeast corner of the island, he came close to Otter Cliff (see figs. 5, 34, 83), and there struck the offshore ledge usually submerged at high tide. Able to make his away around the headland, he put into the long mud-flat inlet of Otter Creek nearby (fig. 82), where his men could repair their vessel and take on fresh water. Next Champlain sailed along the rest of the island's southern coast, continuing his explorations through Penobscot Bay.[7] The changing panorama of the Mount Desert summits led to his giving this barren terrain the name by which it has been known since: "The land is very high, intersected by passes, appearing from the sea like seven or eight mountains ranged near each other. The summits of the greater part of these are bare trees, because they are nothing but rocks. . . . I named it l'isle des Monts-deserts."[8]

Champlain's observations were noteworthy in other respects as well. He was the first European to record the fact, presumably learned from local Indians, that the island was clearly separated from the mainland. In addition to leaving an evocative written account of his travels, he drew what have been called "remarkably accurate maps and harbor charts, the best ever of northern America in that century."[9] His passage here was only part of his continuing explorations: he navigated much of Penobscot Bay again and went farther south in the summer of 1605, and by the end of his life had crossed the Atlantic twenty-nine times.[10] But perhaps he struck the most resonant chord for all who have followed him in observing that "on arriving in summer everything is very pleasant owing to the woods, the fair landscape and the good fishing."[11] Over the next century and a half the French and English struggled intermittently for the possession and settlement

of eastern Maine and Canada. The French called this territory Acadia (which name is memorialized today in the parklands on the island). Conflicts reached a climax with General Wolfe's triumph over the French in Quebec in 1758 and the conclusion of the French and Indian wars. Thereafter English interests were in the ascendancy, passing to their own former colonists after the American Revolution two decades later.

The English governor of Massachusetts, Francis Bernard, arrived by boat in 1762 on a surveying expedition. On October first, he recalled,

> at daybreak entered Penobscot Bay. . . . Between Fox Islands saw Mt Desart hills at 30 miles distant . . . with a pilot boat proceeded for Mount desart. . . . At first we came to a spacious bay formed by land of the great island on the left and of the Cranberry islands on the right. Toward the end of this bay, which we call the Great Harbour, we turned onto a smaller bay called the southwest harbour. This last is about a mile long and three fourths of a mile wide. On the north side of it is a narrow opening to a river or sound which runs into this island eight miles and is visible in a straight line with uneven shores for nearly the whole length.[12]

After watching the sunrise a week later, Bernard sailed up Somes Sound (see figs 41, 49), which he described as "a fine channel having several openings and bays of different breadths from a mile to a quarter of a mile in breadth. We passed through several hills covered with wood of different sorts. In some places the rocks were almost perpendicular to a great height."[13] Bernard's interest marked the beginning of increased visits and settlement by the English. After the Revolution the territory of Maine remained part of Massachusetts through the first quarter of the nineteenth century, when it gained separate admission to the Union.

With the lingering disputes between the young republic and Great Britain finally settled by the War of 1812, commerce prospered along the entire Atlantic coast. In New England the architects Charles Bulfinch and Samuel McIntire built fashionable houses for the new merchant class of sea captains and shipowners. Immigrants from Europe swelled the population of the East Coast cities, and trade to distant oceans expanded the nation's horizons and its pride. America's wilderness landscape not only called for exploration and settlement, by the second quarter of the nineteenth century it was also perceived as

providing the substance of national self-definition.

At just this time, America's first great native writers and artists began their travels into the wilder tracts of the Northeast. In 1836 Thomas Doughty, a founding figure of American landscape painting, completed the first major canvas of the Mount Desert area (fig. 10), and a decade later, Henry David Thoreau made his first journey into the wild interior of Maine nearby. Thoreau made three excursions into the northern woods, in 1846, 1853, and 1857, traveling by steamer from Boston to Bangor via Monhegan Island. While he never visited Mount Desert, he would have had distant glimpses of its mountains as he sailed through Penobscot Bay and up the river to Bangor. "Next I remember that the Camden Hills attracted my eyes, and afterward the hills about Frankfort."[14]

Reaching Bangor, Thoreau felt he was on the threshold of the wilderness, and this northern city was "like a star on the edge of night." Beyond, "the country is virtually unmapped and unexplored, and there still waves the virgin forest of the New World."[15] Others of his generation shared his acute awareness of balancing on the fulcrum between civilization and nature: "Though the railroad and the telegraph have been established on the shores of Maine, the Indian still looks out from her interior mountains over all these to the sea."[16]

Thoreau's journeys also prompted him to higher thoughts. He pondered the American paradox of having both an established identity and a destiny yet to be discovered: "While the republic has already acquired a history world-wide, America is still un-settled and unexplored. . . . Have we even so discovered and settled the shores?"[17] These sentiments, an extension of the original experience of exploration in the New World by voyagers three centuries before, animated American aspirations through much of the early nineteenth century. Thoreau was the first important writer to articulate the belief that an excursion to the Maine wilderness was more than a physical passage. It led, he claimed, to a glimpse of basic matter and of God's first nature.

To the transcendentalist this was no less than "the fresh and natural surface of the planet Earth, as it was made for ever and ever. . . . It was Matter, vast, terrific."[18] Thoreau was particularly impressed with the continuousness of the Maine forest. The far-ther he traveled inland, the more aware he became of uninter-rupted woods—still, even timeless. By contrast, when he reached the mountains, he felt they were "among the unfinished parts of the globe . . . their tops are sacred and mysterious."[19] On climbing Katahdin, he expressed a reaction equally applicable to the hills of Mount Desert: "Here not even the surface had been scarred by man, but it was a specimen of what God saw fit to make this world. What is it to be admitted to a museum, to see a myriad of particular things, compared with being shown some star's surface, some hard matter in its home."[20]

Travel along the coast was arduous and memorable as one proceeded east. The first steamer service from Boston to Maine began about 1850. Runs were made to Portland and Rockland; from there the *Ulysses* ran to Southwest Harbor and Bar Harbor on Mount Desert. Subsequently, there was service from Boston to Bucksport and Bangor, in turn the points "of departure for a journey of from thirty to forty miles by stage."[21] One of the first recorded accounts was a trip by Charles Tracy of New York, father of Mrs. J. Pierpont Morgan, Sr., who came for a month in the summer of 1855. He arrived by steamer in Southwest Harbor, accompanied by the family of the Reverend Mr. Stone of Brook-line, the writer, Theodore Winthrop, and the painter, Frederic Edwin Church, back for his fourth visit to sketch (see figs. 92, 93), this time with his sister along.[22]

Getting to this part of the coast on one's own, by chartered or privately owned vessel, would have been even more demanding. In the same years as Church's visits, the Gloucester painter Fitz Hugh Lane reached Mount Desert (see figs. 50, 59), sailing with friends from Castine. Robert Carter, the Washington corre-spondent of the New York *Tribune,* kept an account of another voyage made in the summer of 1858. "Summer Cruise on the Coast of New England" described his trip from Boston to Bar Harbor. "The approach to Mount Desert by sea is magnificent. It is difficult to conceive of any finer combination of land and water."[23]

For those who sailed the coast in modest sloops or schooners, there was always the glory as well as the unpredictability of Maine summer weather. Besides the daily rush of tidal currents, torpid calm alternates with forceful storms, dense fog with sparkling sunlight, favoring breezes with unmarked hazards. During the first half of the nineteenth century there were rela-tively few navigational aids along the Maine coast, though a number of major offshore ledges and islands did have lighthouses.

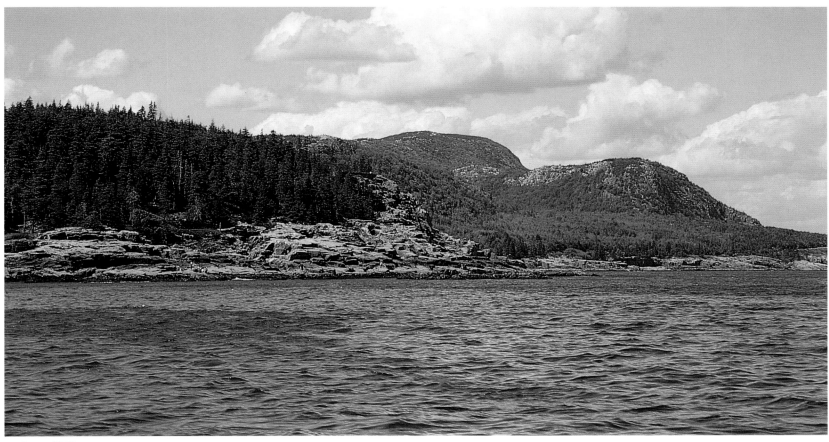

5. Otter Cliffs

The oldest lighthouse in Maine is that at Portland Head, built in 1791 at the direction of George Washington. At least one other, that on Seguin Island marking the mouth of the Kennebec River, was constructed in the eighteenth century. More than two dozen others were built on sites between Portsmouth, New Hampshire, and Isle au Haut before the Civil War.[24]

East of the Mount Desert area, at least half a dozen lights were put up between 1807 and 1856 on points from Narraguagus Bay to West Quoddy Head at the Canadian border. Around Mount Desert itself and the nearby approaches, seven lighthouses are known to have been constructed during the early nineteenth century: those of Bass Harbor Head, 1858; Mount Desert Rock, 1830; Baker Island, 1828 (rebuilt in 1855); Bear Island, 1839; Winter Harbor, 1856; Prospect Harbor, 1850; and Petit Manan, 1817 (also rebuilt in 1855). In addition, the government erected a

stone beacon daymark on East Bunker's Ledge off Seal Harbor (see figs. 6, 87) in 1839–1840.[25] These facilitated travel along the many treacherous passages leading down east, and made it possible for artists and others in increasing numbers to sail at their leisure to Mount Desert by midcentury.

But these starkly simple stone towers served as more than fixed points of reference. For the early generation of travelers, they also had symbolic and emotional connotations. They were emblems of safety and security, guidance and direction, and metaphors for spiritual salvation.[26] No wonder artists painting in a period of increasing national strife and anxiety turned for solace to the imagery of lighthouses. For example, between the 1830s and the 1860s Thomas Doughty, Frederic Edwin Church, Fitz Hugh Lane, and Alvan Fisher all painted lighthouse views around Mount Desert (see figs. 10, 65, 57, 16). These towers were not merely

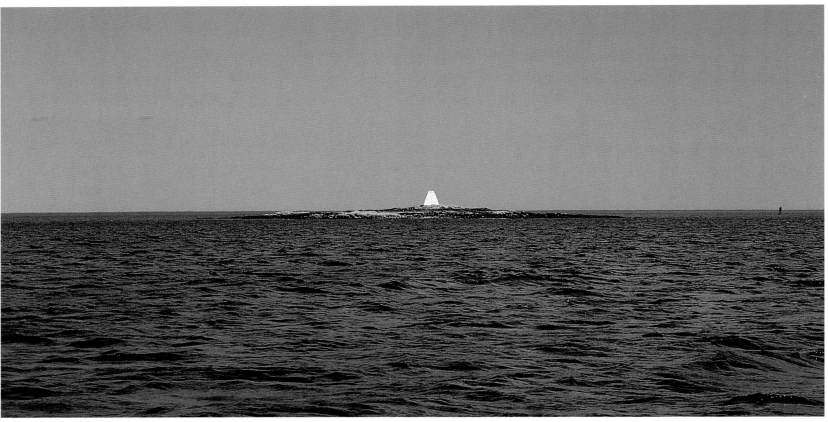

6. Beacon, East Bunker's Ledge

features punctuating the physical landscape. They were also beacons of stability, founded on the literal rocks of ages of Maine granite.

Coastal traffic of all sorts increased during the middle decades of the century. Mount Desert and the larger islands of Penobscot Bay were good areas for a growing economy based on forest and sea. Shipping and shipbuilding flourished in the older fishing villages. Timber was cut from the lower slopes of Mount Desert more than once and loaded aboard sturdy schooners (see figs. 50, 60) for transportation back to Portland or Boston. This rocky landscape also yielded up another element of its "basic matter": Maine's quarries (see fig. 166) provided much of the granite for the new Greek revival buildings rising in Boston and elsewhere, and many of the smooth popplestones from its shores were re-moved for the streets of New England's cities.[27] Broad-bottomed schooners carried these loads of stone to harbors to the west and

south. Finally, the island's waters offered a bounty of fish, especially herring, crab, and lobster.

Visitors to Mount Desert who came to see its splendors or stay for a few summer weeks found simple accommodations in private lodgings or taverns around the island. The painter Church, for example, stayed on his 1855 trip at the tavern in Somesville; on another occasion he boarded at the Higgins homestead in Bar Harbor.[28] One of the most popular places artists chose to stay was on Schooner Head, an especially dramatic site on the eastern side of the island overlooking Frenchman Bay. This was "the Lynam Homestead, to which Cole, Gifford, Hart, Parsons, Warren, Bierstadt, and others renowned in American art have from time to time resorted to enrich their studies from the abounding wealth of the neighborhood."[29]

Among other painters making early excursions to the island who stayed at Somes Tavern, besides Church and William Hart,

were Thomas Birch and Charles Dix.[30] After the Civil War, increased prosperity and better transportation led to replacement of the taverns by larger hotels built in Bar Harbor, Southwest Harbor, and (later) Northeast Harbor. During the 1870s and the 1880s new growth occurred in summer cruising and yachting, followed by the first wave in the building of large summer cottages.

Travel on the island itself was fairly primitive well into the middle of the nineteenth century. When the first artists arrived, most roads were rough tracks and the sea was "still the high road for the dwellers on the island."[31] However, by 1875 surveyors had laid out a carriage road to the summit of Green Mountain, and beginning in the 1880s for a few years a narrow-gauge railway ascended nearby. Sightseers crossed Eagle Lake, in the center of the island, by steamer, landing on the west slope of Green Mountain, where they could board the tram car for the ride up and back.[32]

Mount Desert attracted a host of prominent visitors, including vacationing clerics and academics, such as Bishop William Doane of Albany and Charles William Eliot, president of Harvard. The one distinguished writer of the period who made the trip and recorded his observations was John Greenleaf Whittier. In contrast to the scientific and philosophical cast of Thoreau's journals, Whittier's lines bear the romantic sensibility of the later nineteenth century:

> Beneath the westward turning eye
> A Thousand wooded islands lie,—
> Gems of the waters: with each hue
> Of brightness set in the ocean's blue . . .
> There, gloomily against the sky
> The Dark Isles rear their summits high;
> And Desert Rock, abrupt and bare,
> Lifts its gray turrets in the air.[33]

The painters who visited the island over the past century and a half worked in an array of artistic styles. Some, like John James Audubon and Thomas Eakins, intended to paint subjects quite different from the Maine landscape. Audubon came in search of local bird species he might include in his grand pictorial inventory, *The Birds of America*, completed in 1838. Eakins was a guest in Seal Harbor of Henry A. Rowland, a professor of physics at the Johns Hopkins University in Baltimore and a summer resident; he worked on Rowland's portrait for several weeks in 1897.[34]

The Maine coast has also attracted other major American painters; in the nineteenth century Winslow Homer and in the twentieth Edward Hopper worked in the southern part of the state, but they were never lured farther east to the Mount Desert region. But those who did venture this far, whether for brief stays and single works, or for repeated visits and an extensive output, collectively give us an unusual and striking survey of American art. Indeed, part of the island's continuing allure is that a fixed point of geography can inspire such diverse visual responses and stylistic treatments as the romantic realism of the early Hudson River painters, the crystalline luminism of artists in the middle of the nineteenth century, the variants of impressionism practiced at century's end, and the new modes of representation in the twentieth, approaching aspects of abstraction.

The figures most central to this chronology are, first, the pioneers, Thomas Doughty, Alvan Fisher, and Thomas Cole, who generalized and romanticized nature in their visits of the 1830s and 1840s. Next came Fitz Hugh Lane in the 1850s and Frederic Edwin Church in the 1850s and 1860s. Each drew and painted extensively at Mount Desert. In particular, they recorded the northern sunsets in forms that made Americans give serious thought to the significance of their country's geography and its destiny. After the middle of the century, William Stanley Haseltine produced a large group of refined drawings and watercolors around the southern shore of the island. Following him were numerous painters of varying stature who marked their stays for the most part with only one or two sketches. Some made drawings: William Trost Richards, John Henry Hill, Xanthus Smith, and Ralph A. Blakelock; others produced watercolors: Alfred Thompson Bricher; and still others singularly beautiful oils: Sanford Gifford and Childe Hassam. In the first half of the twentieth century Mount Desert commanded the attention of artists working in a range from traditional to modernist visions, among them Carroll Tyson, William Zorach, Oscar Bluemner, Marsden Hartley, and John Marin.[35]

Each generation of artists was favored with a glimpse of nature many felt to be God's first creation; with their own creativity they returned the favor by changing that nature into an American art for posterity.[36]

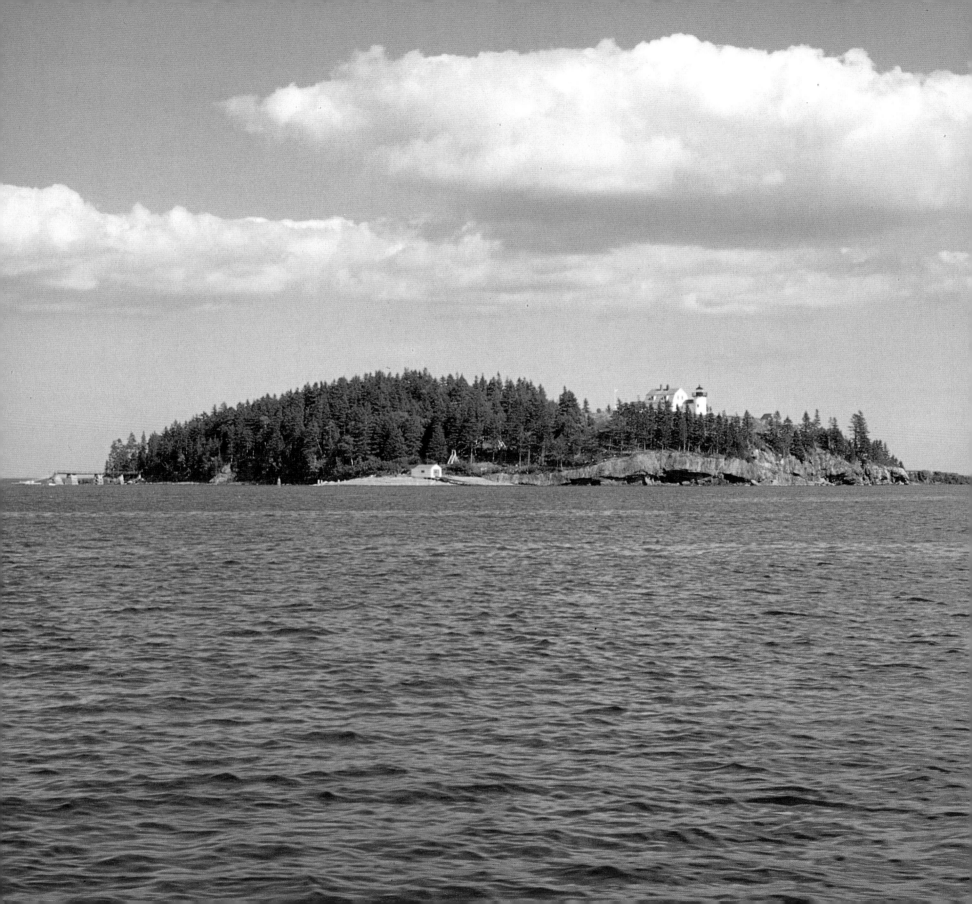

II.
The Early Nineteenth Century

EIGHTEEN THIRTY-SIX might arguably stand as a marker date for the first flourishing of a native American culture. It is perhaps most often cited as the year in which Ralph Waldo Emerson published *Nature*, his cogent celebration and philosophical defense of landscape's spiritual power. At the same time, Thomas Cole, the leader of America's first major group of landscape painters, the Hudson River school, completed his ambitious suite of canvases, *The Course of Empire*, moralizing about nature's role in civilization. And that same year, in the annual art exhibition at the Boston Athenaeum, the native Philadelphia painter Thomas Doughty showed his recently completed oil, *Desert Rock Lighthouse, Maine* (fig. 10), the first important image of the wilderness on the New England coast. Thus by coincidence, American art and literature shared a starting point in articulating for subsequent generations a consciousness of national identity founded in nature.

During the preceding year Cole wrote his summary *Essay on American Scenery*, and Alexis de Tocqueville published his influential *Democracy in America*, drawing on the political and social observations he made during his tour of the United States at the beginning of the decade. Indeed, the period was one in which the nation tried to define itself through the writing of history and the documentation of resources. George Catlin spent much of the decade of the 1830s sketching the Indian tribes of North America. Meanwhile, John James Audubon brought to completion his monumental project, *The Birds of America*, published in 1838. Another artist, William Dunlap, finished his three-volume *History of the Rise and Progress of the Arts of Design*

7. Bear Island, Northeast Harbor

in the United States, which was, in effect, the first survey of American art history. Significant in its title were those strong, self-confident nouns, "rise," "progress," and "design," speaking of growth, optimism, and order in the new republic. Emerson championed a native intelligence in his 1837 Phi Beta Kappa address at Harvard, *The American Scholar.* Central to his argument was the influence of nature on the American mind and a belief in history as it might help shape new indigenous traditions. Implicit in both was the accumulation and ordering of facts. "Classification begins," he declared.[1] At every turn, it seemed, the artists and writers of Jacksonian democracy proclaimed their common aspiration to delineate a national history and culture.

Emerson saw nature as a "vehicle of thought," wherein man approached the "presence of a higher, . . . spiritual element."[2] But nature was also a voyage "to go into solitude" so that one's "inward and outward senses are truly adjusted to each other."[3] Emerson wrote about the equation of travel and thought. As contemporary artists set out to visit and depict the Maine coast, they were embarking, in Emersonian terms, on a voyage both physical and mental: "But is it the picture of the unbounded sea, or is it the lassitude of the Syrian summer, that more and more draws the cords of Will out of my thought and leaves nothing but perpetual observation, perpetual acquiescence and perpetual thankfulness."[4] Thoreau spoke in a similar voice a few years later: "In the spaces of thought are the reaches of land and water, where men go and come. The landscape lies far and fair within, and the deepest thinker is the farthest traveled."[5]

For this generation nature had a high moral purpose. As Thomas Cole argued, "the contemplation of scenery can be so abundant a source of delight and improvement."[6] He asserted

13

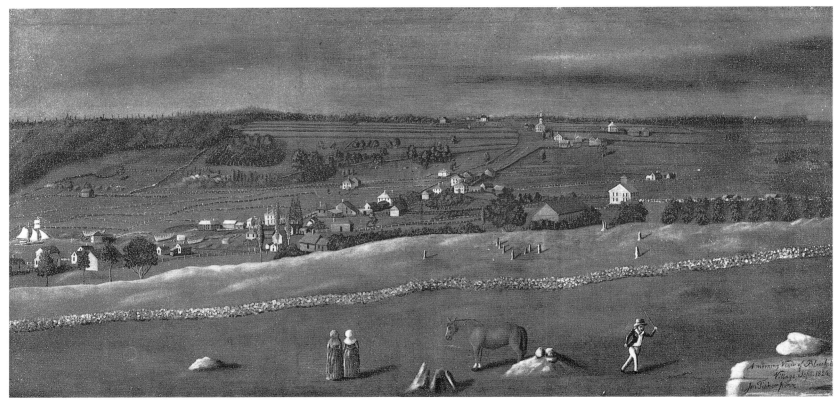

8. Jonathan Fisher, *A Morning View of Blue Hill Village*, 1824

that the most distinctive aspect of American nature was its wilderness, that which separated it from and elevated it above the worn and changed landscape of Europe. Of all the pristine, sublime elements of American scenery, Cole called special attention to water and air, which he and his colleagues would experience in dramatic fullness on the Maine coast. In his 1835 essay he wrote, "I will now speak of another component of scenery, without which every landscape is defective—it is water"; and later, "The sky will next demand our attention. The soul of all scenery . . . whether it be the serenity of the summer's blue, or the dark tumult of the storm."[7] In this intellectual climate, Thomas Doughty set forth by steamer that same summer to depict the physical weather en route to Mount Desert.

But even before Doughty began his journey, and before he took up, with his fellow artists, the role of secular preacher interpreting God's nature, one artist had taken up the calling of

Congregational minister in a country community looking directly across Blue Hill Bay at Mount Desert. Jonathan Fisher was graduated from Harvard in 1792, and four years later accepted an offer from the newly incorporated village of Blue Hill to serve as pastor. In addition to his pursuits in farming, writing, science, and art, he led his congregation until his death in 1847.[8] Fisher was prepared for his calling. He had grown up with his uncle Joseph Avery, a Congregational minister in Holden, Massachusetts; following his graduation from college, he continued work for a master's degree and visited Blue Hill to preach in two successive summers before he moved there permanently.

Once settled, he energetically began a variety of intellectual and professional activities, including designing and building his house, studying languages and philosophy, writing an illustrated book, *Scripture Animals: A Natural History of the Living Creatures Named in the Bible*, and painting portraits and landscapes.[9] In his

landscapes he made a point of fusing to the factual details he saw before him emblematic phrases or images of moral themes. Typical was the charming bust-length painting of a young woman allegorically posed as Spring, which included at the bottom the inscription of his poem composed on the subject:

Youth in the Spring, when those celestial flowers
Should bud and Blossom in the cultur'd mind,
Which give to life a Summer free from blight,
And yield an Autumn rich in holy fruit
Matur'd, and waiting joyful harvest home.[10]

In conception as well as practice Fisher's life in Blue Hill was tied to its landscape, a union reflected by his execution the same year, 1824, of his *Self-Portrait* and his most celebrated work, *A Morning View of Blue Hill Village* (fig. 8).[11] In the former he austerely showed himself with his right hand resting on a Bible, forefinger pointing to a verse in the open book, linking the artist's intelligent face to his acts of moral interpretation. With his village panorama, perhaps the first major scenic landscape of this part of the Maine coast, Fisher recorded key details of his environment while projecting through allegorical flourishes his belief in the higher significance of this Edenic setting. Significantly emblazoned on a prominent boulder at the painting's lower right, like a gravestone or a tablet of scripture, are the title, date, and maker's signature, stating Fisher's active presence in Blue Hill. His first words state that this is not just a "morning view" of a new day, but an indication of God's cleansed wilderness and the beginnings of civilized enterprise in this rural frontier of Maine just at the start of its statehood.

Blue Hill was at the juncture of nature and civilization, here suggested by the foreground tree stumps cut to make way for the cleared fields and orderly stone walls on the far side of the town. Cool, clear light washes this verdant landscape and sets off with angled shadows the important structures of the parson's world. A large schooner at the left draws near in the inner harbor, signifying the arrival of commerce, to be matched by the rising industry of shipbuilding visible along the waterfront. As viewers, we join the two women standing at the lower center beholding the fine prospect, while the stolid workhorse of this new order waits nearby. Being driven from this Eden is the proverbial snake in the grass, the biblical serpent, who must not corrupt Fisher's God-fearing community. Our view from the slope of the hill above the town is an elevated one, literally and metaphorically, over a middle ground and distance filled with the essential buildings of that community: houses, barns, school, parsonage, and the parson's own church appropriately at the rise on the far horizon. Evil and temptation are to be kept outside the stone walls, as if in a medieval village, allowing man's harmony and progress to advance within.[12] Fisher as artist and preacher leads us through the text of his landscape of promise and optimism, unequivocally conveying to us his serene vision of national prosperity and well-being, in ways soon to be articulated by more famous academic counterparts such as Thomas Cole and William Sidney Mount.

The approaching schooner reminds us of the arduous travel any artist would have experienced along this coast during the first decades of the nineteenth century, and such vessels are prominent images in the first seascapes painted here by Doughty and his contemporaries. As Fisher's biographers have shown, the world he built, the fields he cultivated, and the voyages he made were both physical and spiritual undertakings. Sailing from Blue Hill to Salem, he wrote some lines that might well have served the sense of higher passage many of his colleagues felt as they ventured forth into the sublimity of nature:

Shipmates, adieu! We part, perhaps to meet
On earth no more; be this our future prize:
Through faith in Christ, to find a calm retreat,
Each in the Salem of the blissful skies![13]

While his Blue Hill panorama stands as a remarkable early record of an identifiable view, much more common in the landscape painting of the first third of the nineteenth century were generalized scenes that captured the essential ingredients of nature and thereby evoked elevated moral or spiritual feelings. The seascapes painted by Thomas Birch along the mid-Atlantic and New England coasts are typical. Born in 1779 in England, Birch emigrated with his family to Philadelphia in 1794 and remained active as a marine painter in that area throughout the first half of the century.[14] He became especially well known for his series covering many of the major naval engagements between the Americans and the British during the War of 1812. Although notable for their depictions of gunfire and the dramatic damage to vessels in close combat, these paintings also show Birch's mastery

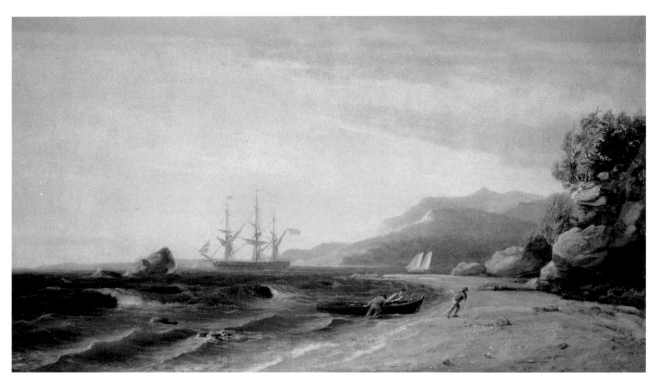

9. Thomas Birch, *The U.S.S. Pennsylvania off Mount Desert,* 1810

of naval architecture, turbulent seas, and a range of light and atmospheric effects, which he would successfully exploit in his subsequent coastal views.

His father, William Birch, was an engraver as well as a collector of prints, so the younger artist grew up knowing examples of seventeenth-century Dutch and eighteenth-century French marine painting. In particular, the precedents of Salomon van Ruisdael and Claude Joseph Vernet help explain Birch's scenes of romantic drama, such as stormy seas and shipwrecks, but also his care in drafting and his broad tonal contrasts. Aside from his War of 1812 works, many of Birch's images were tied to the environs of Philadelphia and the Delaware Bay. Often employing a spacious midharbor vantage point in paintings of the Philadelphia waterfront, he easily adapted this compositional formula to a similar series of New York harbor views painted in the 1830s. A related category of pictures indicates that he ventured farther up the Atlantic coast to paint sailing traffic in different kinds of weather and shoreline settings. Many of these are generic: beach expanses, rocky cliffs, vessels off a lee shore or aground, and the occasional lighthouse. Some of the lower coastal promontories

seem typical of southern New England, while views of rugged seas and looming cliffs suggest the wilder scenery to be found more to the north along the Maine coast.

He painted some documented locales, such as *Minot's Ledge Rock Light* (Historical Society of Pennsylvania) near Boston, and views at Narragansett and Nantucket. Canvases titled or said to depict the Maine coast are rare.[15] One, *Off the Maine Coast* (Fruitlands Museum, Harvard, Massachusetts), gives the conventional Birch composition with breakers crashing against sharp cliffs to the left, a large reefed schooner set against the open seas to the right, and in the middle distance a lighthouse on a rising promontory. Unfortunately Birch includes no other telling details by which to locate the subject, although Portland Head Light, one of the coast's earliest and most prominent lighthouses, is a good possibility.[16] Moreover, we are not certain when Birch might have become interested in Maine subjects, or even traveled that far northeast.

At least one intriguing picture combines his interests in historical and topographical elements, both in this instance most likely tempered by his imagination. Titled *The U.S.S.*

Pennsylvania off Mount Desert (fig. 9) and said to depict an incident from 1810, the theme relates to Birch's celebrated maritime battle series of the War of 1812, a series painted and exhibited at the time. Political affiliations had long been a lively matter even in the relative frontier of the Mount Desert region. The island had been the scene of ongoing conflict, first between English and French settlers, and then during the Revolutionary War and Federal periods between colonists and loyalists. During this second struggle with England, HMS *Tenedos* attempted a landing on Mount Desert Island at Southwest Harbor, and signal fires often had to be lit on the nearby hills.[17] Not surprisingly, this part of the coast had an important stake in a war waged over maritime commerce and prosperity. In the preceding years it would have been natural for a United States ship to have been on patrol in these waters; here one is shown at anchor under the rising headlands.

There is no evidence of this work resulting from any firsthand experience, although Birch has accurately captured the effects of Mount Desert's hills rising directly from the shore's edge. Yet there are other aspects that are doubtless contrived: the mountains' overly jagged contours, the open, curving beach, and in the far left distance the towering lighthouse, none of which can be found in these configurations around the island's shores. But it is a sophisticated picture in its conception and technique, with narrative interest and sublime drama fusing together national history and geography. Whatever the actual circumstances of Birch's invention and execution, it is a painting that, characteristically for its time, freely embellishes the experienced with the imagined.

When Thomas Doughty visited Maine in the 1830s, he brought a similar sensibility; he also combined effects taken from nature with modifications made in the studio for purely compositional reasons. Even his famous images of Desert Rock Lighthouse (figs. 10, 12), arguably the first important identifiable views painted of the Mount Desert region, turn out to be composites of elements presumably observed during his tour around the island. Doughty was the senior member of America's emerging landscape painters, known as the Hudson River school from their base in New York City and their interest in upstate scenery. Himself a Philadelphian, born in 1793, Doughty received some early training in drawing, and soon gained experience in painting by copying old masters in local collections and exhibitions. In particular, he drew inspiration from works by the seventeenth-century Dutch artists Albert Cuyp and Jacob Ruisdael and the popular eighteenth-century exponent of the sublime, Salvator Rosa: their creamy brushwork, low horizons, spacious cloud designs, and narrative details all find their way into Doughty's mature style.

By the 1820s he was exhibiting at the Pennsylvania Academy and keeping company with such prominent Philadelphia painters as Thomas Sully and Joshua Shaw. In the exhibition catalogues the subjects of Doughty's pictures were frequently qualified as done "from nature," "from recollection," or "composition," indicating the degree of his visual recording or invention. Within this range he began to undertake a repertory of topographical and imaginary views, a diversity that led critics to conflicting observations about his art: "Doughty, in study perpetual, is the Painter of Nature," wrote one, while another claimed, "it is obvious that he has never painted much from nature, for there is a monotony in his touch."[18] The truth is that his style was a fusion of the extremes, which helps explain the inaccuracies in his Mount Desert view.

Doughty moved to Boston in 1828 and painted there for two years. Where previously he had made sketching trips along the Schuylkill River in the company of Thomas Sully, now he made the friendship of the Boston painters Chester Harding and Alvan Fisher, and joined them on journeys to North Conway, New Hampshire, to draw and paint.[19] At Fisher's instigation, Doughty made an early visit to the Maine coast, when he painted his canvas with that title (fig. 11) dated 1828. Like Birch's earlier scene, this is a charming but generalized work of a rocky evergreen coast typical of a northern setting, yet no identifying features indicate exactly how far northeast along the coast Doughty went to paint this. In any case, he went back to Philadelphia in 1830 for two years, and then returned to Boston for a five-year period of activity. With an older brother, William, listed in the Philadelphia directories as a "naval draftsman," and another brother, Samuel, listed as a "mariner," Doughty had additional reasons to be interested in maritime travel and subjects for his art. During this second Boston stay he made at least two trips down east, for he painted Camden in 1833 and then two years later his first Mount Desert picture.[20] Perhaps due to his

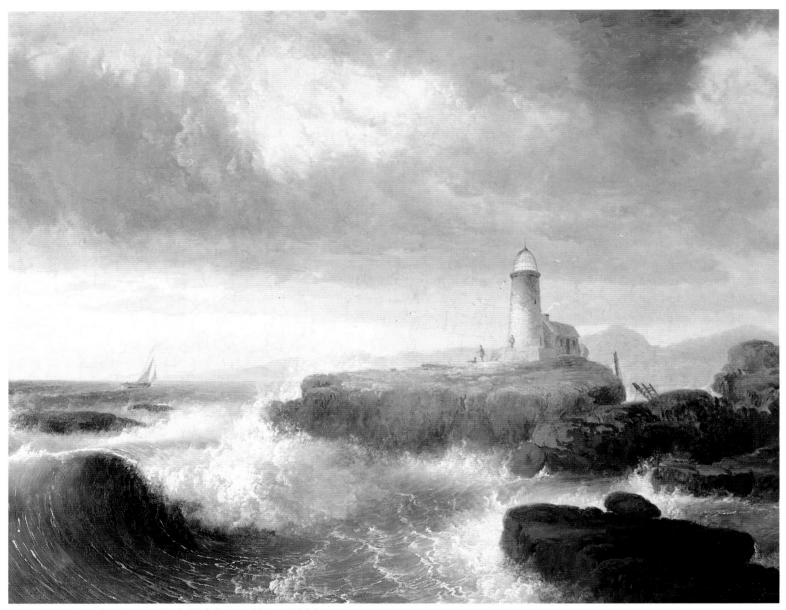

10. Thomas Doughty, *Desert Rock Lighthouse, Maine,* 1836

acquaintance with Fisher, Doughty began the practice of making multiple versions of a subject, and his *Desert Rock Lighthouse, Maine,* became the best-known example of this habit, doubtless due to its wide circulation in print form.

Since he showed his first version at the annual exhibition of the Boston Athenaeum in the winter of 1836, we may assume that he made his actual visit to the Mount Desert area the preceding summer, when he apparently executed a number of preparatory drawings for an ambitious painting of the lighthouse. Just a few years later, his publisher, Nathaniel Parker Willis, noted, "There is beautiful scenery in Maine, however; and Doughty, from one of whose pictures the accompanying drawing was taken, made a tour

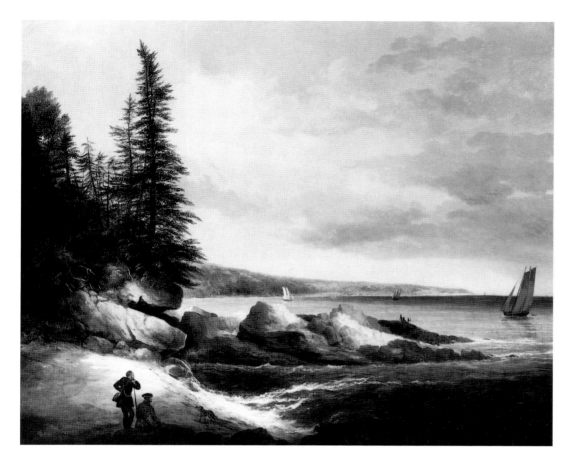

11. Thomas Doughty, *Maine Coast*, 1828

in search of it and filled a portfolio with sketches which (the most of them) might belong to any Tempe for their summer look."[21] These drawings, whose whereabouts are unknown, would be useful in determining what details and angles of vision Doughty was most interested in recording, thereby illuminating further his process of observation and manipulation. Willis went on to indicate that the artist's sketches "were taken from the neighborhood of Desert Rock, and within view of Mount Desert, shown in the drawing."[22] At this point we become uncertain whether Willis is recounting Doughty's actual practice or simply creating a descriptive narrative from the painting the artist provided him for engraving.

There are several aspects of the original canvas worth noting, for they undergo subtle but significant changes in the later versions. Not only is the lighthouse inhabited, but we witness a scene of domestic relaxation. Smoke drifts lightly from the chimney. Two figures stand at ease outside, one holding a gun with a dog by his side, ready to shoot at the passing birds, and although waves crash on the rocky ledge, a small sloop comfortably sails by. Following the painting's completion and exhibition in Boston, Doughty made plans to go to London, where he continued to paint "from recollection." Here he arranged for Willis to engrave his image for publication as an illustration to a book on American scenery. Doughty stayed abroad for two years, and shortly after his return to America, the engraving was completed. Published by George Virtue of London, it bore the date 1839, and appeared with Willis's accompanying text in the book, published the following year.

Where there was a hint of some ship's wreckage just below the lighthouse to the right in Doughty's painting, the engraving executed by W. Radclyffe embellishes the notion of a shipwreck and rescue with the hauling of a large mast on the rock now sharply set off in the foreground. The lighthouse also stands on a clearly isolated outcropping with sheer cliffs. Other details have

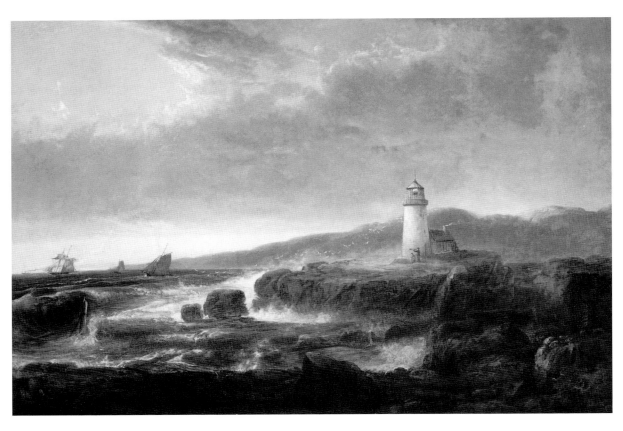

12. Thomas Doughty, *Mount Desert Lighthouse* (*Desert Rock Lighthouse*), 1845

been modified as well in the translation: the shape of the light atop the pier is more cylindrical, the chimney is located at the far end of the house, many more vessels sail in the distance, and most importantly, the contours of Mount Desert Island proper now loom up behind the lighthouse ledges. When Doughty undertook his second version of the view in oil, he appears to have relied more on this engraving and his memory than on the original composition.

He was back in London in 1845 and two years later was in Paris, where he painted the second scene (fig. 12). This version retains the same general form of the lighthouse and chimney location as in the print, along with the several sailing vessels offshore. The island's ledges are closer to those of his first painting, although he suggests a continuing foreground of the rock masses, as if forming a more protective channel, and pieces of wreckage in the outer breakers to the left. The profile of the background mountains is higher, with the effect of bringing the mainland even closer.

Two principal geographical elements in this sequence appear to be consciously distorted: the relation of Mount Desert Island behind and the narrow channel within the lighthouse rocks. Here Willis's storytelling narrative offers a clue to the obvious drama Doughty wanted to impart in his image. After citing Desert Rock as an example of beautiful scenery in Maine, Willis went on: "Such spots as this are expected, like the knife-grinder, to have a story to tell, and this, unlike the knife-grinder, answers to expectation." Before he goes on with this tale of a classic shipwreck, he observes that "the Light-house in the fore-ground stands upon a rock, about twelve miles from land; and near it lies a low reef, hidden at high tides, with a channel between it and the loftier rock."[23] In fact, Mount Desert Rock is twice that distance from the coast, and neither observation of a chart nor consideration of the site itself reveals any adjacent channel or hidden reef. Mount Desert Rock is a single elongated oval ledge rising a few dozen feet out of the sea, and is clearly surrounded by deep water on all sides. Likewise, from a vantage point at sea

level, the distant hills of Mount Desert Island are low and barely distinguishable, even in the sharpest and clearest summer light.

Indeed, the angle of Doughty's view is not one looking northward from Mount Desert Rock, but evidently one from the east, with the high hills of the Newport and Cadillac mountains on the eastern side of the island seen to the right and sloping southward off to the sea across the center background. Also, given that the main island is closer, this view could be of Egg Rock at the entrance of Frenchman Bay, almost on a line with the southern shore of Mount Desert. Moreover, the ledges of Egg Rock are divided by a trough in the rocks and partially submerged at higher tides. Since a lighthouse was not constructed there until 1875, these rocks were a site for potential shipwrecks, and Willis's account makes much more sense if the painting is of this location: "Some years before the erection of the Light-house, a homeward-bound vessel ran upon the breakers in a storm, and went to pieces."[24] Willis then gives the details of the storm, wreck, survivors, and rescue in the lee of the channel. The adventure no doubt occurred, but in the repetition of its telling and eventual publication most likely its precise location was obscured. Doughty no doubt had sailed around both rocky islands, each well offshore from Mount Desert proper. In effect, his composition combines the lighthouse that did exist on Mount Desert Rock—built in 1830, it was one of the earliest on the coast—with the different configurations and setting of Egg Rock. Such a composite would have been in keeping with his preference for lofty feeling over slavish accuracy of record. Fidelity to physical and atmospheric conditions would await a later generation of artists like Fitz Hugh Lane (see fig. 58), whose stylistic aims and responses to this landscape were to be quite different. There is a final, pictorially amusing coda to the evolution of Doughty's image: its further transformation into a color lithograph later in the nineteenth century by Currier and Ives (fig. 13). Both its main title, *American Coast Scene,* and its consolidated format have made this a generic lighthouse situated on a cliff of the Mount Desert mainland. By 1883 Willis's text and illustrations had been incorporated into a larger and more handsomely illustrated book published in Boston for the growing American tourist and vacation industry, with drawings and writings by other native artists included.[25] Both Doughty's original painting and Willis's 1840 volume expressed that

generation's romantic and often private search for the sublime. In the decades after the Civil War, Currier and Ives's prints and Willis's amplified *Picturesque American Scenery* of 1883 spoke to the popularization of American nature and the greater accessibility of regions like Mount Desert, its image gradually shifting from wilderness to resort.

Doughty's Boston friend Alvan Fisher may have first visited the Mount Desert area at about the same time, and quite possibly the two traveled together in the summer of 1835. In that year Fisher bought some tracts of real estate on speculation in Ellsworth, just north of the island, and later wrote that "Doughty and I used to pick up nice bits about . . . the Cranberry Isles,"[26] a group of small islands off the south shore of Mount Desert. Fisher was just a year older than Doughty, and had a similar stylistic approach to paintings of nature, one that generalized and idealized scenery in an often soft and poetic tone. He worked principally in the Boston area, actively painting landscapes by the 1820s and traveling frequently to the Maine coast during the 1840s and 1850s. One of his earliest dated sketches is a drawing he inscribed *View from Franklin-Bay Landing* and dated 27 August 1837 (Museum of Fine Arts, Boston). With sketchy strokes he shows a couple of dwellings near Ellsworth with a broader panorama looking south

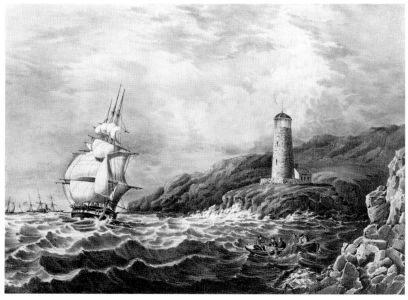

13. Currier and Ives, *American Coast Scene, Desert Rock Light House, Maine,* 1860s

14. Alvan Fisher, *View of Bear Island looking North*, 1848

15. Alvan Fisher, *View from E. End of Bear Is. 13 August 1848. Fog*

over farmlands to the outlined hills of Mount Desert in the distance.

From contemporary exhibition and sales records and from surviving examples, it is clear that one of Fisher's favorite subjects was the variety of picturesque prospects among the nearby Cranberry Islands: Great and Little Cranberry, Sutton, and Bear, the last at the entrance to Northeast Harbor (figs. 15 and 16). In 1847 he sold more than half a dozen local views, including five of Bear Island alone. The following summer he was at work briefly in Camden on 1 August, and then the whole following week at Mount Desert. Unlike many of his landscapes painted around southern New England, his Maine work recorded his fascination with the local topography with relative precision, as his rendering of particular rock formations and mountain outlines as well as his inscriptions attest. Two drawings show views back to the mainland from the shore of Bear Island, readily reached by a short rowboat ride: *View from Bear Island looking North* and *View from E. End of Bear Is. 13 August 1848. Fog* (figs. 14 and 15). A third drawing dated 6 August instead looks at *Bear Island Light & N.E. Harbour* from nearby Sutton Island (fig. 16). Fitz Hugh Lane also went to Maine this same summer for the first time, though he probably did not go as far east as Mount

Desert. A few years later he would sketch and paint the same view of Bear Island (fig. 54). With its stark lighthouse on the western cliff, its terrain partially covered with evergreen, and its distinctive rising striated ledges, Bear Island has unusual visual appeal.

The lighthouse must have held special interest for visiting artists. The one on Bear Island was constructed only nine years after that on Mount Desert Rock, and both would have been a rare sight on this part of the coast at the time. Bear Island's light guided mariners entering the Great Harbor of Mount Desert through either of its two main thoroughfares, the Eastern Way and the Western Way. It embodied safety and domesticity, marking the sheltered water and village of nearby Northeast Harbor. Fisher painted at least one oil (private collection) during this 1848 trip that looked east to Bear Island from the Northeast Harbor shore. Three years later he executed a variation (fig. 17), which similarly showed a tranquil summer day, with cows grazing on one hillside and figures looking out to sailboats gliding by Bear Island.[27] Fisher characteristically composes with gentle, rounded forms, and except for the central feature of its exposed cliff face, the foreground rocks are generalized, while the slow-curving contour of the island gracefully echoes the concave lines of the beach.

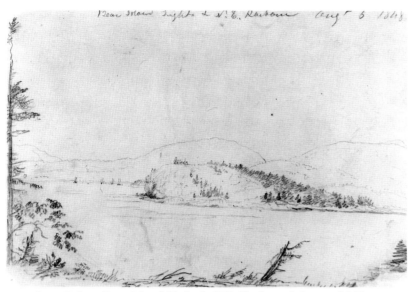

16. Alvan Fisher, *Bear Island Light & N.E. Harbour*, 6 August 1848

Fisher's palette is soft and cool in these paintings. Along with his notations elsewhere about fog, the airy brightness we see here indicated his efforts to record the variable weather conditions he found in Maine. In other pictures from these visits he tried to capture the effects of bright spaciousness and windy turbulence. For example, one canvas (private collection) depicts large breakers crashing on shore with dramatic storm clouds swirling around the mountains flanking Somes Sound, while another (fig. 18) shows figures participating in leisure activities on the sandy point of Sutton Island, with the low coastline of the Manset shore near Southwest Harbor in the distance. Fisher wrote about this area to a friend in 1849:

> I have great pleasure in making known to you Mr. Washburn who will hand you this letter. He proposes with Mrs. W. to sojourn with you a few days to enjoy the fine air, scenery with which you are surrounded.

17. Alvan Fisher, *Bear Island*, 1851

I hope you may find it convenient to introduce him to the romantic Landscape views, and fishing in your vicinity. Any attentions to Mr. and Mrs. W. which may go to bear out my recommendation of Bear Island will confer a favour on your Obt. Serv't.[28]

His friend Doughty had been captivated by the isolation and the threatening seas of the distant offshore islands; Fisher preferred the relative quiet and protection of Mount Desert's picturesque inlets and the textures of congenial scenery to the challenges of travel.

About this time other artists were being attracted to the region, and among the little-known but highly talented figures was Edward Seager, a wide-ranging traveler and sketcher through much of the northeast. Like Birch, Thomas Cole, Robert Salmon, and Joshua Shaw, Seager was a native of England who emigrated to America early in the nineteenth century. Born at Maidstone, Kent, in 1809, he grew up in Wales and Liverpool, went to Canada in 1832, and soon was working in Panama and Cuba. By 1839 Seager was living in Boston, and like Doughty, Cole, Fisher, and Henry Cheever Pratt, went on sketching trips to the White Mountains. Subjects in Massachusetts and Rhode Island attracted his attention in the early forties, and in the summer of 1845 Seager first visited Maine, making refined pencil drawings of views near the center of the state around Gardiner, Hallowell, and the new capital at Augusta. Later in the decade he sketched in

18. Alvan Fisher, *Sutton Island, Mount Desert (Mount Desert Island)*, c. 1848

19. Edward Seager, *Penobscot Bay, Maine*, 1848

New Hampshire and then went briefly to Europe. Eighteen forty-eight found him back in Boston and active again in upstate New York as well as New England; that summer brought him back to Maine, this time to the gentle hills and inlets of the upper Penobscot Bay.[29]

A few years earlier, one historian had described the attractive features of the area in *Maine Beautiful:* "Penobscot Bay, with Belfast, Castine, Bucksport and Bangor, opens to a lordly approach of magnificent dimensions to the rich heart of Maine." It was such a scene that Seager recorded in at least two spacious and meticulously finished drawings, which he titled *Prospect on the Penobscot, Maine* and *Penobscot Bay, Maine* (fig. 19). With its elevated view, partially settled and cultivated landscape, sunlit expanse, and placid bay, Seager's image matches the spirit of the guidebook's observations: "The fine harbor formed in Penobscot Bay by the islands off its mouth is a fitting approach to the river, whose dimensions might also be called lordly."[30] Seager went on to become a professor of drawing and drafting at the United States Naval Academy; he continued to

travel abroad and in America, producing numerous drawings in Virginia and remaining active until his death in 1886. Although his Maine excursions were only brief incidents in his peripatetic career, his few drawings of the scenic approaches to Mount Desert were among the most accomplished of his day: full of texture and light, based on experience but harmonized and even idealized in their balanced, rhythmic compositions and implicit sense of purity and well-being.

Technically, he was especially adept at the use of tinted washes, lines of varying softness and hardness, light accents, and textural modulations. Aesthetically, his attitudes toward nature's components were those common to his generation: an appreciation of the distinct expressive properties of a landscape's major features, whether sky, water, forest, or mountain. Together, these were manifestations of God's voice, whispering, singing, thundering. This was largely an intellectual and philosophical language, most prominently being preached in word and painting by another worldly contemporary, Thomas Cole, who determined to hear for himself the melodic voices of Maine.

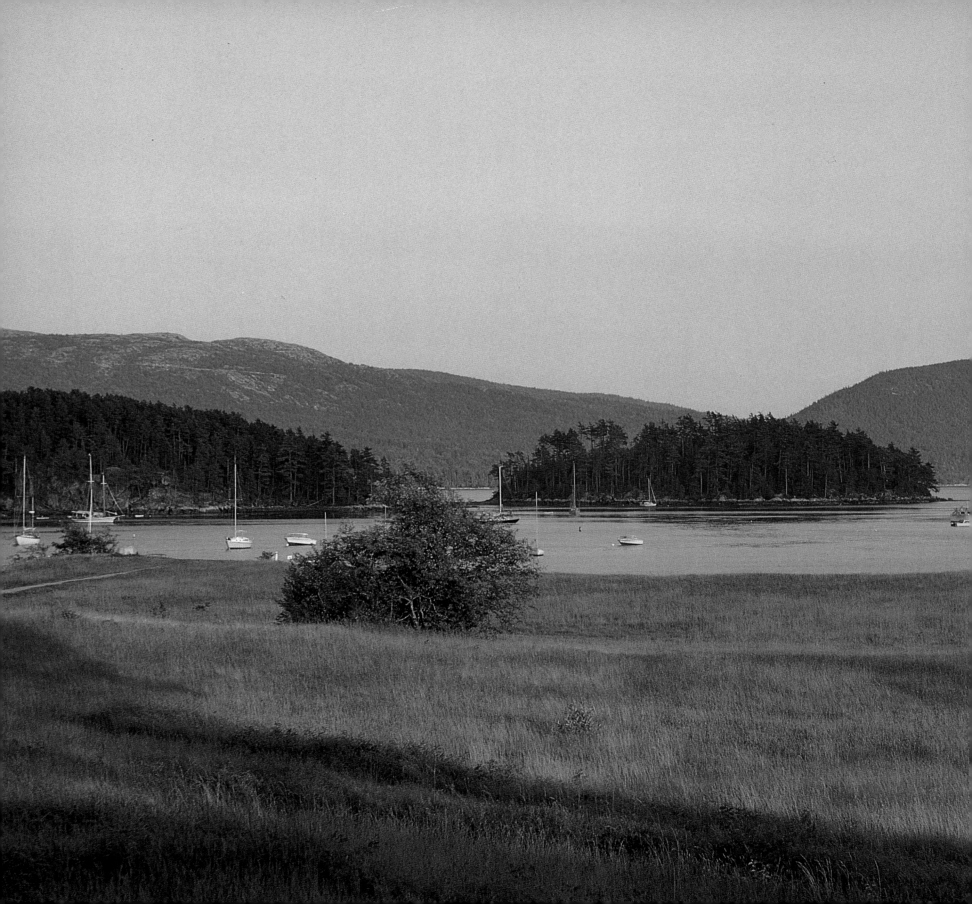

III.

Thomas Cole

THE MOST IMPORTANT figure in the early group to come to Mount Desert during the mid-1840s was Thomas Cole, by then acknowledged not only as the leader of the Hudson River school but as the foremost philosopher-artist of his day. He was the first major painter in America to have been born in the new century, in 1801; a native of Lancashire, England, he emigrated with his family to America in 1818, then traveled briefly in Ohio and Pennsylvania before settling in New York in 1825. Until then he had been struggling to become an artist, but he gained success after a summer sketching trip up the Hudson Valley, which resulted in the completion and sale of his first ambitious landscape paintings. Purchased by three distinguished colleagues, John Trumbull, Asher B. Durand, and William Dunlap, these pictures were soon shown at the American Academy of the Fine Arts and led directly to subsequent patronage from the collectors Daniel Wadsworth of Hartford and Robert Gilmore, Jr., of Baltimore.

Cole's art matured rapidly. Stimulated by his associations in New York with such nature writers as William Cullen Bryant, Washington Irving, and James Fenimore Cooper, Cole produced an outpouring of canvases depicting Hudson River, Catskills, and White Mountains scenery. At the same time, two excursions to England and Europe immersed him in the landscape of ancient ruins and cultures, the philosophy of late-eighteenth-century English aesthetics, and the paintings of his contemporaries John Martin and Joseph Turner. His celebration of national geography and romantic idealism resulted in the creation of such great pictorial icons as *Schroon Mountain*, 1838 (Cleveland Museum of

Art), *The Ox Bow*, 1836 (Metropolitan Museum of Art), *Crawford Notch: The Notch of the While Mountains*, 1839 (National Gallery of Art), and two allegorical series, *The Course of Empire*, 1836 (New-York Historical Society), and *The Voyage of Life*, 1840–1842 (National Gallery of Art). Through his meditations on American nature Cole was able to articulate the physical as well as the spiritual power of his country.

At the time he was conceiving and executing his philosophical narrative, *The Course of Empire*, in five monumental canvases, Cole delivered a significant lecture in 1835, which he published as "Essay on American Scenery" the following year. He talked fervently about the capacity of nature to instruct and inspire, and then dwelt on the fundamental components of America's scenery so that his fellow citizens might "appreciate the treasures of their own country." In general, he argued, "the most distinctive, and perhaps the most impressive, characteristic of American scenery is its wilderness."[1] He then spoke of the specific virtues of mountains, lakes, waterfalls, rivers, forests, and the sky. His imagination staked out the full expressive power of water, to him the sine qua non of any landscape: "Like the eye in the human countenance, it is the most expressive feature: in the unrippled lake, which mirrors all surrounding objects, we have the expression of tranquility and peace—in the rapid stream, the headlong cataract, that of turbulence and impetuosity."[2]

Whereas still water promoted reflection, in motion it was "the voice of the landscape" and sublime in its energies. Most significantly, Cole had found "Niagara! that wonder of the world!—where the sublime and beautiful are bound together in an indissoluble chain." The cataract possessed "the contents of vast inland seas. In its volume we conceive immensity; in its

20. Bar Island, Somes Harbor

27

course, everlasting duration; in its impetuosity, uncontrollable power. These are the elements of its sublimity."[3] Cole compared Niagara to vast inland seas; he was soon to paint the coastal waters of Maine as similarly sublime.

The year 1844 was a key one in Cole's mature career. At the intercession of Daniel Wadsworth, the artist agreed to take on the promising young painter Frederic Edwin Church of Hartford as a pupil; Cole also planned and undertook a summer trip to Mount Desert in the company of his fellow artist Henry Cheever Pratt. The inspiration and work resulting from this visit were certainly factors leading Church himself to travel to Maine more than once in the following decade (see chapter 5). Toward the end of the summer, Cole made his way to Hartford to meet with Church, and then proceeded to Maine, where he joined Pratt and sailed by steamer from Penobscot Bay to Mount Desert. While Church was to keep Mrs. Cole company, the older painter wrote his wife, "I intend to be as spirited as possible, and to get as many fine sketches as I can."[4] He did, if the surviving sketchbook full of drawings in the Art Museum, Princeton University, is any indication.

The Reverend Louis Legrand Noble's biography of Cole includes several paragraphs from the artist's diaries describing his visit and reactions to Mount Desert Island. These are worth quoting at length for their references to the several sites he saw and recorded:

August 29.—We are now at a village in which there is no tavern, in the heart of Mount Desert Island. One might imagine himself in the center of a continent with a lake or two in view. The ride over the island took us through delightful woods of fir and cedar.

August 30.—The view from Beech Mountain—sheets of water inland, fresh water lakes, and mountains, the ocean with vessels sprinkling its bosom—is magnificent.

September 3.—The ride here to Lynham's [sic] was delightful, affording fine views of Frenchman's Bay on the left, and the lofty peaks of Mount Desert on the right. The mountains rise precipitously—vast bare walls of rock, in some places basaltic appearances. Those near us, I should suppose, were not far from 2000 feet above the sea. The road was exceedingly bad, stony and overhung with the beech and spruce, and, for miles, without inhabitant. We lost our road too, and came to a romantic place near a mountain gorge, with a deserted house and a piece of meadow. One

might easily have fancied himself in the forests of the Alleganies [sic] but for the dull roar of the ocean breaking on the stillness. The beaches of this region are remarkably fine. Sand beach is the grandest coast scenery we have yet found. Sand Beach Head, the eastern extremity of Mount Desert Island, is a tremendous overhanging precipice, rising from the ocean, with the surf dashing against it in a frightful manner. The whole coast along here is iron bound—threatening crags, and dark caverns in which the sea thunders. The view of Frenchman's bay and islands is truly fine. Some of the islands, called porcupines, are lofty, and belted with crags which glitter in the setting sun. Beyond and across the bay is a range of mountains of beautiful aerial hues.[5]

Cole and Pratt first made their way to the center of the island and the early village of Somesville, situated on a pretty and protected harbor at the very head of Somes Sound. A few years later, Cole's pupil Church would record his impressions of the town road in the same area, and Fitz Hugh Lane described in sketches and letters his own approach to Somesville by water (see figs. 40, 41). The day after their arrival, Cole climbed nearby Beech Mountain on the western side of the island, which offers a broad view of the area's several features: the long freshwater lakes between the hills, the dense forest cover and open granite ledges on adjacent summits, and to the south and west open views to the surrounding bays and ocean. A second major excursion a few days later took Cole across to the eastern coast of Mount Desert, with its more dramatic shoreline of sheer cliffs, crashing surf, and islands in Frenchman Bay. Here he did his most extensive sketching, which resulted in several canvases, in response to the island's principal scenes of sublime landscape. Due in part to Cole's example, this area also became a favored haunt of Church and William Stanley Haseltine in the next two decades (see figs. 69, 112).

With the exception of a separate sheet and a couple of drawings from the Princeton sketchbook, Cole's Mount Desert sketches are little known and rarely reproduced. The sketchbook has an even greater importance for its coverage—Cole worked in it from 1839 to 1844—and its inclusion of studies related to some of his most famous images, for example, *Crawford Notch, The Catskill Mountain House,* 1843–1844 (private collection), *The Voyage of Life,* and *Mount Aetna from Taormina,* 1843 (Wadsworth Atheneum).[6]

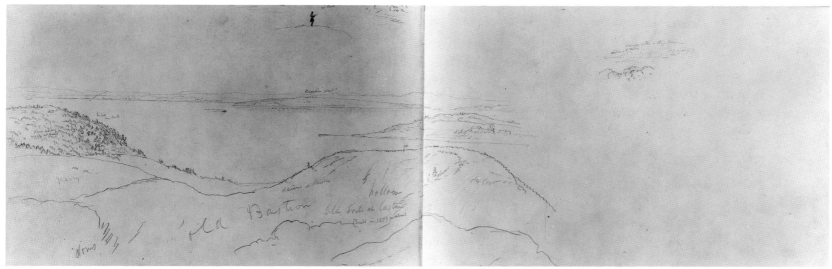

21. Thomas Cole, *Old Bastion, Old Fort at Castine*, 1844

Originally, the book contained twenty-six folios, of which three had been removed or lost; a couple of sheets remained unused. The pages measure 11¼ by 17 inches and contain some forty sketches, several drawn across two facing pages. At least a dozen show Mount Desert views and another handful prospects of scenery around Penobscot Bay. For the most part, these are simple line drawings with little texturing or shading, although many carry extensive notations by Cole as to location, prominent islands or hills, and occasional effects of color. Like Alvan Fisher and Lane, who stopped at picturesque sites like Camden, Owl's Head, and Castine before proceeding to Mount Desert, Cole sketched first around Castine, site of a historic old fort above the town dating from the Revolutionary War. One particularly charming view he titled *Old Bastion, Old Ford at Castine* (fig. 21) and added "Built in 1779 or about." Atop the hillside, which Cole variously marked "quarry," "stones," "hollow," and "daisies and thistles," he looked out to Bagaduce Island and the open waters of Penobscot Bay in the distance. In an upper corner of the sheet, he drew a short line indicating the hilltop and standing on it the small silhouetted figure of "Mr. Pratt" with his sketch pad in hand, presumably recording the same view by Cole's side.

A related drawing focuses on the brick and stone ruins of the circular fort itself (fig. 22) with a brick building nearby and across the harbor the wooded hills of Cape Rosier. Out in Penobscot Bay Cole noted an approaching schooner and in increasingly faint outlines islands respectively "10 miles off" and "20 miles off." This drawing is relatively detailed in its delineation of the brickwork in the foreground and of the forestation beyond, and we may regret that more of these studies did not result, so far as we know, in finished paintings. Curiously, Cole's juxtaposition of the

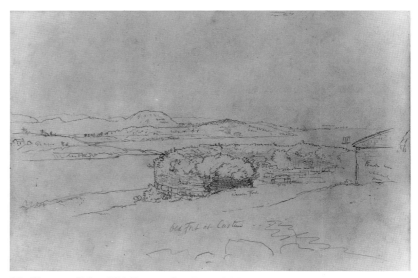

22. Thomas Cole, *Old Fort at Castine*, 1844

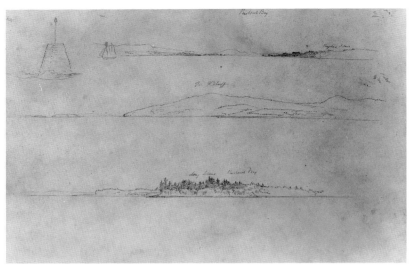

23. Thomas Cole, *Long Island, Penobscot Bay*, 1844

24. Thomas Cole, *Pond Between Ellsworth & Bucksport, Maine*, 1844

crumbling ruins against the wooded hillsides recalls his earlier fascination in Italy with the ancient circular *Torre dei Schiavi*, 1842 (private collection), set in the romantic landscape of the Roman Campagna.[7] Aside from the visual contrasts of color, texture, and structure, the combination of ruins and nature inspired Cole for much of his life as an endless meditation on man's history, the intersection of civilization and the landscape, and the change wrought by time's passage. Indeed, such counterpoints between architectural remains and real or imagined natural settings served as Cole's focus for a number of his major works: *A View Near Tivoli (Morning)*, 1832 (Metropolitan Museum of Art), *The Course of Empire*, 1836, *The Past* and *The Present*, 1838 (Mead Art Museum, Amherst College), *Roman Campagna*, 1843 (Wadsworth Atheneum), and *Mount Aetna from Taormina*, 1843.[8] Cole's drawing called *Old Fort at Castine* possesses neither the air of melancholy nor the investment of moral allegory that some of these ambitious canvases have, though he must have been attracted to the setting in part for its historical associations. Fort George at Castine was among the strategic defensive structures built in the upper part of Penobscot Bay during the period of the War of Independence and the War of 1812, and survived as a bold reminder of the country's early political and economic struggles even along its relatively wild coast.

Cole evidently explored a good bit of the upper Penobscot region, both by vessel and on foot, for several other sketches show the shoreline drawn at water level and from a hillside vantage point. One he titled *Inlet of Sea, Penobscot Bay*, and a second *Long Island, Penobscot Bay* (fig. 23); this latter sheet includes three shoreline views, with the upper one appearing to focus on the outline of Blue Hill in the far center, while the middle one is identified as "The Bluff." Also outlined at the upper left is a sketch of an unidentified stone beacon, which Cole quite likely added after he had gotten to Mount Desert. No other such beacon had been built on the coast by this time, and its distinctive pyramidal shape marks it as the first one constructed; it was built by the government in 1839–1840 on East Bunker's Ledge just off the mouth of Seal Harbor.[9] A casual, almost incidental notation here, it was later to become a stark image in one of Frederic Church's most austere sunrise paintings (fig. 87).

From subsequent drawings it appears that Cole's party made its way overland from Castine via Bucksport to Ellsworth and thence southward to Mount Desert Island. En route he sketched *Pond Between Ellsworth & Bucksport, Maine* (fig. 24), one of the many small inland lakes just in from the coast. Although these views were intimate and spontaneous, Cole instinctively made gestures toward composing what he saw. Here he ruled off the left margin

25. Thomas Cole, *View of Mt. Desert from Trenton on the Main Land*, 1844

to close in his design and reinforce the large tree trunk on that side, and he centered the small island in the middle ground of the scene. Conscious as always of nature's stages of growth, he contrasts the young pines in the distance with the cracked tree stump to one side and on the other a "Dead trunk with hanging green moss." Characteristically careful observations elsewhere mark the water as "bronze & glittering" and indicate in the foreground a "sandy & pebbly beach."

Approaching the narrows where Frenchman Bay and Blue Hill Bay come together at the head of Mount Desert, Cole executed two panoramic drawings of the island's full range of hills crossing the horizon before him (figs. 25, 26). *View of Mt. Desert from Trenton on the Main Land* looks toward the westerly range, including the Newport, Dry, and Green mountains (known now as Champlain, Dorr, and Cadillac). Of unusual interest is Cole's notation on the highest summit, "called Big Dry Mt." During the

26. Thomas Cole, *Mt. Desert Island in the distance seen from the Main Land,* 1844

later nineteenth century this was called Green, until it was renamed Cadillac by the National Park Service in the early twentieth century.[10] The companion drawing, *Mt. Desert Island in the distance seen from the Main Land,* also records what must have been an exhilarating first view of Champlain's several hills. Cole's attention to the elongated format was atypical, but it was needed here to include the island's full silhouette from east to west; to so do he extended his drawing across two pages of his sketchbook, and used his right-hand sheet to indicate the expanse of Blue Hill Bay and Blue Hill itself at the right edge.

Once on the island, Cole paused at Somesville to sketch nearby views from the village looking toward Sargent Mountain on the east side of Somes Sound and toward the hills on the western side (figs. 27, 28). The former, *View in Somes Sound,* is an anomaly in this sequence, for its size, paper color, and stained left edge indicate it was probably taken from a different sketch pad. The

use of light blue paper and white highlighting, along with a much more precise and varied handling of pencil, results in a more finished and sophisticated drawing, as if Cole was thinking of an oil to follow. His vantage point is from the stream and millpond at the head of Somes Harbor, looking out on a view that would equally charm Fitz Hugh Lane a few years later (fig. 44). Unlike the relatively cursory touch evident in most of the Princeton sketchbook drawings, this displays care in its execution, as shown in the greater range of darks and lights, the unobtrusive narrative elements such as the foreground rowboats, and the gentle rhythms of shorelines and hillsides surrounding the schooner at the composition's center. The use of colored paper as a tonal midground allowed Cole a greater richness of modeling, texture, and atmospheric ambience, and became a favored method of sketching by the next generation of Hudson River and luminist artists (see figs. 109, 154).

27. Thomas Cole, *View in Somes Sound, Mt. Desert*, 1844

Climbing a nearby mountain on the western side of Somes Sound, Cole next drew in his sketchbook the *View from Mt. Desert looking inland Westerly* (fig. 28). This was his first glimpse of the island's varied elements from an elevated position near the center, and in a series of intricate patterns he recorded the alternating contours of sloping hillsides, lakes, inlets, and islands as he looked west to Blue Hill, which, he noted to himself, he had drawn "not quite high enough." To felicitous effect, he instinctively lightened his line as he moved from the firm dark strokes of the foreground to ever more delicate ones in the distance, capturing the sensation of suffused light and haze in a broad panorama. Possibly this was "the view from Beech Mountain" toward "the ocean with vessels sprinkling its bosom" that he described in an August 1844 letter to Mrs. Cole.[11] This side of the island offered an endless variety of mixed prospects,

28. Thomas Cole, *View from Mt. Desert looking inland Westerly*, 1844

29. Thomas Cole, *From Mt. Desert looking South by east*, 1844

30. Thomas Cole, *Scene in Mt. Desert looking South*, 1844

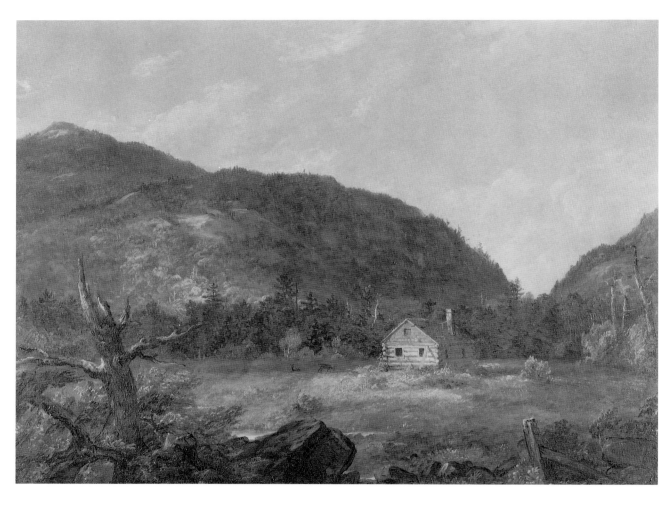

31. Thomas Cole, *House, Mt. Desert, Maine*, c. 1845

combining slopes of forested hillsides and slices of both freshwater and saltwater coves.

Except for saying that "the ride here to Lynham's was delightful," Cole did not give details of his explorations around the major inland hills of Mount Desert's eastern side. But presumably in the first few days of September 1844 he found much of visual interest as he crossed the island, a supposition confirmed by at least three drawings in the sketchbook and one small oil (figs. 29 through 32). With the ascent of each mountain slope he saw a new angle on the coastline, and turning almost like a compass, he dutifully recorded *From Mt. Desert looking South by east* and *Scene in Mt. Desert looking South*. Both of these look down on either Jordan Pond or Eagle Lake, framed by the slopes of Cadillac, Pemetic, and Sargent. Upon his return to

Hartford, Cole must have shown his sketchbook to his pupil Church, for the latter would draw much of the same area a few years later (see chapter 5). From these drawings Cole composed a modest oil showing a log cabin, *House, Mt. Desert, Maine* (fig. 31). Like many of his studio paintings, this tended to generalize his experience of a particular scene; here we are unable to determine exactly where this is set within the island's interior. Cole also introduces details to comment on the humble presence of humans in the wilderness, as deer graze near the dwelling, while the large blasted tree trunk in the foreground reminds us of nature's great cyclical forces. We view the forest in its several stages of growth and decay and in contrast to its transformation by humans into fences and houses. In its narrative allusions and simplified design, the picture echoes Cole's major White Mountain canvas

32. Thomas Cole, *Mt. Desert*, 1844

of a few years earlier, *Crawford Notch*. At Mount Desert, Cole clearly enjoyed the shifting vignettes, from intimate valley enclosures to sweeping mountain overlooks.

One drawing in this sequence he titled only *Mt. Desert* (fig. 32), though its vantage point and distant island details indicate a similar prospect from possibly the western side of Cadillac or Pemetic looking south toward Little Long Pond, Sutton, and the Cranberry Islands in the middle distance, and Baker's Island and the Ducks beyond. Then, finished with views to the south, Cole began an altogether different sketch on the right-hand sheet of his book, *Sand Beach Mountain, Mt. Desert Island* (fig. 33). On 3 September he noted that he had moved to Lynam Farm, just to the north at Schooner Head, where numerous artists coming to the island thereafter, including Church and William Stanley Haseltine, would stay.[12] It was a convenient location a few miles

33. Thomas Cole, *Sand Beach Mountain, Mt. Desert Island*, 1844

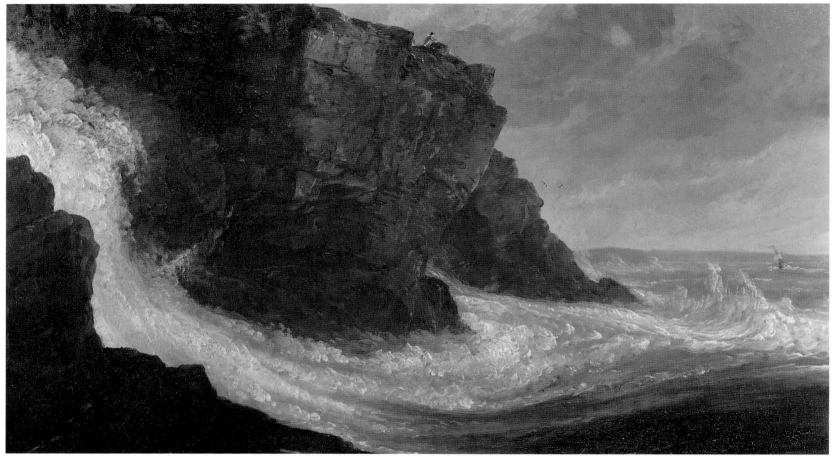

34. Thomas Cole, *Frenchman's Bay, Mt. Desert Island, Maine,* 1845

south of Bar Harbor, nestled in a meadow off a small cove next to
Schooner Head, one of the most dramatic promontories on the
island's eastern coast. From there it was an interesting walk down
to Sand Beach, which as Cole noted was "the grandest coast
scenery we have yet found." Just behind the beach is a tidal
marsh and rising above it a small precipitous cliff, today known
as the Beehive.

Squaring off his drawing to emphasize the vertical rock
formation, Cole added a long verbal description of his impression
on the right-hand margin: "This is a very grand scene. The craggy
mountain, the dark pond of dark brown water—The golden sea
sand of the beach and the light green with its surf altogether with
the woods of varied color—make a magnificent effect such as is
seldom seen created in the sun." Cole made his drawing from

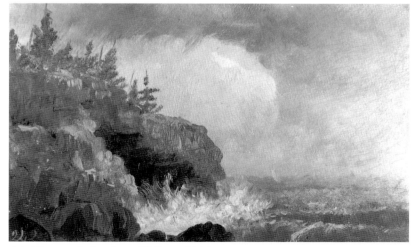

35. Thomas Cole, *Otter Cliffs,* c. 1844

36. Thomas Cole, *Hull's Cove, Mt. Desert*, 1844

partway up the adjacent slope of Great Head, which he called "Sand Beach Head, the eastern extremity of Mount Desert Island . . . a tremendous overhanging precipice, rising from the ocean with the surf dashing against it in a frightful manner." He did not sketch the headland itself, as Church and Haseltine later would (figs. 69, 112), but he did venture a few miles to the east to view the equally bold precipice of Otter Cliffs, which resulted in an oil painted after his return (fig. 34).

There is no preliminary drawing known for this picture, although an attributed oil sketch does exist (fig. 35). Cole appears to have relied on his memory of the site in composing his canvas. Indeed, his written description of Sand Beach Head (seen in the far right distance here) seems to have served as the basis for his interpretation of Otter Cliffs. In any case, once back in his studio, he took certain liberties with factual accuracy, introducing exaggerations and narrative details. Typical of the latter are the small sailing vessel off the lee shore and the figure atop the cliffs, dwarfed by the turbulent scene. This is nature sublime, following the pictorial conventions of that term: humans stand in awe before the overwhelming elements, seen as well as heard to be boldly contesting one another. To enhance this wilderness drama, Cole distorted the angle and silhouette of the cliffs. His view looks toward the east, a vantage point that does not expose the cliffs as

he has painted them; one can view its sheer drop against the open seas only from the other side. Cole has conveyed an essential aspect of the site, but freely modified it for expressive ends. Similarly, he has projected the angle of the cliffs too far forward—they are actually a straighter vertical drop—to heighten the precarious but exhilarating position of humans in this primal setting.

Cole also worked his way north from the Lynam Farm area to Hull's Cove just above Bar Harbor, where he made a simple line drawing from the head of the cover (fig. 36) looking out to Bar Island and the Porcupines. One wonders whether the neatly drawn schooner and lone figure in a rowboat nearby are merely devices for focus and scale, or if the schooner was possibly a vessel Cole had boarded for daytime travel around these shores. This relatively light and delicate work in turn led to a more expansive and finished sketch from a point just south of Bar Harbor, *Islands in Frenchmans' Bay from Mt. Desert* (fig. 37).

(To one side turned at right angles is an unrelated sketch, *Mill, Ellsworth*, which he may well have executed quickly on his way off the island. It is a reminder of the early prosperity and industry of lumbering on and around Mount Desert, an activity Lane, Church, and Haseltine all would observe [figs. 77, 116] in the following decades.) Cole's full drawing of the Porcupine Islands extending across the bay from Bar Harbor crosses over a page and half of his sketchbook, and is unique as a preliminary study leading directly to a painting. No doubt with this in mind, Cole made extensive notes on the sheet indicating the correct names of islands and mountains along with particular effects of colors and light.

The canvas called *View Across Frenchmans' Bay from Mt. Desert Island, After a Squall* (fig. 38) is his largest and most ambitious Maine image, a sweeping landscape painted at the height of his maturity, which anticipates the shift about to occur in American art toward open horizons and eloquent light effects. Cole had written his wife about the "glitter in the setting sun" and the "beautiful aerial hues," and he proceeded once again to paint his embellished recollections. While the view is fundamentally true to life, it actually conflates a panorama of 180 degrees, at once looking north to the islands and southeast to the open end of the bay and Schoodic Point. It is as if Cole stood on a point as he had at Otter Cliffs, and turned his gaze around a broad arc to

Unrelated sketch, *Mill, Ellsworth.*
The other part of this page from the
sketchbook completes the sketch on
the opposite page.

37. Thomas Cole, *Islands in Frenchmans' Bay from Mt. Desert*, 1844

capture nature's fullest range of power and variety. Witnessing the purity of Eden and the sense of infinite spaciousness, as he could here, he found fulfilled his beliefs in the promise of American geography: "In looking over the yet uncultivated scene, the mind's eye may see far into futurity . . . mighty deeds shall be done in the now pathless wilderness."[13]

Cole's compositional liberties were subjected to some criticism. When his painting went on view the following year in New York, a reviewer wrote facetiously in the Broadway Journal that "Mr. Cole

has gone down to Frenchman's Bay, four or five hundred miles off towards North Pole, and has come back and painted a pea-green sea with ledges of red rocks." Discussing the picture specifically, the critic went on:

88. *View across Frenchman's Bay from Mount Desert Island, After a Squall*—T. Cole. This is the only marine picture that we have seen by Mr. Cole. The water is well drawn, but not well colored, and the rocks are of a kind that no geologist would find a name for; the whole coast of Maine is lined with rocks nearly black in color, and tinged with a

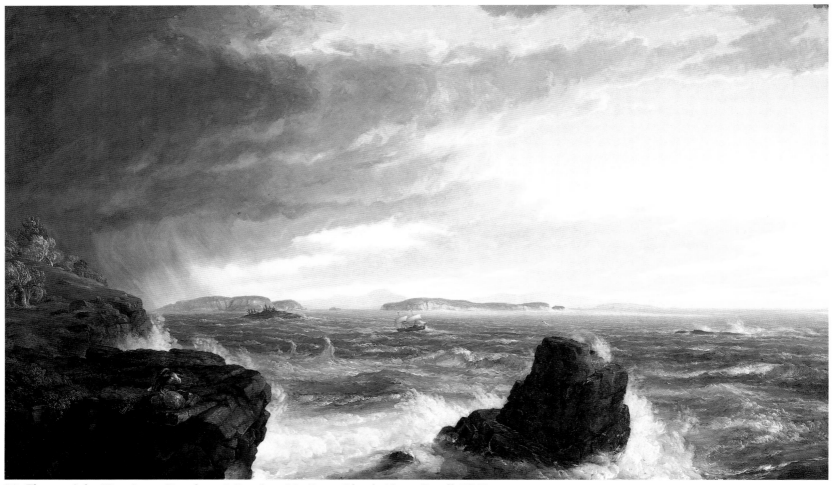

38. Thomas Cole, *View Across Frenchman's Bay from Mt. Desert Island, After a Squall*, 1845

greenish hue, as all marine rocks are. These in Mr. Cole's picture are red. An artist should be something of a geologist to paint rocky scenes correctly, as he should be a botanist to paint flowers, and an anatomist to paint the human form. The picture is a good deal too large. So wide a surface for so meagre a subject must be filled up chiefly with common places; a few inches of canvas will serve to convey as vivid an idea of the sea, if properly conveyed, as a yard.[14]

In fact, Cole's reddish rocks were an accurate rendering of the pink granite found throughout the Mount Desert region, and his panoramic scale is both true to the locale and a forward-looking format in midcentury American landscape painting.

There is another unusual detail in Cole's canvas: the presence of a bald eagle on the left foreground ledge. One biographer has speculated that this may have had symbolic associations with nationalist ideas of destiny and progress, visually reinforced by the seagoing vessel setting forth in the bay.[15] Given Cole's taste for allegory and moralizing subjects, such a sentiment is entirely likely, and is in any case one quite consciously proclaimed by his pupil Church a decade and a half later, most famously in his *Twilight in the Wilderness* (fig. 99), where the American eagle perches atop a tree silhouetted against a fiery sky. A second speculation connects this image to contemporary interests in

ornithology and the natural sciences, a tradition going back to Alexander Wilson and Charles Wilson Peale and present in the efforts of John James Audubon, whose *Birds of America* Cole could well have known in New York.[16] But it is equally likely that Cole was recording a firsthand experience, for bald eagles nested around Mount Desert, and must have been a common sight sailing on the air currents over the island's hills, even as they are occasionally observed today. Certainly it would not have been beyond the artist's capacity to fuse all of these associations in the meaning of his painting.

Cole considered it the artist's duty to improve upon nature by rearranging its components on canvas and thus instill the desired qualities of spaciousness and grandeur in his landscape views. By so doing in his pictures of Otter Cliffs and Frenchman Bay he was revealing nature's higher purpose. He summarized this philosophy for his friend and biographer Louis Noble:

> The pictures of all great painters are something more than imitations of nature as they found it. . . . If imagination is shackled, and nothing is described but what we see, seldom will anything truly great be produced either in painting or poetry. . . . The most lovely and perfect parts of nature should be brought together and combined in a whole that shall surpass in beauty and effect any pictures painted from a single point of view.[17]

Throughout the late 1830s and the 1840s, Cole and his contemporaries initiated an active and productive artistic exploration of the environs of Mount Desert. Cole left for his successors perhaps the most varied and intellectually stimulating record of his visit, and almost all the views he sketched or painted would serve as either direct or indirect inspiration for the next generation. Alvan Fisher, who preceded Cole to the island, returned in 1848. That year also saw Edward Seager at work not far away; meanwhile the young Fitz Hugh Lane was making his first voyage to Maine, which resulted in his first important and influential sunset picture, *Twilight on the Kennebec* (private collection), and the beginning of a critical career painting around Mount Desert. By 1850, Lane's cruising companion could state that "the beauties of this place is [*sic*] well known and appreciated among artists. We heard of Bonfield and Williams who had reluctantly left but a short time before. Fisher has spent several weeks there. Champney and Kensett were then in another part of the island and we have reason to believe that Church and some others were in the immediate vicinity."[18]

In 1848 Thomas Cole died, having largely defined American landscape painting. In one summer's observations he left an inventory of discoveries and ideas for a golden age of his country's culture.[19]

IV.

Fitz Hugh Lane

WHEN FITZ HUGH LANE accepted the invitation of his friend Joseph L. Stevens, Jr., to visit the Stevens family homestead in Castine in the summer of 1848, the Gloucester painter was not only setting out to paint a new area of the New England coastline. Forty-four and at the height of his early maturity as a marine artist, Lane was also at a critical moment in his stylistic development, and this first of several journeys down the coast would transform his work by investing it with an elevated level of pictorial eloquence. In turn, the glowing Maine sunset and one storm picture he executed contributed to an original imagery and a new manner of painting in American art at midcentury. Three elements in his career up to this point were especially important in preparing him to paint the Maine coast with intensity and sympathy. Born in Gloucester and brought up on Cape Ann, he had already spent much time sketching along local shorelines, sensitive to the frequently changing effects of coastal light and atmosphere. Descended from a family of mariners, he came to observe closely the area's fishing and shipping industries, which further commanded his attention during his several years of training and practice in Boston in the late 1830s and mid-1940s. Above all, because of a lameness in his legs believed due to the polio he contracted as a child, Lane seemed to be most comfortable, physically as well as psychologically, traveling and painting on boats at anchor or cruising offshore. His paintings of Maine subtly fused observations of commerce and trade and the most delicate conditions of northern summertime light—images, in other words of place as well as of states of mind.

39. Looking towards entrance of Somes Sound

Lane had trained as a lithographer with William Pendleton in Boston during the mid-1830s, and subsequently formed his own printmaking firm with fellow marine artist John W. A. Scott. This experience had given Lane a solid technical command of drafting and tonal values, and, through extensive early production of sheet music and book illustrations, a feel for anecdotal detail. When he did supplement his graphic work with oil painting in the 1840s, Lane tended to fill his early pictures with narrative elements and incidental textures, all to record painstakingly the lively activities of the harbor. By the end of the forties most of his Gloucester scenes exhibited his preference for generally compact compositions and reportorial content, whether depicting shipbuilding on the wharves or fishing transactions along the nearby beaches. Up to this point, Lane as an artist was largely an observant storyteller. Shipping and village business would continue to interest him down east, but the new vistas afforded him when he stayed with the Stevenses in Castine and sailed the broad reaches of Penobscot Bay and Blue Hill Bay were to prove subtle but decisive catalysts for artistic change. Joseph Stevens, Jr., also belonged to an old Gloucester family, and doubtless his many civic and cultural interests proved to be common ground and helped forge his friendship with Lane. Manager of his family's dry-goods business in Gloucester, Stevens had broad and cultivated tastes. He promoted the American Art-Union and the local lyceum movement, and was an early purchaser and admirer of John Ruskin's *Modern Painters*, which he enjoyed discussing with Lane. Enthusiastically he declared, "If you have not read what that eloquent writer says of clouds, be exhorted to do so,"[1] an exhortion he could well have urged on Lane, who now made skies a critically expressive part of his canvases.

Joseph L. Stevens, Sr., was a doctor in Castine, and the family homestead was well up from the waterfront with sweeping views out to the Bagaduce River as it opened into eastern Penobscot Bay. The vantage point clearly impressed the visiting artist, who painted more than one view looking out over the town below. Often he inscribed small oils of local scenes as presentation gifts to the Stevenses; one charming vignette showed the doctor on horseback in front of the pale yellow Federal house, presumably about to set off on his local rounds, his wife glancing out an upstairs window.[2] Joseph L. Stevens, Jr., became more than an intellectual companion to Lane; he was also helpful and eventually indispensable in rowing the painter around harbors in order to secure desired views. Friends recounted that Lane was even "hoisted up by some contrivance to the mast-head of a vessel lying in the harbor in order that he might get some particular perspective that he wished to have."[3] As Stevens later recounted,

> For long series of years I knew nearly every painting he made. I was with him on several trips to the Maine coast where he did much sketching, and sometimes was his chooser of spots and bearer of materials when he sketched in the home neighborhood. Thus there are many paintings whose growth I saw both from the brush and pencil. For his physical infirmity prevented his becoming an outdoor colorist.[4]

Stevens' devoted companionship lasted until Lane's death in 1865, when as executor Stevens sorted and annotated more than one hundred of the artist's drawings with dates, locations, and other informative details. It is from these sheets, most of which have been preserved in the Cape Ann Historical Association, Gloucester, and related circumstantial evidence, that we can partially document a number of Lane's Maine trips. The first can be placed in 1848 only from his completion and exhibition the following year at the Art-Union in New York of four paintings, two of which had Maine subjects. The first was *View of the Penobscot,* and its location remains unknown; the second was *Twilight on the Kennebec,* lent by W. H. Wheeler of Lynn Massachusetts, which carried a description in the catalogue possibly provided by the artist: "The western sky is still glowing in the rays of the setting sun. In the foreground is a vessel lying in the shadow. The river sketches across the picture."[5]

Now in a private collection, this picture contains several elements that caught Lane's eye. First, it is a sunset image, painted in ranges of yellow, orange, pink, and lavender with the new cadmium pigments only recently made available to artists in greater variety and intensity. The strong but subtle color effects of the twilight hour would be a central motif of Lane's Maine canvases. Second, he gives attention to a broad-beamed schooner bottomed out near the foreground shore. Nearby, rowboats are pulled ashore alongside a platform of trimmed logs, all suggesting activities related to the transporting of lumber downstream from the interior wilderness. In the distance to either side of the shadowed island at the center are, respectively, another schooner under sail and a steamer moving upstream. This observation of vessels of different function and scale is an extension of pictorial interests found regularly in Lane's earlier harbor views of Gloucester and Boston, as if both to inventory and to celebrate the diversity of maritime industry in midcentury America. Finally, Lane notes that this is a river view, set on one of the major water arteries reaching north into the center of the state. The steamboat is a reminder of the means of travel Lane and Stevens almost certainly used to get from Boston to Portland and thence to Rockland at the southern end of Penobscot Bay. The lumber schooner, bottomed out on a flat muddy shore, indicates that Lane probably set this scene along the lower reaches of the Kennebec where the river widens north of Brunswick and Bath or opens out to the coast east of Casco Bay at Popham Beach. This area is tidal, and Lane's distilled composition appears to be a meditation on the confluent ebbing of both light and water. By contrast, we do not know where his *View on the Penobscot* was set, except that it refers to the other major waterway of central Maine, and took Lane to the great picturesque bay that would so vividly inspire him throughout his remaining career, and to the welcoming guest room in Castine, which he was to use almost as a second home.

Because there are at least a few known oils of Maine subjects dated 1850, it is possible that Lane returned to the coast in the summer of 1849, a year after his first visit. But he may also have been preoccupied in Gloucester then, having purchased a piece of property on Duncan Street overlooking the harbor, and set about building a seven-gabled stone house and studio on the site. Construction took much of the year, and Lane moved in with his in-laws soon after New Year's Day, 1850. From dated drawings we

40. Fitz Hugh Lane, *North East Harbor, Mount Desert,* August 1850

do know that Lane and Stevens returned to Castine in August of that year, and at least a few of the paintings of that period clearly derive from sketches made on that trip, suggesting that this was his second major exploration of the coast. There he found the elevated vistas expanding in several directions. One drawing, titled *Majebigweduer Narrows from North Castine,* looked across to the profile of Blue Hill on the horizon; another, *Western View of High Head Neck,* centered on the distant outline of the Camden Hills.[6] These vantage points, reminiscent of Parson Fisher's overlook of the village of Blue Hill (fig. 8), must have given him the concept for the format of his oil titled *Castine from Fort George* (Museum of Fine Arts, Boston), which looks down over the descending fields, roads, and houses to the broad riverfront and hills of Cape Rosier beyond. The other canvases of nearby locales resulted from this visit; they are significant because they pair sunlit and nighttime views of a sheltered cove at Brooksville: *Indian Bar Cove* (collection of Mr. and Mrs. Jefferson E. Davenport) and *Moonlight Fishing Party* (Museum of Fine Arts, Boston). Both this last and the general Castine view must have

been well received, for Lane later made second versions of each.

Lane and Stevens then made ambitious plans to cruise east to explore the Mount Desert area for the first time. According to one drawing, they chartered the "boat General Gates, Pilot Getchell from Castine," and were joined by two other companions, Tilden and Adams. Stevens kept a detailed account of the voyage, which he later wrote up for publication in the *Gloucester Daily Telegraph.* Unlike Cole on his earlier trip from this area, Lane's group sailed from Castine, and after rounding Cape Rosier, they entered the long protected passage of Eggemoggin Reach, which separates Deer Isle from the mainland, but "baffling winds and calms, the first day compelled a stoppage for the night half way at Naskeag." The next day they crossed the south part of Blue Hill Bay, and approaching the great island, experienced the exhilarating sensations of the looming hills shifting in perspective before them:

It is a grand sight approaching Mount Desert from the westward, to behold the mountains gradually open upon the view. At first there

41. Fitz Hugh Lane, *Somes Sound, Looking Southerly*, August 1850

seems to be only one upon the island. Then one after another they unfold themselves until at last some ten or twelve stand up there in grim outline. Sailing abreast the island, the beholder finds them assuming an infinite diversity of shapes, and it sometimes requires no great stretch of imagination to fancy them huge mammoth and mastodon wading out from the main.[7]

Lane and Stevens were seeing this landscape from the water's level, and passing steadily by it as if before a moving panorama. The artist's first impulse was to capture in pencil the mountains' contours unfolding laterally across his view, so for most of his sketches he glued two and sometimes more sheets of paper together horizontally, continuing his lines depicting the shore fully across them. Given his infirmity, as Stevens noted, Lane with rare exceptions limited himself to carrying pencil and paper, presumably committing atmospheric and light effects to memory for later distillation in his studio at home. It is one of the greatest paradoxes, as well as sublime achievements, of his art that his drawings are of generally indifferent strength while his paintings contain both superb drafting and nuances of color almost unmatched for their sensitivity and expressiveness. At last passing through the Western Way into the Great Harbor of Mount Desert, the travelers now beheld vistas of unique scenic and geological interest:

With such a beautiful prospect to wonder at and admire, now wafted along by light winds, then entirely becalmed for a time, we were slowly carried into Southwest Harbor. Here, from what seems to be a cave on the mountain side, is Somes Sound, reaching up through a great gorge seven miles into the heart of the island. It varies much in width, the extremes being perhaps a half mile and two miles, is of great depth, and contains no hindrance to free navigation. An intervening point concealed the entrance until we had nearly approached it, and the sails passing in before us disappeared as if by enchantment.[8]

The group anchored off Northeast Harbor near the entrance to the sound, where Lane made a delicate drawing (fig. 40) showing some of the early houses in the village and two schooners, one offshore and another beached near the town steamer wharf. Lane became fascinated with the angles of vision on the sound's narrow entrance; the view was largely obscured until one was upon it, and then it swiftly rose within the dramatic confines of the fjord itself. Other drawings on this and later trips testify to Lane's fascination with the shifting changes of scale and depth, and the concealed entrance Stevens described would provide the viewpoint for one of Lane's most memorable paintings two years later (fig. 50). As so often happens during August, warm and gentle days favored the sailors' pleasures, which were jointly recorded by Lane's pencil and Stevens' pen: "It was toward the

42. Fitz Hugh Lane, *Mount Desert Mountains, from Bar Island, Somes Sound*, August 1850

close of as lovely an afternoon as summer can bestow that we entered this beautiful inlet. Much had been anticipated, the reality exceeded all expectations. . . . the old boat went leisurely up the current, and so engrossed had we become in the grandness of the scenery on every hand."[9]

Halfway up the sound Lane pieced three sketch sheets together to made his drawing *Somes Sound, Looking Southerly* (fig. 41), which Stevens later annotated: "Lane made this sketch sitting in the stern of the boat General Gates as we slowly sailed up the Sound at Mt. Desert on a lovely afternoon of our first excursion there. He painted a small picture from this his first sketch of that scenery. It was sold by Balch to Mrs. Josiah Quincy Jr." This latter may be the small undated oil now in the Cape Ann Historical Association. For the party, time and space seemed to flow as gently as the sound's limpid waters: "so illusive the distances were that it seemed as if we could be but halfway up the inlet when we passed through the narrows into the basin forming the head of the Sound. Just as the sun was setting we encamped opposite the settlement, at the entrance of the miniature bay, on an island well wooded and covered with a profusion of berries."[10] Once settled on this small island, Lane began sketching again, this time drawing the broad view looking south in *Mount Desert Mountains, from Bar Island, Somes Sound*

(fig. 42). Stevens noted that this too inspired a "picture painted from this sketch once in my possession and afterward sold by W. Y. Balch." While the location of this oil is no longer known, another drawing of the area resulted in his first major canvas that does survive, his *View of Bar Island and Mount Desert Mountains, from the bay in front of Some's Settlement* (figs. 43, 44). As the sketch indicated, the *General Gates* lay anchored off Bar Island, with the encampment nearby, while Lane was probably rowed ashore—almost surely shown in the two figures approaching the beach in the center foreground of the painting.

This was almost the same viewpoint Thomas Cole had chosen for his drawing during his stay in Somesville six years earlier (fig. 27). While Lane gives us the same mountain contours in the distance and the heavily wooded Bar Island at the center, his vision is more panoramic than Cole's, both in the actual horizontal dimensions of his extended sheets and in the open, unframed sides of his composition. But in completing his canvas later at home, Lane did not fully carry out the implications of airy spaciousness he recorded on the spot. Rather, he stressed new anecdotal interest in the foreground elements of active figures, cut timber on the beach, and the grounded schooner with bright red long johns drying on the forestay. The composition too is more contained, and in this regard more conventional, with its stronger

43. Fitz Hugh Lane, *View of Bar Island and Mount Desert Mountains, from the bay in front of Some's Settlement,* 1850

framing devices of detailed promontories and ships set at each side. His cool palette of pale blues and greens and the general air of serenity do capture the character of Maine scenery, but his picture's arrangement remains little changed from his previous harbor views of Gloucester or from the formulas of Hudson River school painting as largely defined in the preceding years by Cole. Lane's evolution toward the glassy and expansive manner of the pure luminist style was just beginning, and would crystallize only with the further observations and meditations of the next two years.

In Somesville, Lane presumably continued his sketching while the others set off to climb one of the nearby hills, as recalled in Stevens' narrative: "An attempt was made the next day to ascend the highest and boldest of the mountains that skirt the Sound. But after a long and laborious scramble up among the rocks and fallen trees we had reached a peak but half way to the summit and stopped to rest there, when a thunder-storm burst with savage fury." One feels his ensuing description catches not only the mundane details of a typical late-afternoon storm in summertime, but also captures the nineteenth century's language of sublime drama. The image is of isolation, noise, near-helplessness, yet thrilling exhilaration:

We seemed to be in the very midst of the clouds and tempest. Advance we could not, neither could one recede in such darkness and blinding rain. Here then, in the bleak surface of the mountain, with no shelter but a jagged rock against which we could crouch when the wind blew strongly from the opposite quarter, we were forced to receive the drenching of a pitiless storm. Yet it was a scene of such sublimity up there where the lightnings seemed playing in their favorite haunts and the thunders reverberated in prolonged and deafening peals, among the trembling hills, that we were not unwilling occupants of this novel situation.[11]

Stevens concludes by noting that Lane "made good additions to his portfolio," but that "many months would scarcely suffice amid such exhaustless wealth of scenery." Their discovery of this region had captivated their imagination so Lane returned to Maine the next two summers to concentrate and expand his vision.

In August 1851, Lane took advantage of his boat passage to Rockland by making sketches of the distinctive promontory marking the southern entrance to the harbor. He drew the unusual lumpy form of the headland from both sides, *Owl's Head from the South* and *Northeast View of Owl's Head* (Cape Ann Historical Association), "taken from steamer's deck while passing." Lane set

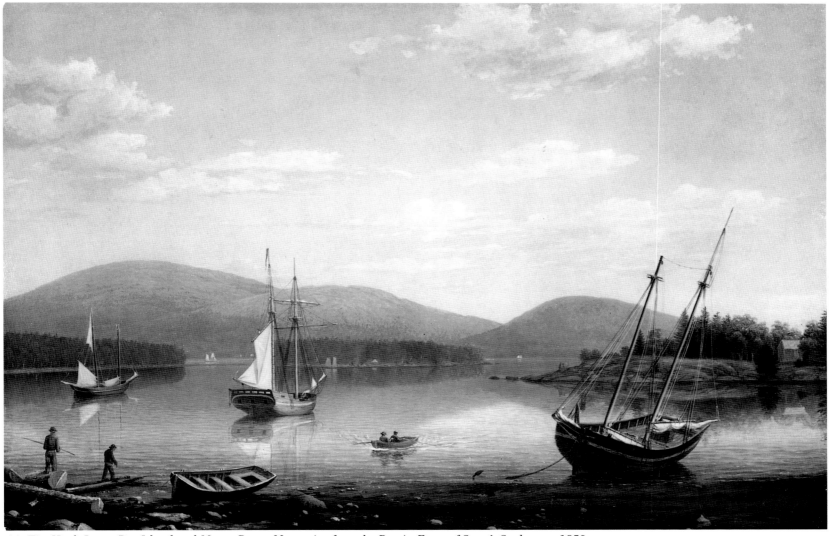

44. Fitz Hugh Lane, *Bar Island and Mount Desert Mountains from the Bay in Front of Some's Settlement*, 1850

to work directly the following winter to paint an oil of the southerly view, which he finished and dated in 1852. The other, which looked to the north (as was now becoming Lane's habit), was a view he would sketch again on another trip and paint more than once in subsequent years. Meanwhile, he made good use of his steam travel across Penobscot Bay en route to Castine. Just north of Rockland he made his first drawing of the Camden Hills, also from the steamer's deck, and again it would serve as the basis for both "a small painting" given to Stevens and other larger

canvases executed later in the fifties.[12] Once in Castine, he sought out new vistas around town, for example *Castine from Fort Preble*, and for Lane a rare combination of pencil and watercolor, *Castine Harbor and Town* (Museum of Fine Arts, Boston). From the start he must have meant to prepare for a full-scale painting, for he filled in his foreground with green washes, gave color to the hull of a lumber schooner offshore, and added careful touches of pink and green to some of the houses and the landscape of the town on the distant hillside. He even marked the faint letters *R, Y,*

and *B* near key buildings to indicate their colors in the final picture. Since Lane's first visit, the Stevens family had been urging him to execute a lithographed view of the town similar to ones he had previously completed of Gloucester. Joseph L. Stevens, Sr., wrote to Lane:

> I have no doubt copies enough could be disposed of to remunerate you. . . . There are several points of view, which you did not see, and to which it will be my pleasure, next summer, to carry you. I know many of our citizens would be gratified to have this done by you. Our house we shall expect to be your home. . . . I will only say that my wife and myself will spare no efforts on our part to make your visit agreeable, and perhaps useful. You have not or did not exhaust all beauties of Mt. Desert scenery, and perhaps there may be other spots in our Bay, that you may think worthy of the pencil.[13]

Lane did not complete his Castine lithograph until 1855, after he had made additional visits to and further sketches of the area. In late summer 1851 he sailed east again, and turned his attention to the approaches to Mount Desert. Only one dated drawing is known from this part of his trip, a carefully composed and finished view of Blue Hill (Harvard University Art Museums), which Lane appears almost immediately to have begun translating into an oil (private collection). The painting has a light, airy quality, with a new sense of stillness, lateral emphasis in the composition, and concentration on leading the eye out toward the distant hillside and the sky beyond, all of which were subtle advances over his painting of Bar Island and Mount Desert a year before. Perhaps aware of the shifts his style was undergoing, Lane intensified his attention to the possibilities of Mount Desert subjects the following year. In particular, drawings of one new prospect and of a familiar locale, Mount Desert Rock and the entrance to Somes Sound, came directly to fruition as major canvases upon his return home. Fortunately this excursion is well documented by drawings and paintings dated to 1852 and a surviving diary kept by another cruising companion of Lane's from Castine, William Howe Witherle, who detailed a week's sailing adventure from 16 to 22 August: "Our party consisting of F H Lane and Jos L Stevens Jr of Gloucester—Geo F Tilden, Saml Adams & myself and Mr. Getchell-Pilot left Mr. Tildens wharf at about 11 'clock in the good Sloop Superior—bound on an excursion among the Island of the Bay."[14]

The group made first for the prominent island marking the southern turning point from Penobscot Bay into Blue Hill Bay, Isle au Haut, now largely, like Mount Desert, included in Acadia National Park. Witherle commented on Lane's equal talents with the pencil and the fishing line:

> We had a charming run down the Chip Channel towards "Isle Au Haut"—anchored off Isle Au Haut about 5 'clock and Fished till about sun down—when we put away for Kimballs Harbour—but the wind died away and the tide headed us—so we were obliged to anchor in Shoal Water near the entrance of the Harbour—this had been a most Auspicious commencement to our Excursion—and we have enjoyed it highly—have done our own cooking and made out first rate under the Superintendence of Geo Tilden—whose talents in that line are the most prominent—Mr Lane however has a decided knack for frying fish and gave us a specimen of fried cod for supper—which was most excellent.[15]

The next day, 17 August, "After breakfast we weighed Anchor and with a light breath of wind put for 'Saddle Rock' some 10 miles off—but did not make much progress—and finding a chance to run into 'duck Harbour' we took advantage of it and run in—a very pretty snug little place—dropped Anchor and landed and leaving Mr Lane to take a Sketch we took a climb on to a Hill."[16]

Lane's double-sheeted sketch (fig. 45) looks out from the head of the small harbor, with the *Superior* anchored at the center and on the distant horizon the Saddleback Ledge and its marker. Soon the actual rock commanded their attention, for with a fair wind they sailed out to it and climbed ashore for a look before sailing on to "Lunts Long Island" to the east, where "we Stretched ourselves out on deck spun yarns—and read a little and enjoyed our life on the Ocean Wave—under such pleasant circumstances—to our hearts content." They passed much of the following day on Long Island before setting out on open waters to the southwest for Mount Desert Rock, notably visited and recorded by Thomas Doughty (fig. 10) almost two decades earlier. The passage seldom is calm; to them it seemed desolate and uneasy:

> We started with a fresh breeze for "Mount Desert Rock" 18 miles distant—it was rougher than we have yet had it—being considerable swell but we got on finely—with the exception of George being sea

45. Fitz Hugh Lane, *Duck Harbor, Isle Au Haut, Penobscot Bay, Me.*, August 1852

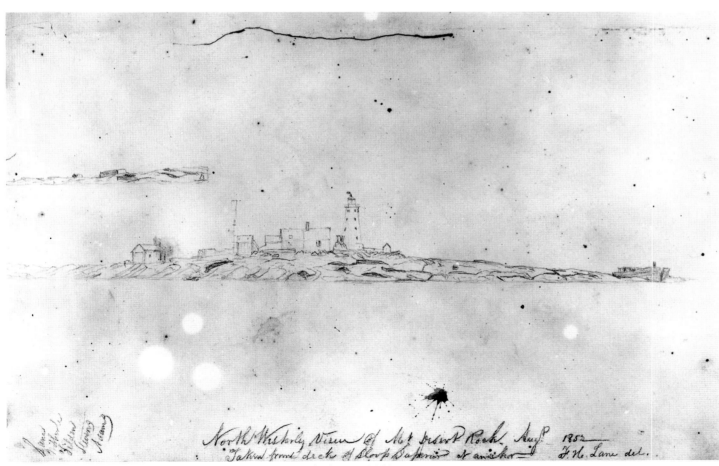

46. Fitz Hugh Lane, *North Westerly View of Mt. Desert Rock*, August 1852

47. Fitz Hugh Lane, *Northwesterly View of Mt. Desert Rock*, 1855

sick—which however we comfort him with the opinion that it will do him good—About noon we arrive[d] at the Rock. . . . we spent a couple of hours most pleasantly rambling about the Rock Examining a wreck of a Sch[ooner] was lately cast away there—watching the seas dash up onto the windward side—as a Fin Back Whale dash[ed] every now and then into Shoals of Herring which almost surrounded the rock. . . . we felt that we should have enjoyed two days there— but as we had proposed to reach Somes Sound that night we had to tear ourselves away—Mr Lane took two sketches while there.[17]

One of these drawings is titled and annotated *North Westerly View of Mt. Desert Rock*, "taken from deck of Sloop Superior at

anchor" (fig. 46). Using only a single sheet, Lane extended the thin profile of the ledges in an area above, and at the top of the page drew a brief undulating line to suggest the distant, barely visible distant outline of Mount Desert itself. From this as well as the relationship of the buildings on the rock we can tell that this is not a view *of* the northwest side of the island, but rather one from the south looking *to* the northwest. Lane's painting of the scene, only rediscovered recently, carefully transcribes the details of the rock into a much more sweeping panorama, with our vantage point set further off into ocean swells (fig. 47). Possibly the sloop to the left is the *Superior*, while the single figure seated

in the bow of the rowboat, turned by the two oarsmen accompanying him to look back at the view, may be Lane himself. The large number of schooners and the steamer on the right complete the inventory of coastal traffic at the time. While he still followed the impulse to enhance his paintings with narrative foreground elements, they are fewer here, and are diminished as well by being set on open water rather than on the firm stage of a beach or shoreline.

The experience of crossing the empty expanse from the coast to the rock, and the extended views there, seem to have stimulated Lane visually. He was now ready to paint both luminist light and luminist space, and his return to Somes Sound would provide the perfect opportunity. "We had a fine free wind for the sound—and the view of the Mt Desert Hills as we approached them was splendid—Mr Lane improved it to take a sketch of their outlines. . . . we had a fine sail up between the high hills which in one place are perpendicular—and we came to our anchorage above the 'Bar Island' just after sunset—after supper we went up in the Boat to Somes."[18] The next morning they went ashore, now familiar from their earlier stay, fished for mackerel, and again climbed "one of the highest mountains." this time notably joined by Lane: "we found a pretty good path about ¾ the way up—we had to wait once in a while for Lane who with his crutches could not keep up with us—but got along better than we thought

possible. . . . Lane got up about an hour after the rest of us."[19] Another thunderstorm overcame them as they returned to the sloop, but clearing weather favored their departure the next day "as we took our breakfast on deck drifting down the Sound— Surrounded by the noble Scenery." Now they leisurely explored the little inlets and islands just outside the sound's entrance; they

> ran in to North East Harbour looked about and ran out again and put for Bear Island—where we landed and visited the lighthouse—this is a high bluff island—the Beach that we landed on appears from the top of Island of a perfect Crescent Shape—started again for Suttons Island—and landed Mr Lane to take a Sketch. . . . then run down to South West Harbour and anchored—Mr Lane took 2 sketches here.[20]

Although most of these specific sites would later be subjects for drawings and paintings, it is these last two that Lane would distill into one of his greatest works of art. The first drawing, *Southwest Harbor* (fig. 48), is the more expansive in its view looking north across Norwood's Cove, perhaps from the Clark Point shore, while the second, *West Harbor & Entrance of Somes Sound)* (fig. 49), is a slightly closer and more concentrated view, likely drawn from the tip of Greening's Island opposite the entrance to Somes Sound. Two paintings quite similar in composition but intentionally contrasting in mood followed almost immediately. The first is a glassy, sunlit image that Lane must have begun directly

48. Fitz Hugh Lane, *Southwest Harbor, Mount Desert*, 1852

49. Fitz Hugh Lane, *West Harbor & Entrance of Somes Sound*, August 1852

upon his return to his studio in Gloucester that fall, for he was able to sign and date it 1852 (fig. 50). The companion picture shows a more turbulent vista (fig. 51), with nature and vessels in action; it probably followed not long after the first, for it caught the favorable attention of a sympathetic critic two years later.

The painting *Entrance to Somes Sound from Southwest Harbor* (fig. 50) Lane's first classic luminist work. Combining the lateral sweep and the focused equilibrium of the two drawings, it achieves a fusion, new in his art, of stillness and spaciousness. Compositionally, the scene is an artful sequence of orchestrated echoes, counterpoints, and balances harmoniously unified in a magical, almost hallucinatory, vision. Lane exploits in his viewpoint the elusive and concealed entrance to the sound he and Stevens had observed in their visit two years before. Specific as his stance is here, he is just as interested in the surprising revelations of the island's beauties, as if it were a direct and accumulated experience. Indeed, the dramatic visual glories of

the sound proper are just out of sight beyond the point of Jesuit Meadow at the right, and instead we look across the compressed space of Norwood's Cove from the mundane activities of fishermen gossiping on the shore to the loading of a lumber schooner in the middle distance. These activities are now minimal in Lane's painting, but critical to it. The figures give human scale and interest to the scene, but are subsumed by the larger stillness and order of nature around them.

Rather than centering the view on the deep cut of the sound itself, as suggested in the drawings, Lane looks directly at the hills on the sound's western shore, Robinson and Dog mountains, which have a formal echo in the rounded rocks on the beach. To either side are the balanced hillsides of Beech Mountain to the east and Brown Mountain on the sound's eastern side. In the middle ground, the diagonal axes of the small and large schooners complement each other. Further linking foreground and background are the beached dory and its oar pointing across the

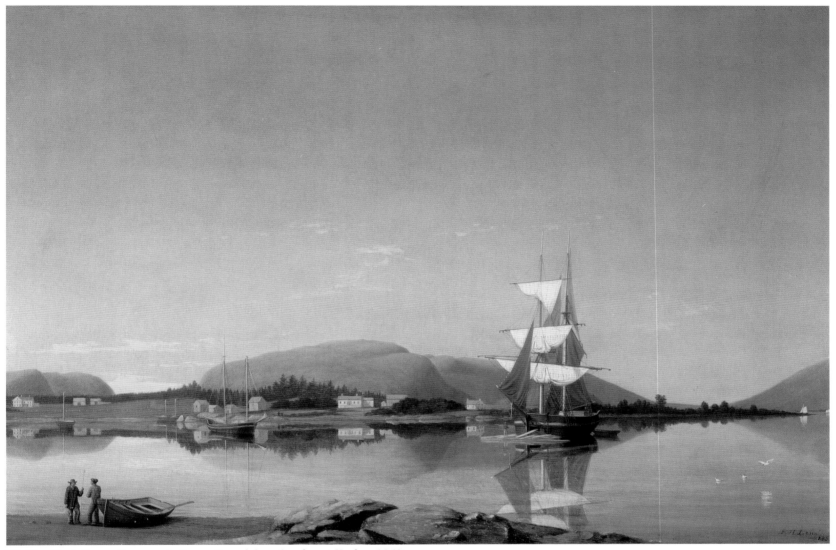

50. Fitz Hugh Lane, *Entrance to Somes Sound from Southwest Harbor*, 1852

lumber schooner, matched by its angled sails and bowsprit, and reinforced by two red-shirted figures. At the same time the geometric reflections of the masts and sail patterns cross the mirrored surface of the middle ground. Earth and sky seem further tied together by the reflected houses and evergreens on the far shore, by the dominant ascending vertical of the lumber schooner's rigging, and by the continuous translucent blue of water and atmosphere. This is nature (and, metaphorically,

America) at high noon, an image of self-confident equipoise also to be found in a number of other key American paintings of this period, most notably William Sidney Mount's *Eel Spearing at Setauket*, 1845 (New York State Historical Association, Cooperstown), George Caleb Bingham's *Fur Traders Descending the Missouri*, 1845 (Metropolitan Museum of Art), John Frederick Kensett's *Beacon Rock, Newport Harbor*, 1857 (National Gallery of Art), and George Inness's *Lackawanna Valley*, 1855 (National

Gallery of Art). National expansion and prosperity were at a high point during this decade before the Civil War, when political tensions were for a time held in the stasis of compromise, and cultural expression reached an apogee of pure and abundant originality. Calling this moment the "American Renaissance," F. O. Matthiessen was the first to argue that in the years immediately surrounding the date of Lane's painting, several of the country's greatest writers published an unparalleled concentration of masterpieces. These included major works by Ralph Waldo Emerson, Nathaniel Hawthorne, and Harriet Beecher Stowe, as well as Herman Melville's *Moby Dick,* Henry David Thoreau's *Walden,* and Walt Whitman's *Leaves of Grass.*[21] This elevated context is appropriate for Lane's achievement, his own poetic celebration of the self and the universe.

For all its grandeur of spirit, however, the picture is grounded in a specific time and place; this is evident in the prominence Lane gives to the loading of lumber at the center and to the bare mountains beyond. Before the arrival of the early settlers, most of Mount Desert Island, like much of inland Maine, was covered with forest. An occasional fire laid bare portions of the landscape. During the nineteenth century meadows and hillsides were cleared by sheep, and working farms were established. As early as 1806, William Gilley was cutting woodlands on Baker's Island to make "a tolerable farm," and two years later Captain Hadlock was settled on Little Cranberry Island with a "large fish business." By the 1830s Southwest Harbor was an active fishing and shipping port, and "the building of small vessels . . . went on in several little shipyards" around Mount Desert, two of which were located in Somesville. Deacon Henry H. Clark in 1835 was known as "the largest builder and owner of coasting craft on the island."[22] Like Lane's native Gloucester, this and other areas he visited had industrious shipbuilding enterprises—for example, Rockland, which also saw extensive activity through the clipper ship era from 1845 to 1860. Local shipbuilding was one reason for the harvesting of Maine's forests; the transportation of lumber to the major ports to the south and west and to the rest of the world also stimulated the cutting of timber. As one historian remarked, "lumber carrying for Maine was a very important phase of the nation's commerce. . . . for over seventy-five years it equalled, and in some respects excelled, the thoroughly described whale fishery."[23] Nearby Bangor was a major exporter of lumber,

and numerous shipyards prospered there and all along the Penobscot River south to Bucksport at the head of the bay. From this area birch went to Scotland and other types of wood to Italy, Spain, and ports in South America.[24]

Evidently the same preparatory drawings served as the basis for a second painting of this scene, usually known as *Off Mount Desert Island (Entrance of Somes Sound),* but on the basis of contemporary exhibition records probably originally titled *Off the Coast of Maine, with Desert-Island in the Distance* (fig. 51). The viewpoint is shifted slightly to open water, just as several vessels formerly at rest are now under sail in the brisk air and shifting light. Executing companion pictures of nature in different moods or sequential moments had become something of a fashion at this time. Thomas Cole had painted his famous series *The Course of Empire* in 1836 (New-York Historical Society) and *The Voyage of Life* in 1840–1842 (National Gallery of Art), popularizing the precedent in these allegorical works. Soon thereafter, other landscape painters such as Jasper Cropsey and Sanford Gifford chose to depict the cycles of morning and evening and the four seasons, and art historians have made a convincing case for the idea that George Caleb Bingham's two major works of 1845, *Fur Traders Descending the Missouri* (Metropolitan Museum of Art) and *Concealed Enemy* (Stark Museum, Orange, Texas), are actually intended pairs contrasting the fashionable stylistic modes of Claude Lorrain and Salvator Rosa.[25] Lane himself painted other pendant canvases of similar size and title, such as *A Calm Sea* and *A Rough Sea* (Cape Ann Historical Association). In the case of the Somes Sound paintings, we sense that we have moved from stilled time and midday glare to the dynamic energies of people and nature at work. The lumber (or quarried granite, another local resource) having been loaded aboard a wide schooner, the vessel, now low in the water, plows out of the harbor. Like high tide and high noon, everything once held in gentle equilibrium is now in fluid motion, the world a place equally for contemplation and for action. Lane appears to have completed this complementary piece during 1853, following his dated work of the previous year and before its mention by the critic Clarence Cook in 1854:

A sea-piece, "Off the coast of Maine, with Desert-Island in the distance," is the finest that Mr. Lane has yet painted. The time is

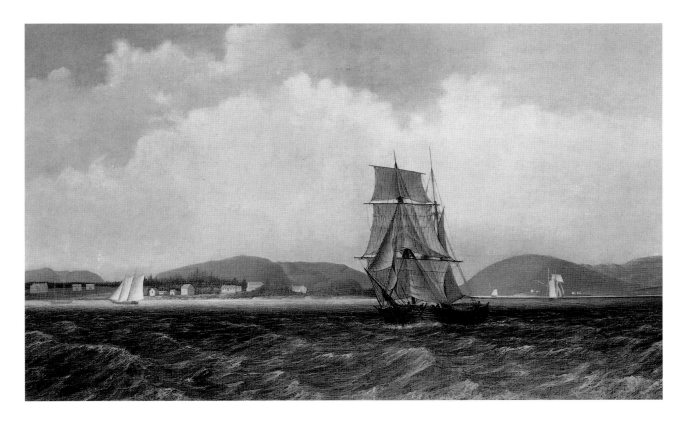

51. Fitz Hugh Lane, *Off the Coast of Maine, with Desert-Island in the Distance,* 1850s

sunset after a storm. The dun and purple clouds roll away to the south-west, the sun sinks in a glory of yellow light, flooding the sea with transparent splendor. Far away in the offing, hiding the sun, sails a brig fully rigged, a transfigured vision between glories of the sky and sea. . . . In the foreground of the composition is an old lumber-schooner, plowing her way in the face of the wind; the waves are rough but subsiding; dark-green swells of water, crowned with light and pierced with light. . . .

I urged Mr. Lane to send this picture to New-York for exhibition. It could not fail to make an impression, and to call forth criticism. A finer picture of its class was never in the academy.[26]

Whether because of his intense memory of Mount Desert on this 1853 trip, and its transfiguration into a luminous vision, or because of Cook's encouraging visit to Lane's studio, the artist returned to record the same prospect in September 1855. Cook had praised his special mastery of marine subjects, referring to "his new experiences and the new inspiration." During the winter of 1853 Mrs. Stevens wrote Lane from Castine that "the 'General Gates' is destroyed, yet [my husband] thinks Mr. Getchell will

have a better boat, but he hopes, as has been suggested, that you will be able to come down in your own yacht."[27] Lane was busy at this time painting views around Gloucester and in Boston Harbor, and only one painting of Maine is known to be dated 1854, a twilight picture probably of the lighthouse at Camden (private collection), though one newspaper report from Castine said that the artist "visits here nearly every summer."[28]

The next documented trip for which a group of drawings survives is that of 1855. By mid-August Lane was in Castine, where he and Stevens, along with Stevens' brother George and Charles A. Williams, explored a local site of the Revolutionary War, "the great granite boulder on the shore of Perkins' back pasture."[29] Recalling his 1851 drawing and watercolor of the town from the water, Lane now made two other panoramic sketches, *Castine from Hospital Island* and *Castine from Heights East of Negro Island* (Cape Ann Historical Association), possibly at Stevens' urging. The latter proposed "to have a Lithograph print of Castine struck off similar to the sketch lately made by Mr. Lane to be executed in the best style in Boston, in plain dark & white,

52. Fitz Hugh Lane, *Entrance of Somes Sound from back of the Island House at South West Harbor*, September 1855

53. Fitz Hugh Lane, *Looking Westerly from Eastern Side of Somes Sound near the entrance*, September 1855

provided 100 copies are subscribed for at $2.00 per copy."[30] The print was Lane's last and most beautiful, more spacious and delicately drawn than anything before it. The composition views the town shoreline from a distance across the river; it is open at both sides, and Lane devotes over two-thirds of the sheet to a bright, thinly clouded sky. It reflects Lane's new confidence in recording the Maine light and air with a refinement and economy of means that mark his best mature work.

That September he cruised to three places, each of which stimulated a group of drawings and at least one oil. The first was Owl's Head, which he outlined from the south, the southeast, and the north. Unlike his earlier drawing from the steamer's deck, these were typically "made on our cruise. Taken from our boat in the early forenoon of a beautiful day lying north of Owl's Head—on our approach from Rockland," or from a nearby shore. Another series of four sheets looked at the Camden Hills from different compass points: the southwest, the south entrance to the harbor, "the Graves," and the "North Point of Negro Island." Stevens added whether these were done "on our second day's cruise while going from Rockland to Camden," "toward sundown of our second day's cruise," or "from the boat on our return to Rockland."[31] The third group took Lane back to Mount Desert, where he finished

two sketches of Somes Sound with an unusual degree of textural detail, tonal contrast, and variety of pencil stroke. The *Entrance of Somes Sound from back of the Island House at South West Harbor* (fig. 52) is a slight variant of the radiant 1852 canvas; he may have contemplated another painted version, or perhaps he just wanted to fix the image forever in his mind. Its companion, *Looking Westerly from Eastern Side of Somes Sound near the entrance* (fig. 53), is one of the artist's most firmly delineated and well-composed drawings, with its asymmetrical balance of foreground rocks and distant mountainsides, subtle gradations of forest and geologic formations, and hints of sunlight and shadow. This degree of spatial clarity and sense of design surpassing casual observation is unusual among his working drawings, and this suggests the power of place in the strengthening of Lane's late style.

Just to the east of this point lies Bear Island, another rocky outcrop already familiar to Lane, which now prompted him to sketch in serial fashion. One view "from the western side of N. East Harbour" (fig. 54) Lane turned into a painting that he presented to his friend Hooper "as a memento of our excursion." A second, more southerly view also resulted in a painting (fig. 55), as did the third, *Near South East View of Bear Island* (figs.

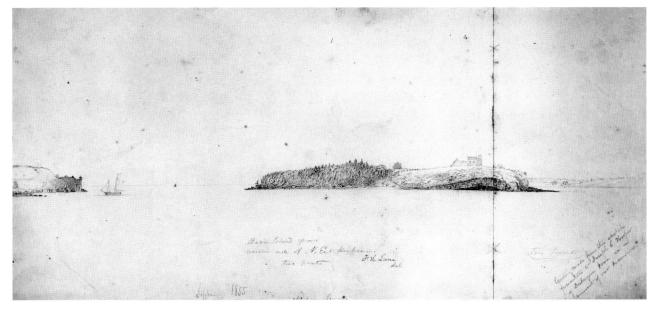

54. Fitz Hugh Lane, *Bear Island from western side of N. East Harbour*, 1855

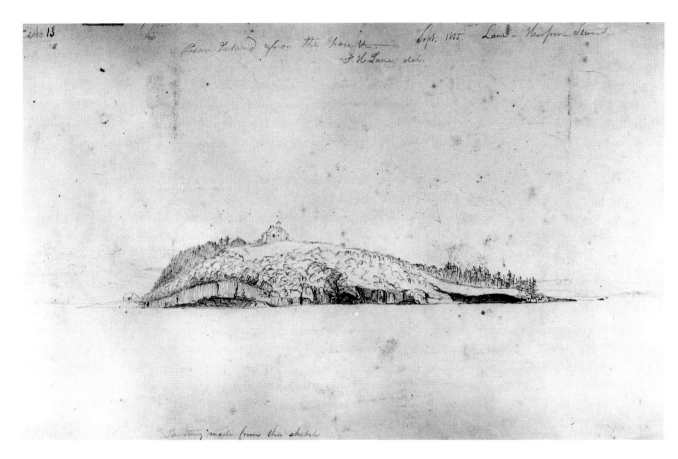

55. Fitz Hugh Lane, *Bear Island from the South*, September 1855

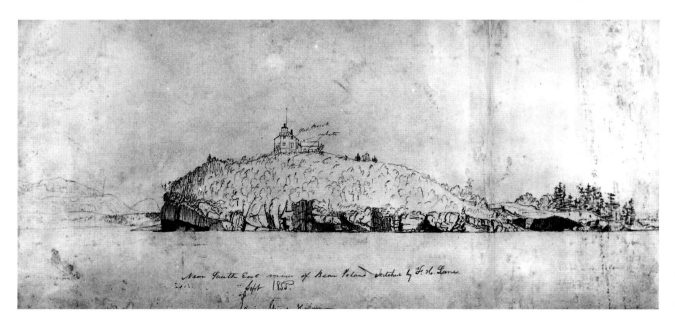

56. Fitz Hugh Lane, *Near South East View of Bear Island*, September 1855

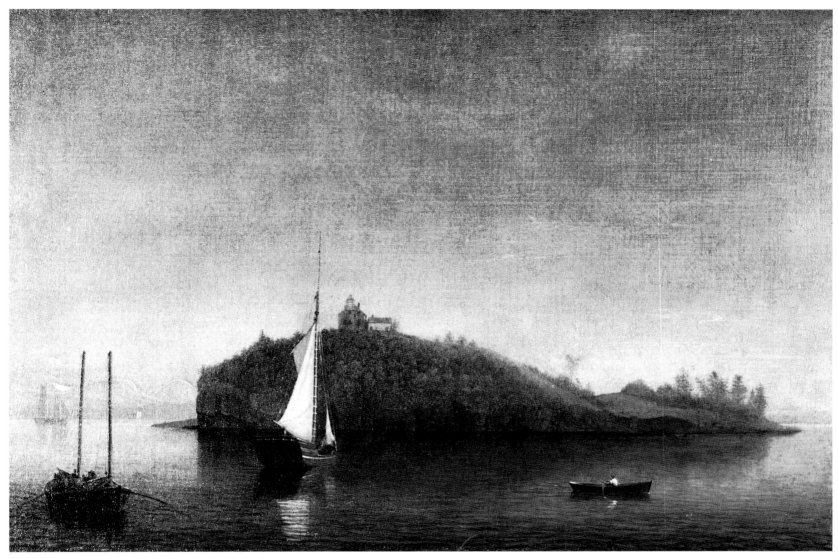

57. Fitz Hugh Lane, *Bear Island, Northeast Harbor*, 1855

56, 57). This drawing is the most specific in detailing the tree cover on the island, the distinctive striated cliffs at the water's edge, and the exact configurations of the lighthouse, additionally marked "red brick" and "white." At home Lane transcribed this almost exactly into a small oil, with two crucial modifications: the three small vessels placed in an arc to complement the island's contour, and the suffused orange atmosphere marking this as a characteristically dramatic summer sunset. Although the hillsides

above the village of Northeast Harbor, clearly outlined in the drawing, are vaguely visible in the painting, the overall effect of enveloping light and colored moisture gives the finished work an almost mystical quality, as Lane seems to overlay observation with contemplation. With this picture and others like it done in mid-decade around Cape Ann and Boston, his style was decisively shifting in emphasis from the recording of specific fact and action to the creation of more general states of mind and feeling.

58. Fitz Hugh Lane, *Sunrise on the Maine Coast*, 1856

A few other sketches and paintings of the area probably date from the mid-fifties; one Stevens could only identify as "Mount Desert sketch" (Cape Ann Historical Association), and another loosely suggests the hills along Somes Sound (private collection). The two most important Maine canvases of this period are *Sunrise on the Maine Coast* and *Off Mount Desert Island,* both from 1856 (figs. 58, 59). Because of Lane's intimate familiarity with the southeastern side of the island, both these works almost certainly show Mount Desert in the soft pink rays of sunrise, though no preparatory studies are known, nor can the exact geographic location be determined. Prominent in the foreground of the former is Lane himself, seated on the shore with his sketchbook, communing with the illuminated hillside beyond, his boat anchored nearby. The other, with a small rocky beach at low tide, slightly varies the composition, but equally emphasizes the

spiritual and cerebral experience of a purified landscape. Significantly, most of the Maine paintings that have been precisely located and dated from the late fifties and early sixties are versions of subjects Lane had initially composed several years before, namely *Castine from Fort George,* 1856 (Thyssen-Bornemeza collection), *Castine Homestead* and *Camden Hills,* 1859 (both private collections), *Castine,* 1860 (Timken Art Gallery, San Diego), *Owl's Head,* 1862 (Museum of Fine Arts, Boston), and *Moonlight Boating Party (Indian Bar Cove),* 1863 (private collection). Even a powerful sunset painting long thought to depict Christmas Cove in 1863 (private collection) is not positively certain as to location, time, or date, although its abstract design and brooding sense of transient light do place it as a late work. No drawings exist of documented later voyages to Maine, and we do not know if these later paintings are

59. Fitz Hugh Lane, *Off Mount Desert Island*, 1856

the result of additional visits with Stevens or of those incandescent wilderness colors burning deeply in his imagination. Ironically, what does survive is the most explicit of images, a photograph: *Steamer "Harvest Moon," Lying at Wharf on Portland* (Cape Ann Historical Association), ruled off for transfer to a canvas captioned "Painting made by Lane for Lang & Delano, India Wharf, Boston, from this Photograph, introducing her into a sketch of Portland Harbor, Taken on our visit in August 1863." But no more is known of any touring work done on this trip. By this time Lane's health was failing, and coastal travel was impeded by the Civil War. The paintings of his last years would focus introspectively on the poignant wreckage of vessels on the starkly exposed rocks of local Gloucester ledges.

Two masterpieces of the early 1860s, however, crown Lane's Maine experiences. Both are set imprecisely on the now haunted reaches of his beloved Penobscot Bay. A surreal air of dislocation fills one with the anxiety of a threatening thunderstorm; the other is an elegy to an exquisite twilight, suggesting impending loss, destruction, and desolation. Both show sturdy working lumber schooners at sea, but the familiar landmarks of the shoreline are distant and barely identifiable. *Approaching Storm, Off Owl's Head* (private collection) is unique in Lane's work, the only storm picture he made, undertaken just as the larger rumblings of national strife were reverberating across the country. On the distant horizon the headland looms up larger than it does in actuality, floating detached from the mainland and magnified by the mirage effects of the squall line fast approaching across the bay. Far off, two vessels with lowered sails pound in rough seas, while deckhands in the foreground hasten to furl and stow their sails in the eerie calm. We have no stable platform of beach or

60. Fitz Hugh Lane, *Lumber Schooners at Twilight on Penobscot Bay*, 1863

shoreline as a vantage point, but instead open, anonymous water. Lane's perfection of the luminist format is complete: the design is tight and orderly in its austere horizontal bands evenly marking off spatial recession, and intersected by the highlighted verticals in near-mathematical calculation. Everything seems frozen in place, yet threatened; the barometric vacuum of silence is about to crack and fill with turbulence.

Almost identical in size, and possibly conceived as a pendant, *Lumber Schooners at Twilight on Penobscot Bay* (fig. 60) is also unusually attenuated in its horizontal proportions. The insistently lateral layout of vessels, shoreline, and evening clouds extends toward the setting sun, as if the glowing light was ebbing through the distant narrows. Again we are far enough from recognizable land to feel isolated and adrift in a moment of change. Heavily laden with neatly cut and stacked lumber, Lane's schooners sit idle as the wind drops, their bows pointed to the west, in which direction they will transport their cargo. The low sloping hills could be any of those islands edging Penobscot Bay or perhaps in

Jericho Bay closer to Mount Desert; Lane's image balances between the particular and the universal, between stopped time and timelessness. One historian has called 1860 the high moment of the lumber trade.[32] It was also an era of thriving commerce in brick and granite, as productive quarries opened on Deer Isle and Mt. Waldo on the Bangor River, and later on Mount Desert. Lane often painted these same large vessels loaded with stone heading back to Boston to serve the current passion for Greek revival buildings.[33] But this was a commerce driven by a dying wind, and soon steam transportation would supplant the power of sails. In addition, just at this time Confederate cruisers were causing damage both at sea and on the coast, and near the end of the Civil War even Gloucester was for a time blockaded, causing disruption to Maine's lumber business and maritime trade. In this context, the expiration of light and air in this late painting takes on the somber cast of an elegy for a world Lane saw disappearing.

When he first visited the Maine coast and sailed into the great harbor of Mount Desert, Lane arrived with a sense of exhilaration, and his style captured the activity of northern New England's ports and waters. As this critical midcentury decade came to a close, the nation was moving toward crisis, and Lane himself sensed some of the uncertainties of age. His first Maine twilights were ones, we feel, of awe and reverence, thanksgiving for day's

fulfillment and the certainty of time's perpetual renewal. But his end of day in *Lumber Schooners* strikes a changed mood of wistfulness and acceptance of loss instead of gain. Spaciousness now approaches emptiness; sunset radiates with a different heat and passion. In painting his one thunderstorm at this time, he was creating an iconography for an anxious and conflicted nation, which his fellow painter Martin Johnson Heade would explore with unsurpassed drama in a series of storm paintings done on the Rhode Island coast. In creating this companion vision of burning twilight, he was moving toward a landscape that Frederic Edwin Church would make his own by turning the imagery of sunsets on Mount Desert into visual metaphors for no less than Abraham Lincoln's "fiery trial."

Lane's health evidently began to decline during 1864, though he was mobile enough to execute numerous sketches around Cape Ann that July and August, some of which are strikingly strong and might had led to compelling paintings. He finished and dated only a few oils that year, most notably those of Brace's Rock on Gloucester's outer shore. During the following summer he suffered some sort of seizure, and lay incapacitated for a week. Lane died on 14 August with, we may imagine, another summer sunset in the offing and a Maine cruise under deliberation.

V.

Frederic Edwin Church

HOW DEARLY WE WOULD LOVE to find these invented memoirs suggesting that the artists met confirmed in some unlocated letter, journal, or magazine. Several facts do place these consummate painters of Maine and some of their key works in close proximity more than once during the 1850s. Church had a number of compelling reasons for traveling to Maine to paint. His famous mentor and friend Thomas Cole had died in 1848. An indelible experience in the young Church's first year as a pupil of the older master had been Cole's summer journey to Mount Desert, from which he had brought back a portfolio of drawings, the most important of which led to paintings executed under Church's watchful eye in the year or so following. Now with his teacher gone and the art world mourning the loss of its leading landscape painter, Church was technically and emotionally prepared not only to pursue Cole's artistic ideals, but to adapt and enlarge them for a new period in the nation's history. As did Asher B. Durand and numerous other artists, Church paid tribute to Cole both by emulation of his style and subject matter in paintings of 1848 to 1850, and by express imagery such as a cross in the wilderness, explicitly titled *To the Memory of Cole* (Des Moines Women's Club, Iowa).

Cole had agreed to give Church instruction in art at the intercession of Daniel Wadsworth. The student's father paid three hundred dollars per year for the arrangement, which was extended for a second year. Cole saw the compact as a personal as well as a professional one: "I have always treated my students as friends as well as pupils and should be unwilling to instruct anyone whom I cannot meet on such [moral grounds]. . . . I will furnish you with a painting room, give you the necessary instruction and admit you into my studio at suitable hours. In the summer season you will at times accompany me in my sketching excursions."[1]

By all accounts he also admitted Church into the life of his family, for the young man often kept Mrs. Cole company when her husband was away working, and helped tutor the Cole children in the rudiments of art. Once Cole wrote from his New York studio to his wife Maria in Catskill, "I hope Theddy draws, and Mary. Ask Mr. Church if he will not give Theddy a little lesson. Tell Mr C that I expect to see something quite fine on my return."[2] After another year, Church's apprenticeship was over, and soon after that Cole himself was gone, but recollection of summer sketching excursions remained vital. Among the ways Church could now advance both his teacher's legacy and his own artistic ambitions was to follow in his master's footsteps and assess firsthand the allure of Maine's wilderness.

A second reason for planning a Maine venture at this time would have been the example of Thoreau, the first installments of whose account of his recent trip to Mt. Katahdin appeared in the

61. Sunset at Mount Desert

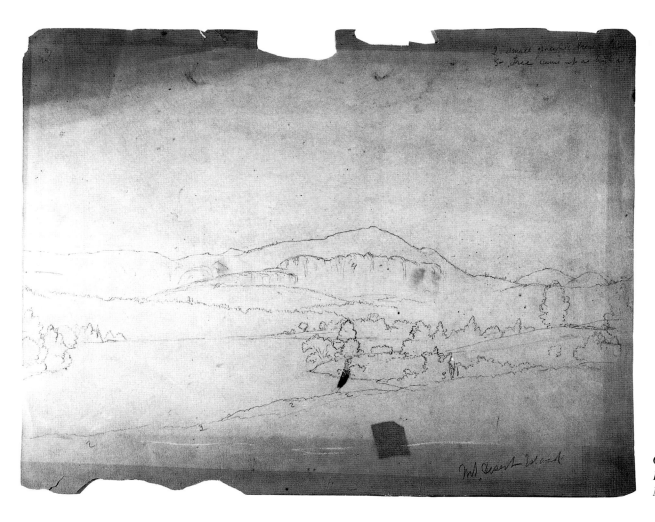

62. Frederic E. Church, *Little Long Pond and Jordan Cliffs* (*Penobscot Mountain and the Bubbles*), 1850

Union Magazine of Literature and Art (July 1848), and were reprinted in the *New York Tribune* of 17–18 November.[3] Thoreau had first visited Maine in 1838 to look for a teaching job. Immediately following his ascent of the wilderness mountain in 1846, he began to work on his first draft of "Ktaadn": "Occasionally, as I came down, the wind would blow me a vista open through which I could see the country eastward, boundless forests, and lakes, and streams, gleaming in the sun."[4]

Church made his first visit to the Maine coast in the summer of 1850, and then returned to go to Mount Katahdin two years later, even as Thoreau was planning his own return trips to the northern interior in 1853 and 1857. On these visits the painter, like the writer, developed a bold and intense form of expression appropriate to the landscape.

A third major stimulus for Church, most often cited by historians probably because more concrete documentation exists for it, was the appearance in the 1849 annual exhibition of the American Art-Union of Andreas Achenbach's dramatic sea painting, *Clearing Up—Coast of Sicily* (Walters Art Gallery, Baltimore). Painted two years earlier by that influential German painter (1815–1910), who had been trained in the then-popular Düsseldorf Academy, the picture displayed breakers crashing against a rocky coast, with light bursting from behind turbulent clouds in the distance. Critics admired Achenbach and the Düsseldorf style for "careful and accurate drawing" and the "fidelity with which natural appearances had been studied," though American painters were warned to distinguish between the warmer coloring and waters of the Mediterranean and the "colder

rocks and sands" of the New England coast.[5] In the same exhibition, Church had on view a much praised piece of his own, *Evening after a Storm*, along with six other works. Seeing the Achenbach hanging nearby clearly made a powerful impression, for subsequently one observer noted that

> Church, Gignoux, and Hubbard have gone to the coast of Maine, where it is said that the marine views are among the finest in the country. None of these artists, we believe, have hitherto attempted such subjects, and we look forward to the results of this journey. The exhibition of the magnificent Achenbach last year in the Art-Union Gallery seems to have directed the attention of our younger men to the grandeur of Coast scenery.[6]

Until this point in his career, Church had, under Cole's spell, largely painted woodland or mountain scenery in upstate New York and northern New England; now he was inspired to attempt marine painting, to try "his pencil in a new field." An admirer of Turner, Church was well aware of the English artist's sea pieces both from mezzotint copies and recently imported originals.[7] Altogether, here was a rich new vocabulary he could test for himself in America's coastal wilderness.

A likely final impetus for Church's visit to Maine was Lane's key early work, *Twilight on the Kennebec*, which was also hanging in the same Art-Union exhibition. Not only was it an explicit Maine scene, but it was one of the first to make use of the intense new cadmium colors recently available as premixed pigments. The hot reds and yellows that pervade Lane's canvas, and the choice of this radiant hour of sunlight, must have had a startling impact on viewers. In journeying to Mount Desert, Church may have had Cole in mind for mountainous views, and Achenbach and Turner for churning seas, but Lane's *Twilight* is arguably the critical precedent for Church undertaking several burning sunrise and sunset pictures in the next few years. These include *Beacon, off Mount Desert Island*, 1851 (fig. 87), *The Wreck* (Parthenon, Nashville) and *Grand Manan Island, Bay of Fundy* (Wadsworth Atheneum), both 1852, and *Mount Ktaadn (Katahdin)*, 1853 (Yale University Art Gallery), among the strongest works of his career.

Church actually reached Mount Desert Island in July 1850, a month before Lane arrived that year with Stevens. In letters to the Art-Union *Bulletin*, Church recounted highlights of his trip. His route differed from those taken by his predecessors. Cole had made his way to Belfast, where he encountered rain and fog. From there he sailed by packet sloop across Penobscot Bay to Castine, much as Lane would a few years later. After sketching in Castine, he made the thirty-three mile journey overland to Mount Desert by one-horse wagon.[8] From several surviving drawings it seems likely that much of his travel around the island was also by wagon. By contrast, Lane's trips to the island were always by boat from Castine, and most of his movements around Mount Desert were along the shore. Consequently, the views he favored for drawing were in protected coves, and looked at the mountains either from the water or from ground level.

For his part, Church crossed by train from New Hampshire to Portland, Maine, where he took a fishing sloop on to Castine, and for the last leg the steamer *Charles* down to Mount Desert. "About two hours before sunset," he wrote, he "came to Seal Cove, on the southeastern coast of the island." He must have meant Seal Harbor, where there was a steamboat wharf. (The only Seal Cove on Mount Desert was on the western coast, and never served as a steamer port.) Going ashore here, he made one of his first series of drawings, of Little Long Pond and Jordan Cliffs (figs. 62, 64). From his many sketches on this and later visits, it is clear that Church preferred to get around the rigorous terrain on foot, and far more than Lane's, his drawings frequently view interior ponds and lakes as well as vistas from the slopes and summits of the high eastern hills.

A few weeks later, Lane was well aware of his colleagues at work in adjacent spots, as we know from Joseph Stevens' account: "[Benjamin] Champney and [John F.] Kensett were then in another part of the island and we have reason to believe that Church and some others were in the immediate vicinity."[9] Lane's documented visits to Mount Desert are in the summers of 1850, 1851, 1852, 1855, 1856, and possibly 1860; Church's are in 1850, 1851, 1852, 1854, 1855, probably 1856, 1860, and 1862. Physically, the latter was able to reach many more places and to travel much further, including to Mt. Katahdin and the northern Maine woods. But despite these differences in their habits of travel and the resulting variations in their pictorial approaches, both artists moved in their content during this decade from the anecdotal to the contemplative; in their formats from the closed to the open and atmospheric; and in their treatment of light from the

functional and incidental to the symbolic and universal. Church was far more prolific at drawing, with a known body of some one thousand drawings (the largest concentrations being at the Cooper-Hewitt Museum in New York City and at Olana, the artist's house at Hudson, New York, which has been preserved); perhaps a hundred or more sheets are devoted to Mount Desert and Maine subjects. While accepted judgment places among his masterpieces paintings of Niagara, the Arctic, South America, and the Near East, one may argue that Maine inspired the full range of Church's working methods and at least half a dozen of his greatest works.[10] Indeed, his consummate achievement of these trips, and many would say of his entire career, is *Twilight in the Wilderness*, 1860, now ranked as a classic textbook icon of American art.

The most ample information exists for Church's first trip to Mount Desert in 1850, thanks to the accounts he sent to the Art-Union *Bulletin* and to an especially large number of dated and captioned sheets. From even a selective overview of the material one can see that he was interested in a number of artistic goals: quick sketches of nature's details, such as individual trees or rock masses; occasional buildings, such as a lighthouse, lumber mill, or farm dwelling; cloud formations and light patterns, especially in evening skies; sweeping hillside panoramas and mountain profiles, both inland and along Frenchman Bay; studies of rock textures and effects of light and shadow; sequential views of a single dramatic site; complete color studies in oil on board; and compositional outlines of a scene anticipating a full-scale studio canvas. His graphic oeuvre suggests a process of continual observation, not unlike that of a sophisticated user of a modern video camera who frames subjects, accumulates records of incidental elements, and moves by zoom lens from close-ups of particulars to wide-angle surveys of distant scenery. There are moments when one feels Church is paying homage to a view or subject recently treated by his teacher Cole; others when he is in search of a theme or effect he has recalled from works by Achenbach or Turner; and occasions when he has come upon a portion of nature with a fresh and original vision.

Having finally reached their destination and put ashore at Seal Harbor, Church and his companions made their way around the eastern shore of Mount Desert toward Bar Harbor. For almost three months, from July to September 1850, the artist did

63. Frederic E. Church, *Mount Desert, Sky Study (Sunset, Bar Harbor)*, 13 September 1850

"considerable sketching and painting" along the nearby coast, finding himself "exceedingly delighted with the scenery."[11] It is possible that on this trip he decided to stay either at the Lynam Farm on Schooner Head, where Cole had lodged six years earlier, or just north in the village of Bar Harbor itself at the homestead of Albert Higgins.[12] He documented this whole area extensively with his pencil, and with exacting oil studies captured "the pleasure of seeing some immense waves."[13] This was the island's most rugged and exposed stretch, and within a few miles of the Schooner Head farm Church found both his artistic destination and his destiny:

> We were out on the "rocks" and "peaks" all day. It was a stirring sight to see the immense rollers come toppling in, changing their forms and gathering in bulk, then dashing into sparkling foam against the base of old "Schooner Head," and leaping a hundred feet into the air. There is no such picture of wild, reckless, mad abandonment to its own impulses, as the fierce, frolicsome march of a gigantic wave. We tried painting them, and drawing and taking notes of them, but cannot suppress a doubt that we shall neither be able to give actual motion nor roar to any we may place upon canvas.[14]

In sum, Church hastened to conclude, "we have not come thus far to be disappointed."[15]

Some commentary on his varied drawings and his attention to nature's typologies is in order, to tell us both *what* and *how* he saw at Mount Desert. For example, a typical working sheet dated

64. Frederic E. Church, *Mount Desert, View Towards Frenchman Bay* (*Mount Desert Island from Dorr Mountain*), 1850

65. Frederic E. Church, *Mt. Desert, Looking Southerly* (*View from Jordan Ridge, Mount Desert Island*), early 1850s

July 1850 shows a "top of tree, one mass of green cones," and in another corner the outlines most likely of the Egg Rock lighthouse he could see out in Frenchman Bay.[16] His rock studies were often especially detailed in contour, striations, moss cover, and sense of location, enhanced further by elaborate notations, as one dated 31 August was: "Marked beautiful reddish orange tone (deep), the Autumn tint of which in close contrast was a fine rich green the edges of the masses of vine which skirted the gray (2) and black (3) rock were turned and the inner portions green. Moss covered evergreens grew from among the vines."[17] Choosing a more encompassing vantage point for his cloud observations, he outlined the mountain slopes along the shore in the lower center of his page as a firm visual ground for the aerial theatrics above.

One group appears to have been made near Bar Harbor over a two-week period from 31 August to mid-September; in these sheets Church makes summary outlines of the cloud formations at different times of afternoon and evening, noting with numbers and comments precise color gradations. On one he indicated "sun dazzling yellow" and on another, "Peculiar character of this sky lay in the great mass of light being at the right as marked shadow at left." A third, titled *Twilight*, also records the "rich broad reflection in the water."[18] The sheet of 13 September 1850 (fig. 63) is characteristic; it lists a "splendid concentrated orange light: with the other key tones, matched up with pencil hatchings and strokes of gouache above. Remarkably, Church was able to select and distill his observations with these economical and suggestive means. However much embellishment he might bring later in the studio to a full-scale painting developed from such on-site sketches, in comparison to Lane, Church sought a near-scientific accuracy in his visual note taking.

He seemed both agile and indefatigable in those first weeks when he was discovering the terrain of Mount Desert, for another long series of drawings shows him climbing across and around most of the hills on the eastern side of the island (figs. 64, 65). These would all have been readily reached from his base at Schooner Head, and several suggest he may have had Cole's earlier sketches in mind as he drew similar views (compare figs. 65 and 29). From the south end of the summit ridge of Jordan Mountain, an arm of the larger Sargent Mountain to the west of Seal Harbor, he recorded the view to the south, looking out over Little Long Pond where it empties into salt water and the

Cranberry Islands in the distance. A pointed boulder on the mountaintop and the minute notation of the lighthouse marking Great Duck Island on the far horizon are cleverly aligned. Barely visible at the left edge of the view is the other local lighthouse on Baker's Island; together they mark the approaches to the great inner harbor. A second, paler drawing contrasts the sheer drop of Jordan Cliffs with the hazy island panorama beyond.[19] Turning his gaze, much as Cole had done, now toward the northeast, Church drew the view from this same area, with Jordan Pond in the foreground below and the Bubbles on the far side, the flank of Green Mountain faintly rising at the far right, and beyond the distant islands on Frenchman Bay, the Gouldsboro Hills crossing the horizon. Church enjoyed linking distances in his compositions, and drawings such as these provided him with a fertile working vocabulary for the large, bold canvases he would paint of Maine in coming years (see fig. 97).

Not surprisingly, one of the largest groups of drawings he made on this trip was devoted to the one-mile stretch of coast on the southeast side of the island from Great Head north to Schooner Head. The Lynam farm was nestled on the protected inland slope of the rocky headland, with a small stone beach, sheer cliffs, and jagged rock indentations at the waterline nearby; this was a picturesque spot for artists to sketch. Church made several

66. Frederic E. Church, *Schooner Head, Mt. Desert*, early 1850s

67. Frederic E. Church, *Schooner Head and Lynam Farm*, 1850–51

68. Frederic E. Church, *Schooner Head, Red Rocks (Mount Desert Island from Halfway Mountain)*, early 1850s

69. Frederic E. Church, *Near Great Head (Coast at Mt. Desert Island, Maine)*, early 1850s

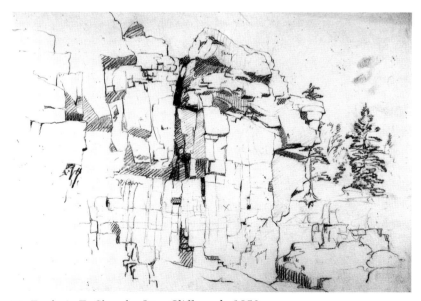

70. Frederic E. Church, *Otter Cliffs*, early 1850s

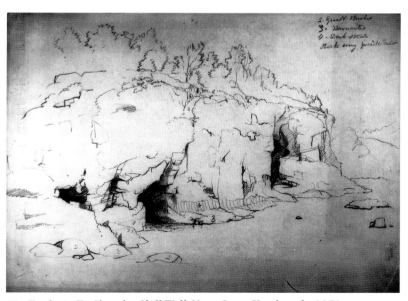

71. Frederic E. Church, *Cliff Wall Near Great Head*, early 1850s

outlines of the promontory from Great Head Cliffs, one quick and
general, capturing the basic forms (fig. 66), another more
delicately and firmly drawn in controlled, even lines and with
touches of chalk highlights, showing the farmhouse where he and
his colleagues lodged (fig. 67), and a third from a vantage point
lower down the ledges, centering on a blocky granite tower rising
up from the water's edge (fig. 68). As an aid to his precise
recollection of the visual facts, he annotated this last sheet, "Red
Rocks—Beautiful reflected light on M[iddle] Rock—Separated
more than right." Indeed, he was like an amateur geologist,
describing, identifying, and cataloguing the various rock textures
and structures before him. During the nineteenth century the
earth sciences rose to prominence as modern disciplines, and
landscape artists were eager to discover and reveal nature's
scientific underpinnings. In this spirit a number of Church's
sketches in both pencil and oil look closely at certain distinctive
rock formations, some extensively annotated (in one instance
differentiating eight separate color variations as "Flood tide just
commenced,"[20] and others seemingly recorded more for the
strength of their abstract design (figs. 70, 71).

This portion of the island appeared at the terminal edge of the
glacial push in the Ice Age, and later periods of erosion and
sedimentation had fused with the original deposits a complex
mixture of rock stratifications, sufficiently unusual to be named
the Bar Harbor Series. The results are the familiar outcrops of
jagged gray rocks broken in rhythmic planes and frequently
discolored brown by their iron-oxide content.[21] For many of his
oil studies, when he wished to capture the elements of local color,
Church used a rust-colored ground, over which he meticulously
built up the intricate planar and cubic configurations of these
ledges (see figs. 69, 70). If views from the water and from the
mountain slopes gave him an inventory of atmospheric effects,
these shoreline hikes helped greatly to expand the richness and
confidence of his geological vocabulary. From Schooner Head he
turned northward to Bar Harbor and the upper stretches of
Frenchman Bay. Again he employed a favorite compositional
device of juxtaposing the rising vertical cliff ledges with the
severe horizontal of the open bay beyond (figs. 72, 73). The best
of these, like the one he proudly inscribed and dated in large
embellished script, are elegant in their combination of great
simplicity and strength of execution.

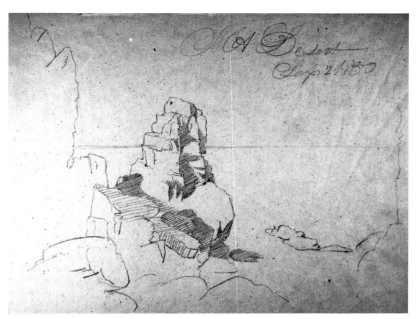

72. Frederic E. Church, *Mt. Desert, Frenchman Bay* (*Stone Pillar, Mt. Desert*) September 1850

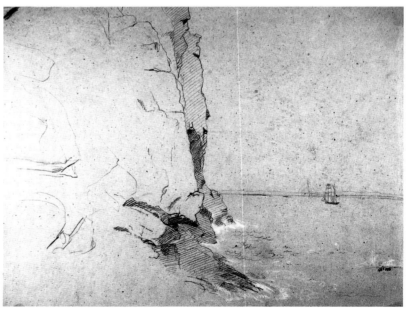

73. Frederic E. Church, *Mount Desert, Frenchman Bay* (*Cliffs on one of the Porcupine Islands*), early 1850s

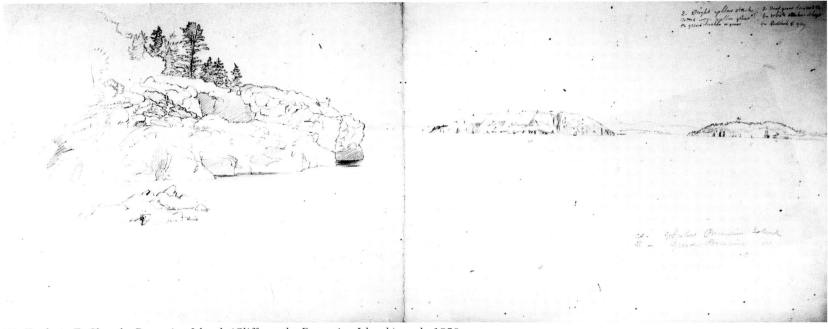

74. Frederic E. Church, *Porcupine Islands (Cliffs on the Porcupine Islands)*, early 1850s

As he moved to Bar Harbor itself, he was able to delineate the lumpy silhouettes of the Porcupine Islands extending eastward into the bay (fig. 74), views that attracted Cole before him and Xanthus Smith later (compare figs. 37, 148). As if telescoping his

75. Frederic E. Church, *Mt. Desert From a Distance*, mid-1850s

sight, Church sequentially drew the islands from afar and close by, [22] though a related series of sheets indicates he actually voyaged north across Frenchman Bay to the Sullivan and Hancock Point area for fresh observations of Mount Desert. Now looking southward, he produced some of his most beautiful and finished sheets, some using colored paper highlighted with broad passages of gouache for the bright clouds and reflections of light across the water (fig. 75). Clearly inspired by this vantage point, he returned to it again in 1851 and 1854 to produce similarly refined renderings (see fig. 92). While in Sullivan on the mainland, Church also explored the activities and sights nearby. One relatively detailed drawing depicts the local lumber mill, a subject that interested him elsewhere on Mount Desert (figs. 76, 77). Such vignettes were reminders of local industry and civilization, which intruded as well into Lane's serene images of lumbering on the coast. At the time of Thoreau's first trip to Bangor in 1838, the region was considered "the lumbering capital of New England."[23] Just as Church sketched the intimate and harmonious relationship between man's and nature's wooden structures, Thoreau, too, at Chesuncook meditated on the life of

76. Frederic E. Church, *Lumber Mill,
Sullivan, Maine,* 1850

77. Frederic E. Church, *Lumber Mill,
Mt. Desert,* early 1850s

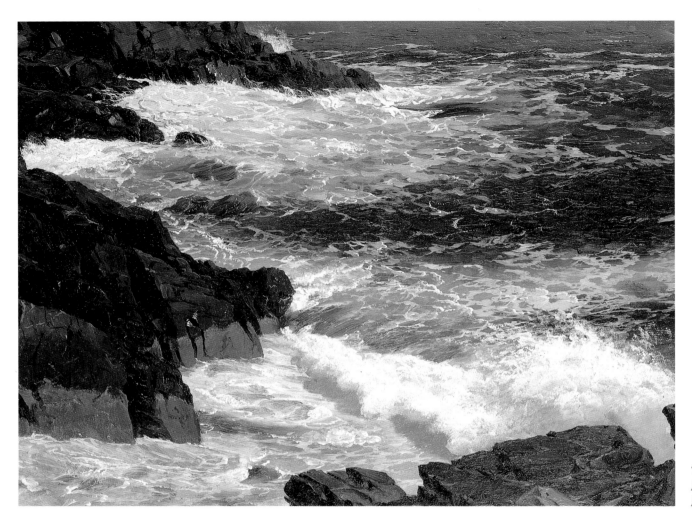

78. Frederic E. Church,
*Rough Surf, Mt. Desert Island,
Maine,* 1850

trees and the transformations of the woods at the hands of humans: "Strange that so few ever come to the woods to see how pine lives and grows and spires, lifting its evergreen arms to the light—to see its perfect success, but most are content to behold it in the shape of many broad boards brought to market, and deem *that* its true success."[24]

Lumber mills caught the attention of Cole on his 1844 visit, as they caught that of William Stanley Haseltine in the decade following (see figs. 37, 116). Thriving everywhere, they signaled the state's contribution to the larger midcentury prosperity of America. At the outset of his essay on "Ktaadn" in *The Maine Woods,* Thoreau observed, "There were in 1837, as I read, two hundred and fifty saw mills on the Penobscot and its tributaries above Bangor, the greater part of them in this immediate neighborhood, and they saw two hundred millions of feet of boards annually."[25] Local historians have noted that around Mount Desert were mills, most powered by water but some by steam, at Bar Harbor, Pretty Marsh, Salisbury Cove, Seal Cove, and Somesville. In Somesville alone by the 1830s there were a bark mill, a sawmill, a lathe mill, and a shingle mill; by the end of the 1860s the community list noted thirty-four house carpenters and thirty-seven ship carpenters and boat builders. Of the island's ten water sawmills the best were deemed to be those at Duck Brook in Bar Harbor, Heath's Stream in Seal Cove, and Somes Stream.[26] This last area would become especially familiar to Church, for he spent much of his two summer visits in 1854

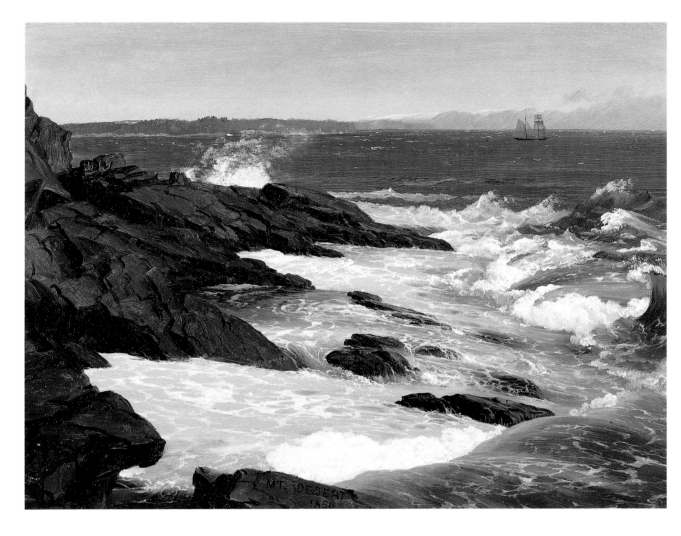

79. Frederic E. Church, *Fog off Mount Desert*, 1850

and 1855 sketching around that part of the island.

But in 1850 he devoted most of his energy to the landscape on the island's eastern side. Along with his extensive pencil work he produced a number of small and intense oil sketches, some so fully developed and polished that he legibly inscribed them in capital letters "MT. DESERT, 1850" (figs. 78, 79). Remarkably, these were on-the-spot efforts little more than a square foot in size, usually painted on primed academy board. Painted not far from where Cole had composed *Otter Cliffs* (fig. 35), these concentrated and vibrant images focus on the breaking surf along the ocean shoreline. Here at last Church had found the American equivalent of Achenbach's European seas, and painted them with a precision and palpability worthy of the German master. He had

seized on these circumscribed sections of ledges, and recorded them with extraordinary energy and directness, yet with great control and coherence. First, from the cliffs he looks down into the churning water, the spatial recession confined by cropping off the horizon at the top, so that we concentrate on the physical process of water moving powerfully back and forth against the rocks. Like his drawings of the cliff walls (fig. 70), this confrontation of liquid and solid, dark and light, stillness and motion, coalesces into a single, almost abstract design.

The second of this pair (fig. 79) Church considered strong enough to submit for exhibition when he got home to the Art-Union, where it was shown the next year as *Fog off Mount Desert*. Here he raises his glance to include a compressed view across the

80. Frederic E. Church, *The Old Boat (Abandoned Skiff)*, 1851

lower end of Frenchman Bay toward Schoodic Point, which is partially obscured by fog being blown in by a southeasterly wind. A sizable schooner is making its way into open, white-capped waters, giving scale to this compact format and enhancing the feeling of wild drama ashore and at sea. Particularly effective is Church's use of his salmon-colored ground, which subtly shows through the receding surf in the foreground to suggest the pink rock beneath the water, while also capturing the vaporous curtain of pearly fog in the distance. Through calculated changes in the thickness and direction of his brushwork, he is able to convey at an almost molecular level the structure and motion of nature's interacting elements. This small painting is a marvel of vision and execution, nearly effortlessly fusing immediate and intimate facts with grander forces.

Not only was Church enormously prolific at drawing during this first trip to Mount Desert; out of his accumulated sketches he was also motivated to produce, besides *Fog off Mount Desert*, several

other exhibitable canvases, one of which was greeted as a major breakthrough in his art. In 1851 he sent four works to the National Academy: *Lake Scene in Mount Desert* (fig. 81), *The Old Boat* (fig. 80), *Beacon, off Mount Desert Island* (fig. 87), and *The Deluge* (unlocated); he also exhibited at the Pennsylvania Academy of the Fine Arts *Otter Creek, Mount Desert* (fig. 82). In some ways *The Old Boat* was the most unusual work for Church in this period, with its implied narrative content in the abandoned skiff largely occupying the foreground, though the luminous background is related to his observations of atmosphere in *Fog off Mount Desert* and arose from direct experience. On occasion he complained that the fog was "the only drawback to the enjoyment" of Mount Desert's beauties, but always alert and resourceful, he was quick to take advantage here of an incoming fog bank: "We have just got to the edge of one, which, however, has not prevented our transferring to canvas an old hull of a boat and some rocks this morning."[27] With the distance blanketed in

81. Frederic E. Church, *Lake Scene in Mount Desert (Little Long Pond and Jordan Cliffs)*, 1851

impenetrable gray, Church gently plays in the foreground with the contrasts between the inert and the active rowboats and between the aging hull and the bright wildflowers around it.

Another oil followed directly from a drawing Church made near Seal Harbor, most likely soon after his arrival on the island: the view of Jordan Mountain and Little Long Lake, which was exhibited as *Lake Scene in Mount Desert* (fig. 81). Of Church's Maine pictures this is closest in spirit to Cole's late Catskill landscapes in, for example, the focus on a central mountain peak across the still surface of foreground water, rising trees framing either side, an expressive evening sky, and a long figure in the remote wilderness. Two of these key elements—the turbulent twilight sky and the man rowing a boat—are not in the original drawing, but lend a powerful emotional and anecdotal content to the finished painting. Church still had in mind his teacher's example of transforming the specifics of nature into a lofty spiritual message for his audience. The New York critics were a

little uncertain about this intensity in Church's work, and one kept his praise just for the right side of the sky, which "impart[s] a tranquillity to the whole scene—which the spectator would hardly have otherwise felt, yet which is essential to the proper impression of the landscape."[28] Although carefully placed figures appear in the foregrounds of other 1851 paintings, they subtly reveal Church's gradual loosening of Cole's pictorial formulas and his search for compositions and meanings of his own.

A related pair of images in this group makes clearer Church's emerging personal style. Along the southeastern shore of the island he found two views of the mountains particularly suitable for larger canvases, *Otter Creek, Mount Desert* and *Newport Mountain, Mount Desert* (figs. 82, 83), the first of which he exhibited in 1851 at the Pennsylvania Academy of the Fine Arts. There it had the descriptive title *Otter Creek and Mount Desert Island, Coast of Maine (Inland View).*[29] Both this and its companion, unlike the lake scene of Jordan Mountain to the west,

are spacious compositions and generally fresh in handling, closer in feeling to his oil studies of surf. Although it is a finished studio painting, *Otter Creek* has a bright, spontaneous touch and an unembellished directness of observation; the immediacy of the firsthand experience carries over into the distilled end result. The view looks north to the notch separating Mount Desert's highest summit, Green Mountain, and the adjacent peak of Dry Mountain (recorded by Cole as Big and Little Dry Mountains), one of the most picturesque vistas on the island. The unobtrusive farm buildings on the distant meadow, and the lad with his furled sail and rowboat in the foreground, speak of daily life.

For the related painting of Newport Mountain, depicting the island's easternmost hill, along with two of Church's favorite shoreline headlands, Schooner Head in the center middle ground

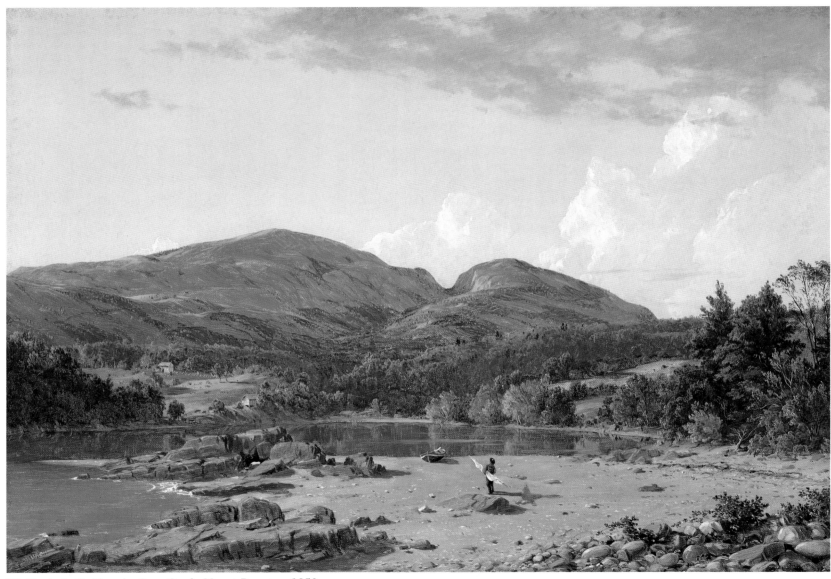

82. Frederic E. Church, *Otter Creek, Mount Desert*, c. 1850

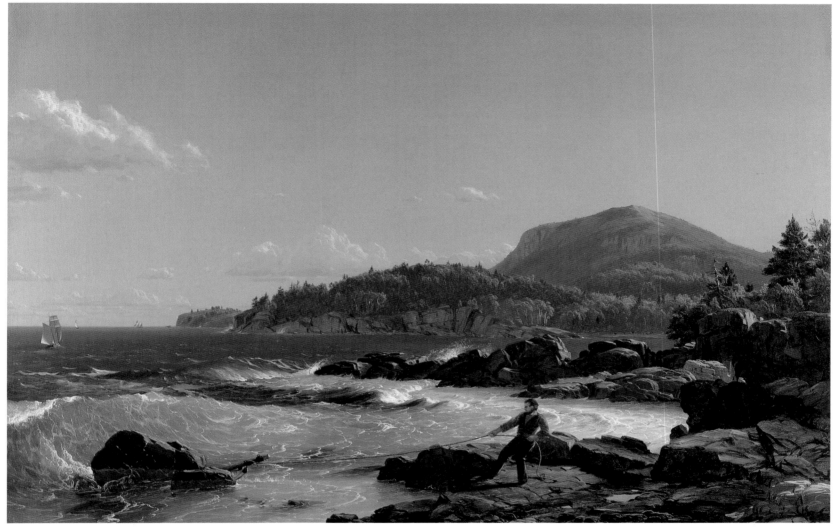

83. Frederic E. Church, *Newport Mountain, Mount Desert*, 1851

and Otter Cliffs in the left distance, he made several careful preparatory sketches during August and September (figs. 84 through 86). Like the Dry Mountain notch, the rhythmic contours of the slopes held a special visual appeal, and Church shifted his vantage point with each drawing to find the best balance between foreground rocks and background promontories. The final composition partially conflates and adjusts elements of the landscape, as different angles of view of the mountain and headlands are synthesized while still remaining true to the

specific place. As with *Otter Creek*, he has added human action to the natural drama. The vessels under full sail and the man hauling the remains of a mast ashore are reminders of the pleasures and perils of the sea, storytelling details that recall Cole's art but also parallel that of Lane (see fig. 44).

Although Church made numerous cloud studies during this excursion, they were executed on different occasions, for the most part independent of his compositional drawings; they were intended to be integrated into a landscape later as needed. This

84. Frederic E. Church, *New Port Mountain, Mt. Desert Island,* 1850

was the case with the twilight sky in *Otter Creek,* but here one feels that the brisk wind and dry air are accurate reflections of a clearing northwesterly, and completely characteristic of an early autumn day in northern New England. The final preparatory sheet for this picture specifically records the location, time, and foliage: "New Port Mountain, Mt Desert Island, Sep 12th 1850. Grey green moss not common. Nearly all the trees are birches—white stemmed." His precise notation of the date indicates that Church wished to recapture in his later painting the crisp, vivid colors of

the season, so evident here in the bright autumnal tints of the trees across the middle ground.

Some historians feel his two other major paintings of this season were also related, perhaps even more closely as intended pendants. One is *The Deluge,* now lost but known through preliminary compositional drawings. It was an explicitly biblical scene, ideal and universal, in contrast to the real, specific *Beacon, off Mount Desert* (fig. 87), by far the most important of his works to be shown in the 1851 New York exhibition.[30] The

85. Frederic E. Church, *Newport Mountain, Mt. Desert Island (Mount Desert Island from Great Porcupine Island)*, 1850

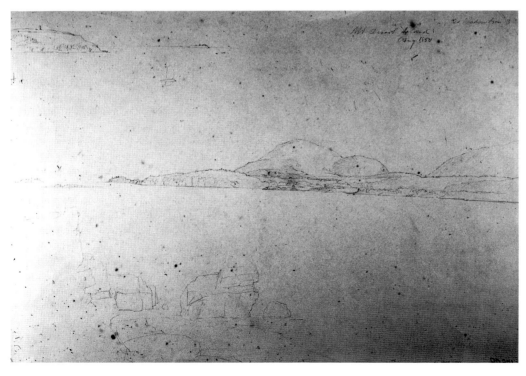

86. Frederic E. Church, *Newport Mountain, Mt. Desert Island (Mount Desert Island from Sheep Porcupine Island)*, 1850

87. Frederic E. Church, *Beacon, off Mount Desert Island*, 1851

culmination of his hard work from his first Maine trip, this directly parallels Lane's comparable accomplishment in his *Entrance to Somes Sound from Southwest Harbor* (fig. 50). But there are further links to Lane in the overwhelming red sky, even more than the convoluted lavenders of *Otter Creek*, suggesting its debt to the Gloucester artist's *Twilight on the Kennebec* of the previous year. Likewise, the balanced moods of the serene *Beacon* and turbulent *Deluge* are comparable to Lane's paired treatments

of Somes Sound and other marine subjects in their respective allusions to the stylistic modes of Claude Lorrain and Salvator Rosa. But Church appears to be looking in two directions here. The explicitly allegorical and moral content of *The Deluge* is almost an apprentice's last tribute to his instructor, while the bold austerity and meteorological accuracy of *Beacon* reveal a new spatial and emotional sensibility unfolding in the young master on his own.

88. Frederic E. Church, *Study of Schooners and Beacon Day Marker*, c. 1850

89. Frederic E. Church, *Fleet of Mackerel Fishers*, August 1850

A few preliminary studies in pencil and oil led, directly or indirectly, to Church's youthful triumph. The first is a delicate drawing of a dozen schooners sailing in various positions and conditions of light, including through the fog (fig. 88). At the lower center is an isolated sketch of the pyramidal stone daymark on East Bunker's Ledge off the entrance of Seal Harbor. Cole had noted this in passing on one sheet of his 1844 sketchbook, and Church may have recalled this signal marker as he first steamed up to the wharf at Seal Harbor. Situated on a small exposed ledge, it was an important guide into the safe waters of the great inner harbor of the island for vessels approaching from the east. To turn this relatively small and unprepossessing outpost into a major subject for an oil, Church needed to observe and record other phenomena during his time in this region. Looking at the Bunker's Ledge beacon from the shore, one's eye passes on to the uninterrupted eastern horizon. Church caught that consciousness of vast open space in another economical drawing made soon after his arrival at Mount Desert, *Fleet of Mackerel Fishers*, made on "Aug 19—Monday Morning" (fig. 89). For Church at midcentury, American expanses and expansiveness went hand in hand, and at Mount Desert for the first time he was able to experience and articulate both the clarity and the mystery of vast distances. He wrote to the Art-Union *Bulletin;* "From the highest peak. . . we could easily see Mount Desert rock, twenty-five miles off in the ocean; and the mountain on which we stood is seen sixty miles at sea. . . . Far out in the offing, the soft, hazy, blue floor of the ocean was studded with nearly a hundred white sails of fishing smacks."[31] In Church's remarkable pencil drawing with its one line drawn straight across the top of the sheet, we might be able to count some fifty tiny vessels silhouetted on the horizon; the artist noted that these were "about one half the actual number seen." This discovery of sheer space must have been critical to his conception of the oil. In this exercise, at once physical and mental, Church reflected an expression of Emersonian transcendentalism: "The health of the eye seems to demand a horizon."[32] Elsewhere Emerson asked, "is it the picture of the unbounded sea, or is it the lassitude of the syrian summer, that more and more draws the cords of Will out of my thought[?]"[33] Church the painter and poet pondered the same challenge, and succeeded in finding a memorable visual language for describing American space and light.

The last element Church needed to set the course for his work in the studio after his return from the coast was his observation of clouds and sky, as potentially dramatic and expressive as the lone beacon facing an expansive universe. This he found not far from the place where he had made oil studies of the waves near Otter Cliffs, looking eastward across Frenchman Bay (fig. 90). Facing generally the same direction, he recorded a glowing dawn sky along the entire Schoodic peninsula (fig. 91); historians have consistently cited this small but intense oil sketch as the genesis for the impressive later canvas, where nearly the same cloud and light formations fill the painting's upper third (fig. 99). In looking east, Church could celebrate the idea of unfolding promise in both the open horizon and the glorious beginning of a new day. Even more precisely, he depicted the *starting* moments of sunrise, when its yellow light first pierces the clouds on the horizon and turns to shades of pink and lavender the undersides of cloud masses in the lightening sky. The viewer is still earthbound, in relative darkness. In the distance a few vessels seem barely to move, and only the wheeling gulls around the beacon and the gentle surf on the ledge hint of life just beginning to stir the silence.

Of all Church's Maine pictures hung in the 1851 New York exhibition, *Beacon* was the topic of the most excited praise. While some argued over the merits of a morning versus an evening sky, one concluded that "he is to show in the splendid play of the light, and air, and clouds, that which we do not see, or seeing, do not perceive."[34] A second reviewer admired the faithfulness of expression in this "charming work—worth almost as much in the sensations it produces, as a visit from the hot city in August to the still, cool seaside."[35] Another astutely sensed the elegiac touch in Church's lonely vista: "As the spectator looks, he muses, and the sea and the shore and their eternal mystery and sadness gather in his mind."[36] This hint of melancholy underlying the celebratory expansiveness of American geography was to create an increasing tension in the subsequent sunset pictures inspired by visits to Maine later in the 1850s (see figs. 97, 99).

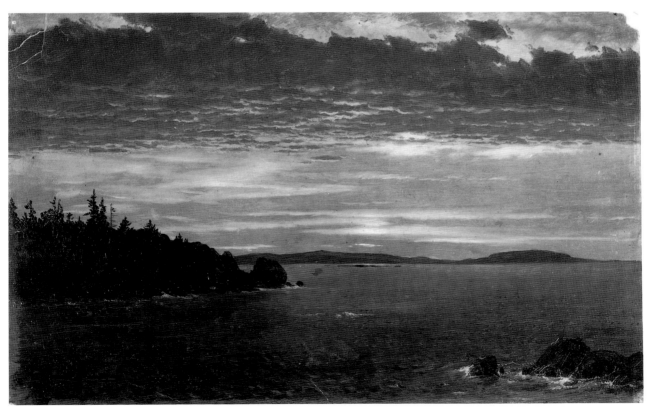

90. Frederic E. Church, *Mt. Desert*, c. 1850

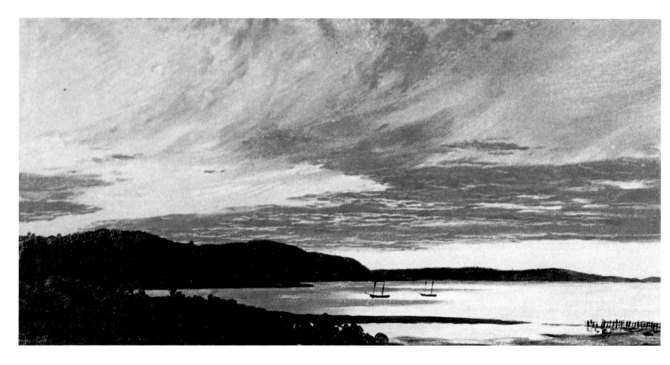

91. Frederic E. Church,
Sunset, Bar Harbor, 1854

But the critical consensus regarding *Beacon* was that it was "deservedly one of the most popular in the Gallery" and "a strong and truthful picture."[37] Church now merited comparison with Turner as "a devoted student and artistic delineator of the peculiarities of atmospheric phenomena." Above all, his audience recognized, he had created a new kind of imagery for Americans—one that now decisively surpassed Cole's way of seeing—whereby "the whole illimitable expanse of sky and ocean is opened to your astonished eyes."[38] With this achievement and its critical success, Church had learned how to translate his observations of sunlight's most delicate hours into finished paintings of great resonance. At the outset of the 1850s he saw the possibilities of America, perfectly served by an inspiring sunrise. By the end of the decade he found the flares of evening's last light more suited to the mood of a nation on the threshold of crisis (compare fig. 99). As the country attempted to make the tense political compromises of the mid 1850s, and the image of "Bleeding Kansas" foretold the spilling of the nation's blood by 1860, Church returned to Maine and worked on a sequence of sunset pictures, each more passionate than the last.

His second visit to the Maine coast in August 1851 took him first to the further reaches of Grand Manan Island in the Bay of

Fundy. A large island like Mount Desert, this was even more isolated; it lay several miles offshore in the southern reaches of the Bay of Fundy beyond the Maine border. Along its southwestern end, towering, sheer cliffs two to three hundred feet high rose up from the rocky beaches, which were made all the more stark when the tide rushed out and dropped nearly fifty feet. Although Church did not make extensive drawings here, the place strongly impressed him, and it generated the idea for two coastal paintings he executed the following year. From here he traveled inland to visit Mount Katahdin for the first time, which also captivated his attention; this led both to a follow-up trip the next year and to an important oil shortly thereafter. During October he moved down to Mount Desert, as if to reaffirm some of the major impressions he had accumulated during the previous autumn's visit. This time there seemed little need for further extensive sketching, and only a few dated drawings of the island are known from this trip.[39]

He visited Maine again in 1852, though his only documented destinations were Grand Manan Island and Mount Katahdin. He almost certainly passed by the Mount Desert area on one or another leg of his trip, and three related marine paintings resulted from these excursions: *The Wreck* (Parthenon, Nashville), *Coast*

92. Frederic E. Church, *Part of Frenchmans Bay near Sullivan*, 1854

93. Frederic E. Church, *Road at Somesville*, 1854

Scene (private collection), and *Grand Manan Island, Bay of Fundy* (Wadsworth Atheneum). All three devote primary attention to the dramatic light and cloud effects of dawn or twilight, as settings for man's small presence along the rugged coast. The specific locations in two of the canvases are not identifiable, but appear to be composites of the scenery he had observed at both Grand Manan and Mount Desert. With these works, especially *The Wreck*, Church earned high praise from the New York critics. He was now "without doubt the first of our marine painters."

> The highest triumph we remark in Mr. Church's marines is the *solemnity* of the sea. . . . through and above all the fine detail of Mr. Church, which no one surpasses, his pictures have a broad and grave character—a meaning—a thought which elevates them from sea-pieces into works of art. . . . Whoever has been overtaken by nightfall upon the shore . . . has had that feeling of pathetic solemnity in the ocean of which Mr. Church, this year, and the last, has shown himself the Poet.[40]

Relatively little is recorded of the artist's first trips to the Katahdin area, except that he had the guidance of "a squad of lumbermen."[41] While travel to other exotic destinations took up much of the following year, Church did complete a summary picture of these early experiences in the north woods. *Mount Ktaadn (Katahdin)* (Yale University Art Gallery) depicts a gentle twilight sky over the great ridged peak. A friend later recounted that for the artist these were the "days when he was probing New England for the picturesque,"[42] and this painting evolved in part from that search. By virtue of its remote location, difficult access, and rugged physical character, the scene, as Thoreau had described it and as Church discovered, held all the characteristics of the sublime experience. The distant and upper parts of his composition reflect this, while the foreground embodies the softening touches of the picturesque. Back in his studio, Church domesticated the wild landscape by including the farm, country road, stone bridge, cattle, and resting youth. Seated beneath the gentle forms of the overarching trees, he contemplated, historians assert, man's accommodations with nature, the benevolent promises of the daily cycle, and ambitions for the future. Like *Beacon, off Mount Desert* this painting is about looking far and thinking big. As Emerson said, "We are never tired, so long as we can see far enough."[43] Much of Church's actual trip, it turns out, consisted of "wet and ineffective

days in the dripping woods,"[44] which may have only stimulated his imagination further and led to the emotional and pictorial embellishments we see in his finished canvas.

During these years Church energetically expanded his own travel horizons with strenuous excursions north to the Arctic and south to the equatorial mountain ranges of South America. His vision of America came to embrace not just the geography of the United States but the larger continental reaches of the Western Hemisphere. Fresh in mind were his readings of the early-nineteenth-century natural scientist Alexander von Humboldt, whose influential publication *Cosmos* was widely available in English by midcentury. This described the German's own pioneering explorations of South America, and contributed to the popular theory called geographic determinism, whereby the distinctive climate and geography of an area was said to condition its eventual national character and development. Such theories of civilization well suited the aspirations and self-confidence of America at this moment, and in this spirit Church set forth to follow in Humboldt's scientific and intellectual footsteps. Very much a New Englander and a northerner at a time when the state of the nation was increasingly unsettled, Church returned to Maine to continue refining his perceptions of America's strengths and virtues. His imagery of the northern wilderness in the mid and late 1850s took on a greater stridency and urgency. His paintings, like Lane's, began to assume a more universal character, based on actual places but enhanced by synthesizing observations and ideas.

Eighteen fifty-four found Church back at Mount Desert, sketching north of the island on the mainland and also around the secluded areas near Somesville, where he was probably based. Few drawings document this visit, though two are especially attractive in their refined drafting, record of textures, and variations of darks and lights, including the use of white chalks and gouache (figs. 92, 93). On his sketch of a woodland road at Somesville he made elaborate notations about light effects and the different colors of the pines and maples. This same September he also drew, in a series of sheets, the cloud outlines of twilight skies, most with extensive color observations. The accompanying descriptive paragraph on one begins "A suggestive arrangement of the sky,"[45] while another suggests a more carefully worked-out panorama in anticipation of further development (fig. 94). The

94. Frederic E. Church, *Twilight, Bar Harbor* (*Sunset, Bar Harbor*), 1854

"rich orange," "brownish purple," and "splendid silvery blue" appear throughout the jigsaw patterns of the sky above the mountains overlooking Bar Harbor. Two silhouetted schooners are at rest in the "sky reflections" of the bay, "ruffled by wind." Either then or the following summer Church codified these color observations in a nearly identical oil sketch (fig. 91), which in turn led directly to the sky in his next major Maine canvas, *Sunset,* 1856 (fig. 97).

Another year and another trip to Mount Desert intervened before he was fully ready to execute this canvas. In the summer of 1855 Church traveled to Mount Desert in a large group, which included Charles Tracy, a lawyer from New York, and the Reverend Mr. Stone from Brookline, Massachusetts, along with their families, Church's sister, and his friend, the writer Theodore Winthrop. They took steamers from Boston to Rockland and to Southwest Harbor, and stayed for a month at the Somesville Tavern.[46] Winthrop was an important figure in the artist's life at this time, for the two journeyed together again the next year to

95. Frederic E. Church, *One Hour After Sunset* (*Moonrise, Mount Desert Island*), mid-1850s

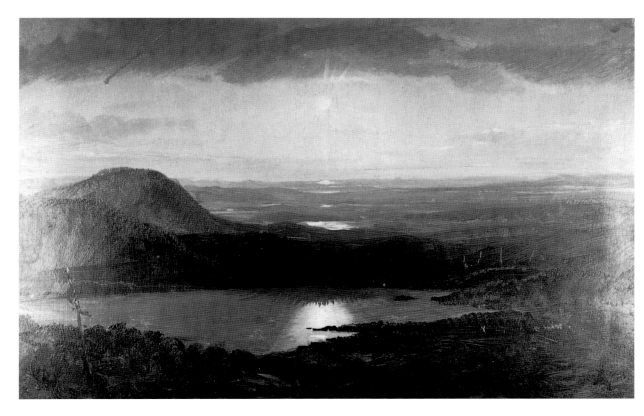

96. Frederic E. Church, *Sunset Over Eagle Lake*, 1850s

Mount Katahdin, and the author later published an eloquent account of their trip with verbal imagery fully equal to Church's visual impressions. This promising career abruptly ended with Winthrop's death during the first year of the Civil War. At Mount Desert the artist continued his studies of the twilight hours, now expanding his inventory of pencil and oil sketches (fig. 95, 96). Typical are an oil study of the late afternoon sun's reflections falling over Eagle Lake and a pencil drawing marked "one hour after sunset" that looks at the "Reflection of Moon rich warm yellow in fine contrast to dark bluish water." Whether from a gradual shift in meteorological observations or from a change in emotional outlook, Church was now fixed more on day's end than on its beginning, and *Sunset* (fig. 97) embodies the state of his mind and his travels in the middle of the decade.

The 1856 venture to Katahdin with Winthrop crystallized his feelings: "We both needed to be somewhere near the heart of New England's wildest wilderness."[47] For Church this return visit allowed him to contemplate the essential duality of Maine's

remote landscape, its stark mountain peaks and its rugged waters, and *Sunset* records the tension between them. The painting is a composite of memory and experience. Church was revisiting the mountain he had painted three years before, and its sharp isolation ("the distinctest mountain to be found on this side of the continent")[48] was strongly in his mind. To him—and to anyone who goes there—Katahdin seems "large and alone."[49] In addition, his recent cloud studies of sunsets prompted him to summarize the expressive possibilities he felt could be realized in the burning colors of this hour. Winthrop reported that Church had "an eye for a sunset. That summer's crop had been very short, and he had been for some time on a starvation-allowance of cloudy magnificence."[50] But for both men's pencils the heavens produced powerful effects:

To the cloud-forms modelled out of formlessness the winds gave life of motion, sunshine gave life of light, and they hastened through the lower atmosphere, or sailed lingering across the blue breadths of mid-heaven, or dwelt peacefully aloft in the regions of the cirri . . . they

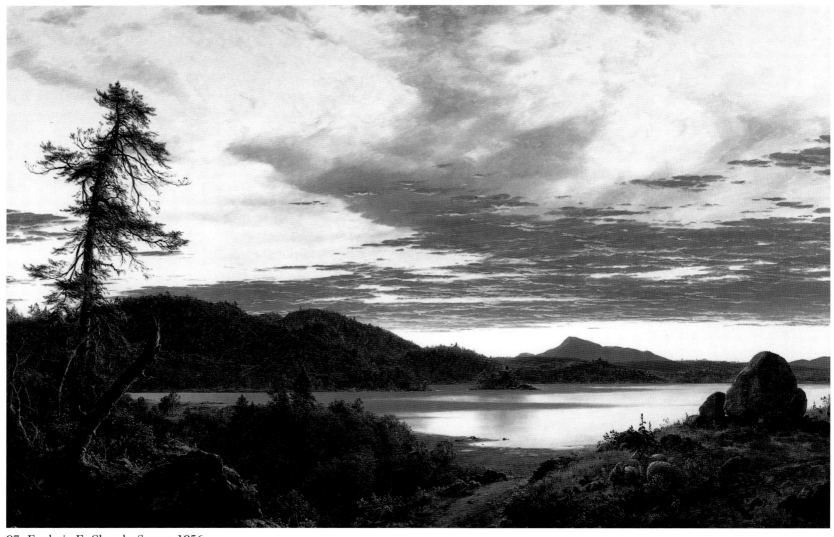

97. Frederic E. Church, *Sunset*, 1856

were still the brightest, the gracefullest, the purest beings that Earth creates for man's most delicate pleasure.[51]

The painter set down the flares of twilight over Katahdin "with cabalistic cipher,"[52] but when he later worked up the composition in his studio, he combined this intensity of the moment with the twilight configuration observed a year or so earlier at Bar Harbor. This synthesis was a compositional solution, but it also suggests Church's desire to make larger connections.

Church wanted to link vast stretches of the continent, to cast his eye across great distances, to join the elemental powers of rock and air and water. Winthrop wrote of seeing Katahdin, a "fair blue pyramid . . . still many leagues away," and from its height the island of Mount Desert "far away on the southern horizon."[53] Physical sight lines joined conceptually in his painting. One or more of Church's recent Mount Desert drawings may have contributed to the final composition. Although it is not dated, a

sketch titled *Lake at Mt. Desert* (fig. 98) bears a general similarity to the view in *Sunset;* significantly, at the top Church indicated that he was facing south. The drawing looks like a view across Eagle Lake, with the rounded summit of Pemetic Mountain at the left and the Bubbles at the center right. The painting translates the far peak into the sharper configurations of Katahdin's ridges, while the more rounded hills, glacial boulders, and sunset remain grounded in the Mount Desert landscape.

Church was making leaps of geography and of the imagination. Not only did this painting fuse his grandest ideas of Maine to date; it also proclaimed the active promise of American geography. Like Thoreau and Emerson, Church saw the act of looking to the horizon not just as a physical exercise but as a metaphor for forward-looking possibilities:

Beautiful, beautiful, beautiful is drawn in the woods. . . . All its golden glow of promise is tender and tenderly strong, as the deepening passions of a dawning love. Presently up comes the sun very preemptory, and says to people, "Go about your business! Laggards not allowed in Maine! Nothing here to repent of, while you lie in bed and curse to-day because it cannot shake off the burden of yesterday; all clear the past here; all serene the future: into it at once!"[54]

From the slopes of Katahdin, Church and Winthrop found another view uplifting: "Not that it makes a Maine less, but that it makes a man more. . . . Up in the strong wilderness we might be re-created to a more sensitive vitality."[55] Both the written account and the visual record touch recurrently on the themes of spiritual renewal and hopefulness. Despite the growing strains in the

98. Frederic E. Church, *Lake at Mt. Desert,* mid-1850s

nation at mid-decade, Church's sunset is not yet a mourning picture; it still holds out the promise of a clear and bright day on the morrow. Yet more than either the dawn of *Beacon* or the twilight of *Mount Ktaadn*, this 1856 image of evening possesses a certain tension and anxiety. Church's cadmium reds, yellows, and oranges, formerly used in more harmonious sequences, now strain in abrupt transitions and contrasts. Historians have hesitated over Church's apparent conflict between the cluttered foreground and the austere distance, and between factual experience and allegorical program.[56] In fact, the cold, shrill edge to this picture hints at an ambivalence that Church expresses even more directly in a sunset painting four years later, *Twilight in the Wilderness*.

There appear to be multiple sources and impulses for this masterpiece of 1860 (fig. 99), and more than a few layers of meaning embedded in it. As we have seen, Church had been studying and sketching the conditions of sunrise and sunset for a decade, both on the coast and inland, so there was an expanding language of forms within his own work from which to draw. There were the remembered precedents of Turner's fiery skies as well as (quite probably) the later twilight pictures of Lane sent to New York for exhibition. There were Theodore Winthrop's extensive accounts of evening skies on the Katahdin trip: "Just before sunset, from beneath a belt of clouds evanescing over the summit, an inconceivably tender, brilliant glow of rosy violet mantled downward, filling all the valley. Then the violet purpled richer and richer, and darkened slowly to solemn blue. . . . Such are the transcendent moments of Nature, unseen and disbelieved by the untaught."[57] Three summers later, in 1859, the Reverend Louis Legrand Noble, friend and biographer of Thomas Cole, accompanied Church on an expedition along the coast of Newfoundland and Labrador, in search of exotic subjects to paint. In a way, this trip was an extension of the previous Maine visits, to explore the extremes of ice in contrast to fire, a step further into the remote, severe wilderness. Again the artist and his companions witnessed dramatic sunsets, and Noble's voice kept the imagery in Church's mind:

> All that we anticipated of sunset, or the after sunset, is now present. . . . The west is all one paradise of colors. . . . Close down along the gloomy purple of the rugged earth, beam the brightest lemon hues, soon deepening into the richest orange with scattered

tints of new straw, freshly blown lilacs, young peas, pearl and blue intermingled. Above are the royal draperies of the twilight skies . . . edge with flaming gold, scarlet and crimson as deep as blood; plumes tinged with pink, and tipped with fire, white fire. . . . The painter gazes with speechless, loving wonder, and I whisper to myself: This is the pathway home to an immortality of blues and beauty.[58]

As a consequence of this voyage, Church began a monumental canvas later that year, and by the following summer needed to return to Mount Desert to make further studies of water (as he had a decade earlier) in order to finish his foreground accurately. At the same time, other voices in America were expressing the sensations aroused by the flaring lights of day's end. In *Moby Dick* (1851), Melville's chapter titled "Sunset" contains these evocative lines: "The warm waves blush like wine. The gold brow plumbs the blue. The diver sun—slow dived from noon—goes down; my soul mounts up!"[59] With *Leaves of Grass* in 1855, Walt Whitman joined Church in seeking to embrace the cosmos, including the skies: "Give me the splendid silent sun with all his beams full-dazzling." Writing before the outbreak of civil strife, the poet could still envision a unifying national sky: "No limit, confine— not the Western sky alone—the high meridian—North, South, all, Pure luminous color fighting the silent shadows to the last."[60] This tone matches the calmer and more optimistic visions depicted by both Lane and Church during the middle of the decade, but the heightened stridency of *Twilight in the Wilderness* appears to reflect the more turbulent national mood in 1860.

Church's biographers have cited as well the possibility that a specific recent sunset in New York was a final stimulus to his undertaking the large canvas.[61] There is no question that precise meteorology is at work in the painting, along with symbolic allusion. But its timing also brings us back to the historical moment, when slave states and free soil had brought the issues of geography and national identity to the point of explosive conflict. For one familiar with the theories of geographic determinism, Church could well have had in mind an association between a spectacular hour of climatic change and a critical time in the country's fortunes. So powerful was the painting in its day, as it is in ours, that from its first reception it has held a range of meanings. A substantial body of literature exists discussing this work; the grand visual symphony reverberates with an overlay of

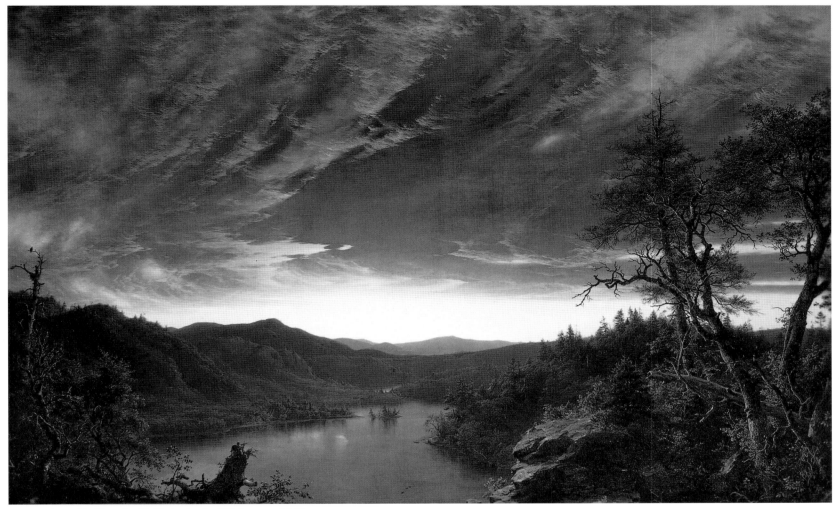

99. Frederic E. Church, *Twilight in the Wilderness*, 1860

historical, religious, and scientific associations. Together they suggest a transforming event.

From Church's own hand we know he invested nationalist meaning in this sky, for the next year he painted a small oil, and reproduced the image as a chromolithograph for wider circulation, of *Our Banner in the Sky* (collection of the Olana State Historic Site, Hudson, New York). From a lone tree silhouetted against the night sky waves the pattern of the Stars and Stripes in the star and cloud formations above. Church was an ardent Unionist, and followed political events closely in this opening year of the Civil War. It was not difficult for him to move from explicit observation of sunsets at Mount Desert to a fiery twilight now set in a generalized American wilderness, bearing the signs of impending change. Although Church proclaims the rightness of the Northern cause and an American landscape of united states, his painting, executed just as division loomed, has evoked differing interpretations. On the one hand we may read it as heroic and triumphant, a call to union; on the other, it can be seen as apocalyptic and prophetic, warning of loss and tragedy. Knowing Church's capacity for embracing distances, ambivalences, even

opposites, we can see that his picture sustains both readings. More than any sunset he painted before, it does convey a feeling of this day's end as something explosive rather than reassuring and hopeful.

The national crisis raised the question whether America was the new Eden, as had been believed, at the moment of Genesis, or whether it was at the Apocalypse facing the Day of Judgment. Nationality and spiritual destiny are both present in two critical details here: the bird perched on the tree at the left and the protruding tree stump at the lower center. The former is an American eagle, perhaps a combined reference to the national symbol, to Cole's bird in the foreground of *Frenchman's Bay* (fig. 38), and to Saint John suffering in the wilderness or Elijah in the desert. If one looks closely at the ragged tree stump, it can be read as the form of a figure praying before a small cross, a Christian motif Church introduced in a number of other works. For example, a cross explicitly appears in the foreground of *To the Memory of Cole*, 1848 (Des Moines Women's Club, Iowa) and *Heart of the Andes*, 1859 (Metropolitan Museum of Art), and more suggestively in the shadow cast by the figure carrying a sail in the foreground of *Otter Creek* (fig. 82).

Church's sky derived from his several previous studies of sunset at Bar Harbor, reworked in such major canvases as *Mount Ktaadn* and *Sunset;* oil sketches such as *Twilight, A Sketch,* 1858 (Olana State Historic Site), and *Sunset,* circa 1858–1860 (private collection, Washington, D.C.); and cloud drawings done at Mount Desert in July 1860.[62] According to meteorologists, the thin clouds sweeping across the sky in *Twilight in the Wilderness* are high in the atmosphere, and belong to a major weather front moving through, likely accompanied by thunderstorms, before a clearing takes place. This impending change of barometric pressure signals yet another powerful element of transition. Viewers at the time certainly understood the accuracy of observation:

> The time is about ten minutes after the disappearance of the sun behind the hill-tops. The air is clear and cool; the whole of the landscape below the horizon lies in transparent shadow; but the heavens are a-blaze. . . . From this clear zone of tender light the clouds sweep up in flaming arcs, broadening and breaking toward the zenith, where they fret the deep azure with the dark golden glory.[63]

But there is another association likely at work here: Charles Darwin's *On the Origin of Species,* arguably the most traumatic agent of intellectual upheaval of its day. It was published in England on 24 November 1859, and all copies of the first edition were sold out that day.[64] Immediately available to and read by Americans as well, this volume brought about an instant scientific revolution, upsetting the theology of nature and introducing the realities of chance, accident, struggle, and cruelty. In one year Darwin's theses overturned the optimistic determinism Church had followed in Humboldt. "Natural selection" and "survival of the fittest" have become commonplaces, but in that year they were statements of a hard-nosed challenge to existing ideas of the natural order. These ideas were as profoundly transforming as the concurrent political contests in American society. In both cases change might be powerful and inevitable: "When we reflect on this struggle, we may console ourselves with the full belief, that the war of nature is not incessant, that no fear is felt, that death is generally prompt, and that the vigorous, the healthy, and the happy survive and multiply."[65]

Isolation, competition, adaptation, and uncertainty are watchwords throughout the treatise, and Darwin added that "we do not know how ignorant we are." This pessimism recurs: "More individuals are born than can possibly survive. A grain in the balance will determine which individual shall live and which shall die."[66] Though Church may not have explicitly had in mind Darwin's lines from the chapter on natural selection as he painted the stark foreground trees in *Twilight in the Wilderness,* the verbal and visual passages are kindred in spirit: "We here and there see a thin straggling branch springing from a fork low down in a tree, and which by some chance has been favoured and is still alive on its summit."[67] With this painting Church created a work of art that addressed the deepest aspirations and anxieties of its day. Its genesis had been the Maine wilderness, and Mount Desert particularly. While holding that experience at its heart, the painting ultimately envisioned a transformed place and time, one tempered by the boldest acts of imagination.

Church at last had realized his fullest expression of Mount Desert scenery. During the late fifties and early sixties he was also at work on a number of other major canvases, including *Niagara,* 1857 (Corcoran Gallery of Art), *Heart of the Andes,* 1859 (Metropolitan Museum of Art), *The Icebergs,* 1861 (Dallas

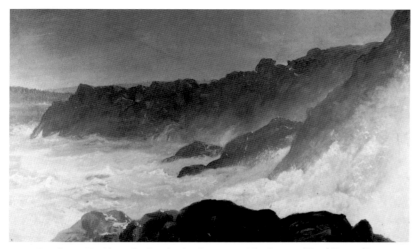

100. Frederic E. Church, *Study for Storm at Mt. Desert (Surf Pounding Against the Rocky Maine Coast)*, mid-1850s

Museum of Art), and *Cotopaxi*, 1862 (Detroit Institute of Arts), all the result of extensive traveling. During the war years the travel diminished somewhat, and family life as well kept him closer to home in New York. During 1862 he returned to Mount Desert in the company of the Reverend Mr. Noble, and made some new oil sketches of the surf along the island's southeastern coast in preparation for a new large canvas (figs. 100, 101). Most of these sketches are undated, and could belong to almost any of his earlier trips. One traditionally assigned to the first visit in 1850 is one of the earliest and most fully worked out sketches (fig. 100) in oil of the rocky cliffs he would paint in the large finished work of 1862. Usually described as depicting the area of Otter Cliffs,[68] it seems more like the shore Church explored in great detail looking

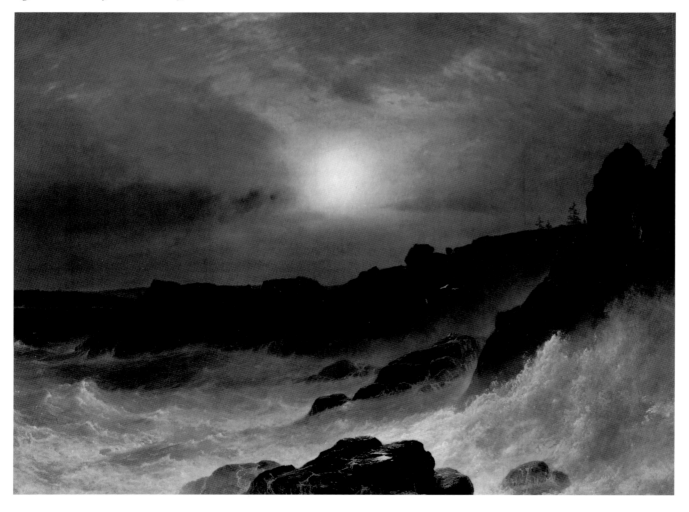

101. Frederic E. Church, *Storm at Mt. Desert (Coast Scene, or Sunrise off the Maine Coast)*, 1863

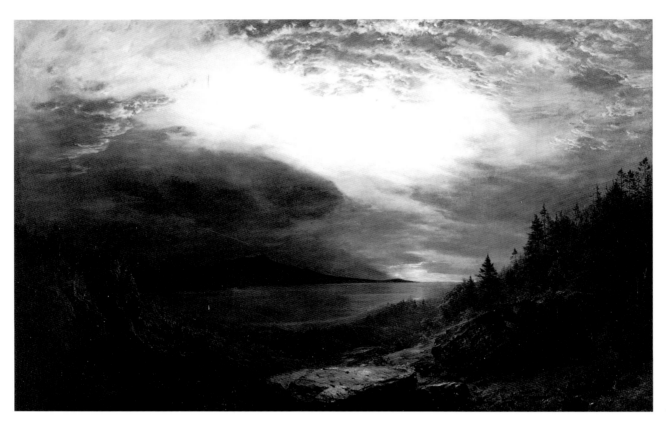

102. Frederic E. Church, *Mt. Desert Island, Maine*, 1865

south from the Lynam Farm at Schooner Head, with Great Head in the distance. Painted on the prepared salmon-colored ground he often employed, it is particularly strong in its fluid brushwork, which defines the faceted planes of rock and the varied shapes of the outcrops receding along the shore. Other oil sketches more clearly show the rising cliff walls of Otter Cliffs,[69] and one almost certainly dating from this excursion defines fully the composition of the large painting to follow (fig. 101). Somewhat arbitrarily telescoped in the background at the far left are the indistinct forms of the Cranberry Islands extending to the south off Seal Harbor. Probably due to confusion arising from the changing titles this picture has been given, specifically mistaking it for the sunrise view of his *Grand Manan Island, Bay of Fundy* from a decade before (also in the collection of the Wadsworth Atheneum), *Coast Scene* has sometimes been incorrectly called *Sunrise off the Maine Coast*. The only way this could show an early morning sky would be if it looked south along the island's eastern shore, in which case one would see only open water, with

no islands or coastline visible in the left distance. In terms of conception and physical location this makes far more sense as a stormy late afternoon sky, with our vantage point the southern coast looking west across the Otter Cliffs headland. Given Church's shift of interest to evening subjects in the later 1850s, and the traumatic conflicts at the height of the Civil War, a scene of veiled illumination and battering forces seems to match perfectly the artist's and nation's mood at this time. The contrast with the more benign surf and optimistic light Church painted a decade earlier in *Fog off Mount Desert, Otter Creek* (figs. 79, 82), and *Grand Manan Island* could not be clearer.

Lacking the glorious call to arms visualized in *Twilight in the Wilderness, Coast Scene* has attracted less interpretive scrutiny. In part because the earlier picture seems so open to resonant meanings for its day as well as ours, to Church's biographers the second "seems no special augury. Rather, it is the image of the exuberant and rugged vitality of New England nature which has helped make New Englanders what they are."[70] No doubt we are

witnessing the firsthand observations of a gathering storm churning up the seas and darkening the sun. But since it was painted in one of the most violent years of the Civil War, one especially threatening to the Union cause, it suggests Church quite consciously chose the subject of nature's forces doing battle with one another. For the same reasons, the image of the South American volcano Cotopaxi, which he painted in 1855 (National Museum of American Art), shows a serene and domesticated landscape, whereas that of 1862 (Detroit Institute of Arts) explodes in lurid combat, dominated by billowing black smoke and molten reds and oranges across the earth and heavens. The second unmistakably belongs to an America at war with itself and a world unsettled by the harsh assaults of Darwinism. This is why Lane's *Thunderstorm off Owl's Head* seems to be an augury, and why oppressive storms become such an obsessive subject for Church's friend Martin Johnson Heade throughout the early and mid-1860s. Like both Lane and Heade at this time, Church moved toward horizontality in his paintings, with light and atmosphere taking up most of the compositions, and their associations conveying the passions of the hour.

Two years later, with the conclusion of the Civil War, many American artists, including Church, gratefully turned to imagery of thanksgiving and reconciliation. Most often cited are Jasper Cropsey's *Wyoming Valley*, 1865, George Inness's *Peace and Plenty*, 1865, Winslow Homer's *Veteran in a New Field*, 1866 (all Metropolitan Museum of Art), and Church's *Rainy Season in the Tropics*, 1866 (Fine Arts Museums of San Francisco). Across the landscape of bright greens and yellows in this last work arches a perfect full rainbow: light is now a symbol of forgiveness, harmony, and redemption. In the same spirit he painted a final picture of Mount Desert in 1865 (fig. 102), which has been treated less kindly by the artist's chroniclers, partly because it seems contrived and sentimental in contrast to its heroic predecessors: "The sky is marked by a turgid formlessness . . .[it] even borders on the maudlin."[71]

Significantly, Church did not revisit the island at this time, but conceived in this work a memory image summarizing his own experiences of the place in the emotional light of the present. His skies, so rigorously observed and organized in previous compositions, here have a more fluid and generalized appearance. Presumably, we come upon the scene like the lone deer emerging from the woods at the right, witness to the clearing after a storm. No longer is Church viewing a precise and identifiable place. The location is unclear: are we standing *on* the island in the foreground and looking toward an exaggerated Schoodic Point across Frenchman Bay, or are we in some imaginary foreground looking *at* the eastern terrain of Mount Desert? Either is plausible. Later in 1865, Church exhibited the canvas at the National Academy of Design as *Twilight*, which makes this an impossible and invented vantage point. Frequently New York reviewers argued about which time of day Church was depicting, and it is possible the name was not his designation. The only discernible section approaching identification is the distant promontory, and this remains a vague composite of Newport Mountain extending to Great Head and the Schoodic Point headland (compare figs. 83 and 90). But in both cases we are looking east, and with the country at peace again, the clearing light of sunrise seems most plausible.

Church's artistic fortunes began to change as this decade wore on, and the taste for his spirited nationalist art started to wane. He turned to other subjects, such as the ancient world of the Mediterranean and Middle East, and to the building of his own landscape in his house and studio in the upper Hudson Valley. The northern Maine woods lured him back regularly for camping during the late 1870s. This last formal painting of Mount Desert reflects a state of mind more than geology; it is poignantly nostalgic for a better world and time. Still, he walked in Thoreau's footsteps through the Maine forest: "If I wished to see a mountain or other scenery under the most favorable auspices, I would go to it in foul weather, so as to be there when it cleared up; we are then in the most suitable mood, and nature is most fresh and inspiring. There is no serenity so fair as that which is just established in a tearful eye."[72]

VI.

William Stanley Haseltine

L ANE AND CHURCH were the major artistic figures painting at Mount Desert during the 1850s; William Stanley Haseltine (1835–1900) was the most prominent and productive artist to follow them. Other important Hudson River school colleagues had visited the island in these years, but no substantial work by them is known. It is probable that the two artist companions with Church on his first trip in 1850 were John F. Kensett and Regis Gignoux.[1] In recounting Lane's visit that summer, Joseph Stevens made note of Kensett's presence "in another part of the island."[2] At some point Albert Bierstadt, an artist who had studied in Germany and traveled through Europe with Haseltine, also visited Mount Desert. So did Charles Temple Dix, another friend of Haseltine's and a painter in the same German-influenced style, who journeyed with him to Maine in 1859. Along with Bierstadt, Kensett, and Church, Haseltine by 1858 had quarters in the Studio Building in New York City;[3] it would be fascinating to know more about their likely discussions and possible travel together to the New England coast.

For his part, Haseltine came well prepared and stimulated to paint the coast, though for no clear reason he executed few finished oils of Maine (in contrast to numerous paintings of the Narragansett, Rhode Island, and Nahant, Massachusetts, coastlines), but he did produce more than two dozen large and impressive drawings in pen, pencil, wash, and watercolor. Because almost all of those go beyond hasty plein air note taking and in many instances exhibit a studied completeness, Haseltine may have regarded them as polished graphic pictures approaching the compositional resolution and presentability of studio paintings. Always central to Haseltine's art was his extensive training in drawing, first in Philadelphia and then in Düsseldorf. Born in 1835, he received early instruction from Paul Weber, an artist who had just gone from his own studies in Germany to Philadelphia in 1842. Haseltine's daughter, Helen Haseltine Plowden, author of the first biography of him, remarks that Weber "grounded him thoroughly in the technique of drawing" and "initiated him into the mysteries of the colours of rocks, trees, skies and water."[4] Following further academic study at the University of Pennsylvania and Harvard, Haseltine returned home to work again, and then set off for Düsseldorf in the summer of 1855. There the young Philadelphian studied drawing with the German masters at the academy, Cornelius, Schadow, and Andreas Achenbach, called "all perfect draughtsmen." Haseltine gained further technical ability rapidly; "one could watch him draw for hours without ever seeing him use ruler or india-rubber."[5] One characteristic of the Düsseldorf style was the tendency to "over-attention to detail," but like his friend Albert Bierstadt at his best, Haseltine was able to control and focus his precise pen and pencil renderings. In addition to meticulous drafting, he learned from the Germans "a clear conception of how contrasts of values, lights, distances, could form themselves into one harmonious whole."[6] A third critical interest gained during this European apprenticeship was a love of the sea. Church had responded directly to Achenbach's seascapes on view in America; Haseltine at the same time worked in the German artist's studio. Early in 1858 he traveled down the west coast of southern Italy, practicing his technique in an expanded range of work, in pencil, pen and ink, wash drawings, and oil sketches. Having acquired a love of the cold northern waters, he

104. William Stanley Haseltine, *Eagle Cliff (from Northeast Harbor, Mount Desert)*, 1859

now experienced the visual pleasures of the bright blue seas of the south. This may explain why his cleanly drawn rocks and sparkling waters at Capri are so close in spirit to the subjects he would soon paint in New England.

Haseltine returned to Philadelphia later in 1858, and made his first trip north the following summer, at which time he produced his first substantial group of Maine drawings. That year he and his fellow artist Dix stayed at the Agamont House on Main Street in Bar Harbor, and from there he moved around the island to draw from mid-July to early August. Several sheets are dated to

particular days, but only one notes the year. Stylistically, the use of pencil, pen and ink, and broad wash passages is relatively consistent within this early group of identifiable Mount Desert drawings, suggesting they were all likely done in the same few weeks on the island. After his trip to Maine, Haseltine painted at Nahant in the early 1860s, returning to France in 1866. Of this time his daughter reports, "he spent many peaceful days, productive of good work, on the East Coast, from Nahant and Little Boar's Head, Rye Beach, to Mount Desert."[7]

Haseltine's presentation and treatment of subject were

105. William Stanley Haseltine, *Eagle Cliff, Somes Sound*, 1859

distinctive. His sheets are consistently larger than those of Lane and Church; virtually all were approximately fifteen by twenty-two inches. While some appear sequential by date and proximity of location, they do not have the cumulative spontaneous effects of note taking we find in Church's voluminous observations, nor Lane's selective outlining of scenery for adaptation in later paintings. Haseltine is attentive to the peculiar contours of the hills and headlands, but he seldom surveys the grand panorama, as does Church, or gives the sense of a shoreline from some distance, as does Lane. Church's occasional rock studies belong

to a large inventory of subjects and types of drawing, whereas Haseltine is primarily concerned with the concentrated masses of geologic structures and formations. Even his mountain slopes and promontories appear as large-scale rock studies. His horizons tend to be less important, despite an awareness of space and light, and often his vantage points look downward to the water or the ledges, with skylines relatively high in the composition. His daughter makes the point that "he became known as a painter who possessed an uncanny knowledge of sea colouring and rock formations," and cites an English colleague who remarked, "his

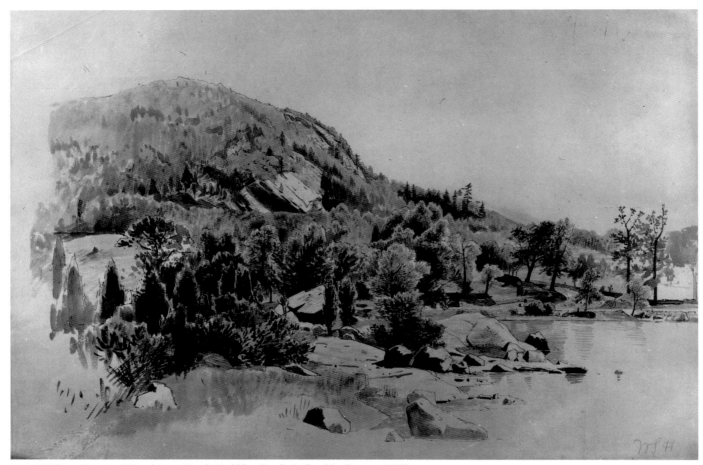

106. William Stanley Haseltine, *North Bubble, Eagle Lake, Mt. Desert*, 1859

rocks are individuals, essentially characteristic of the land they belong to."[8]

Not primarily concerned with the emotional content of sunlight or the nationalist associations of the wilderness experience, Haseltine looked closely at the basic natural elements of Mount Desert with dispassionate scrutiny. There is little sentiment or symbolism in his art, and he was content to examine slices of the island's terrain with a serenity of mind and representation. His career, like that of many in his generation, was shaped by the fundamental shifts in scientific and artistic theories from the late 1850s on. Here, Haseltine's association with Louis Agassiz at Harvard must have had a critical impact. Concurrently, Darwin's work was a sensational agent of change in the biological, botanical, geological, and climatological sciences. As Church was

well aware, these disciplines were important for their new processes of analysis and systemization. Above all, the earth sciences could instruct artists about the identification and cataloguing of nature's individual components. When Darwin asserted the significance of geological study, he cautioned that "we continually forget how large the world is, compared with the area over which our geological formations have been carefully examined." With unsentimental realism he concluded: "I look at the natural geological record, as a history of the world imperfectly kept, and written in a changing dialect; of this history we possess the last volume alone, relating only to two or three centuries. Of this volume, only here and there a short chapter has been preserved; and of each page, only here and there a few lines."[9]

With the advances in scientific thought and practice articulated

107. William Stanley Haseltine, *Rocky Coast, Mount Desert Island*, 20 July 1859

by Agassiz and others during the nineteenth century, nature shifted from being a spiritual presence to being a physical one. Geological history and change, formerly signs of national, even moral, character, were now clues to the accidental and unpredictable survival of the fittest nature. With an almost regretful tough-mindedness, Darwin observed: "The noble science of Geology loses glory from the extreme imperfection of the record. The crust of the earth with its embedded remains must not be looked at as a well-filled museum, but as a poor collection made at hazard and at rare intervals."[10] From 1859 on, Haseltine and other American artists who traveled to Mount Desert could not avoid looking at its ledges, shoals, and cliffs as so many pieces of "the crust of the earth." Indeed, the art historian Henry Tuckerman confirmed as much when he wrote an astute passage

about Haseltine in his *Book of the Artists* in 1867: "Few of our artists have been more conscientious in the delineation of rocks; their form, superficial traits, and precise tone are given with remarkable accuracy." Calling the artist's recordings "rock-portraits set in the deep blue crystalline of the sea," Tuckerman said "they speak to the eye of science of a volcanic birth and the antiquity of man."[11]

Along with the scientific motivations for studying and recording some of America's most striking geography, artists were influenced by theories of fidelity to nature articulated in the same period by academies like that at Düsseldorf, art movements like the Pre-Raphaelites, and the writings of critics like John Ruskin. While these cultural forces varied in their degrees of influence in Europe and America, they all advocated scrupulous attention to

values of colouring and form. . . . When he paints a mountain it is solid and heavy."[12]

Ruskin was then exerting enormous influence with his several volumes of *Modern Painters*, in particular by his championing of Turner and that painter's celebrated atmospheric studies in watercolor and oil. Ruskin's writings were familiar to Lane and Church, and the critic's ideas were the foundation of a widespread American Pre-Raphaelite school at midcentury. Ruskin's publication of *The Elements of Drawing* in 1857 had a special impact; it was soon widely read. In the first chapter of his book, "Letter I," Ruskin describes the exercise of selecting and drawing a stone: "you can draw anything: I mean, anything that is drawable . . . if you can draw the stone *rightly*, everything within reach of art is also within yours." He calls attention to variations in roundness and shading: "Look your stone antagonist boldly in the face."[13]

Besides obeying nature, Ruskin says one should depend "on early precision in the commencement," and "when you have done the best you can to get the general form, proceed to finish, by imitating the texture and all the cracks and stains of the stone as closely as you can; and note . . . any of the thousand other conditions they present."[14] Later, he itemizes particular landscape engravings by Turner that can be emulated for certain effects, including "mountains, or bold rocky ground." The next step is to go into nature and "aim exclusively at understanding and representing these vital facts of form. As with a tree, so with a rock, look at it, and don't try to remember how anybody told you to 'do a stone.'"[15] For

> a stone may be round or angular, polished or rough, cracked all over like an ill-glazed teacup, or as united and broad as the breast of Hercules. It may be flaky as a wafer, as powdery as a field puff-ball; it may be knotted like a ship's hawser, or kneaded like hammered iron, or knit like a Damascus sabre, or fused like a glass bottle, or crystallized like hoar-frost, or veined like a forest leaf: look at it.[16]

This spirit permeates the drawings of Church, Haseltine, John Henry Hill, and William Trost Richards, among others, who sketched the Mount Desert coastline in the third quarter of the nineteenth century (see figs. 70, 108, 125, 133).

Known better perhaps for his pictures of Nahant, Narragansett, and Capri, Haseltine nonetheless produced some of his strongest

108. William Stanley Haseltine, *Rock Wall, Near Otter Cliffs,* 25 July 1859

the individual details of nature, precise drawing, and unflagging truthfulness of observation. The training in Düsseldorf may have eventually led to a theatricality of effect in the art of Bierstadt, Emanuel Leutze, and George Caleb Bingham, but at the outset it stressed accurate drawing and graphic control over tonal contrasts. Haseltine, his daughter said simply, "was a master of light and shade." Whether he was recording the shapes of rocks or the palpable masses of hillsides, "he understands the relative

109. William Stanley Haseltine, *Otter Cliff, Mount Desert (Looking towards Sand Beach and Great Head)*, 1859

and most coherent work in his Mount Desert drawings. Since we do not know the full sequence in which he executed them, they are best considered by the areas in which he concentrated his attention. Their location and the notation of days in July or August inscribed on several sheets suggest that he moved methodically from one vantage point to another nearby, making related or complementary drawings in a particular section of the island. For example, a pair of sheets show the western side of Somes Sound (figs. 104, 105) from a southerly and then a

northerly angle. The broad drop of what is known as Eagle Cliff marks the prominent slope of Dog (now St. Sauveur) Mountain at the left, with Robinson (now Acadia) Mountain to the right in each composition. In the cleft between the two, running down to the sound's edge is Man-o-War Brook, named for the fighting vessels that could safely take aboard fresh water from the sheer depths of the sound. Slightly south of this area, Lane made a similar sketch of these hills in 1855 (fig. 52). Unlike Lane, Haseltine makes balanced use of a delicate pencil underdrawing,

110. William Stanley Haseltine, *Thunder Hole, Mount Desert Island*, 1859

reinforced lines or details in pen, and looser ink washes for tonal strength and contrast. Compared to the earlier Hudson River school aesthetic of Thomas Cole, seen in the carefully balanced and relatively closed format of his Somes Harbor drawing of 1844 (see fig. 27), Haseltine's clearly open designs, with their virtual elimination of any solid foreground and active use of white paper to convey a sense of bright sunlight, belong to the general luminist sensibility widespread at midcentury. In contrast to the curving rhythms of Cole's sketches, these drawings adhere to a more lateral organization of receding parallel planes, well suited to a scene essentially composed of faceted rock masses. (There is a provocative stylistic argument to be made that the rocky landscape better suits the luminist mode, whereas the organic forms of forest and trees are the natural subjects of Hudson River school pictures.) Although evergreens appear in some of Haseltine's early Mount Desert drawings, they largely reinforce and highlight the dominant forms of cliffs and ledges. This is true also of another inland view with a dense growth of foliage

111. William Stanley Haseltine, *Near Otter Cliffs*, 1859

(fig. 106), presumed to be of the North Bubble near Eagle Lake. Within the softer textures and looser ink washes, more appropriate to the gentle, protected ambience of the island's interior, one sees throughout the scene the rugged outcroppings of glacial boulders and exposed granite faces, evidence of nature's taut musculature here.

A second large group of works is devoted to the pure rock formations on the island's southern and eastern shores. While it is impossible to identify definitively the flat sunlit ledges in his drawing of 20 July (fig. 107), they were probably not located along the abrupt coast predominant from Seal Harbor eastward, but could well be along the southwestern shore known as Seawall on the Western Way coming in to the harbor. The large slabs of rock protruding from the shore are made of ancient volcanic ash welded into stratified layers of assorted colors within an overall grayish coloration.[17]

Punctuating these ledges are more angular fractured rocks; together they create varied rhythms of plane and mass as they are

112. William Stanley Haseltine,
Great Head, Mount Desert, 1859

accented by low water or strong sunlight and shadow. Because these formations extend underwater along a principal approach to the inner harbors of the island, this southwestern corner of Mount Desert has been the site of numerous shipwrecks. In 1740 the ship *Grand Design* ran aground on Long Ledge, blown off course on a voyage from Ulster to Pennsylvania. Scores of would-be immigrants were drowned or lost; a few survivors put ashore in the little tidal cove of Ship Harbor.[18] But such island lore was apparently not on Haseltine's mind in this drawing, as he cast his eye downward to the geological story at his feet.

Moving further to the east, Haseltine made a series of concentrated studies of the glacial cliffs and deposits along the stretch between Otter Cliff and Great Head (figs. 108 through 112). The one of a fractured rock wall dated 25 July is close in character and probably location to those done by others in that

area a decade before (compare figs. 33 and 35). Technically, this is one of Haseltine's more subtle and richly textured works, with delicate touches of pencil underdrawing, pen outlines in varying degrees of firmness and tone, rock facets in fine-brush hatching, and finally thin planes of light and dark washes for planes in deeper shadow and for the dense foliage on the receding slope above. A second drawing finds him turning around and looking out from the precipitous cliffs (fig. 109) eastward in the direction of Sand Beach and Great Head, which are seen in the far distance. A drawing combining exquisite delicacy and confidence, it is especially unusual for the use of blue paper as a ground. On at least one other occasion during this summer Haseltine drew on colored paper, a paler blue sheet for a view of Bald Porcupine, which was also enhanced with light and dark shadings. At this time pads of drawing paper in multicolored sheets were available,

113. William Stanley Haseltine, *View of Frenchman Bay from Mount Desert Island*, 1859

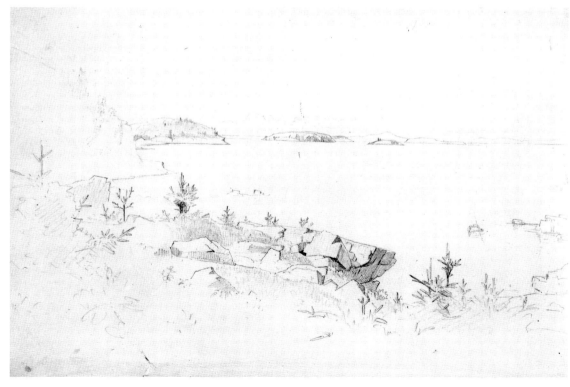

114. William Stanley Haseltine, *Study: Porcupine Islands, Bar Harbor*, 1859

115. William Stanley Haseltine,
*Sand Beach and the Old Soaker
off Great Head,* c. 1860

116. William Stanley Haseltine,
Lumber Mill, Mt. Desert, 21 July
1859

117. William Stanley Haseltine, *Near Schoodic Head*, 1859

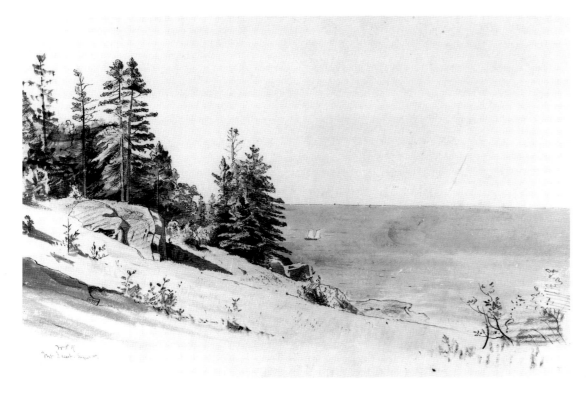

118. William Stanley Haseltine, *Wooded Coast, Frenchman Bay*, 1859

119. William Stanley Haseltine, *View of Mount Desert*, 1861

and Haseltine may well have taken advantage of their varied grounds for different light effects or contrasts.

Not far from this site, with its plateaus abruptly dropping off to the water below, Haseltine drew another of the island's most dramatic and popular attractions, Thunder Hole (fig. 110), where the seas surge into a narrow cleft with a force culminating in a thunderous boom. Unlike Church, whose interest is in the intricacies of water's action, or Winslow Homer, who explores the almost metaphysical combat of surf and land, Haseltine gives center stage to these great cubic outcrops. He devotes just a few telling strokes of wash to the eddying water in the hole, and leaves unfinished the passage of ledge at the bottom center of the

sheet. Open water and sunlight are implied beyond the far ridge, but no horizon is indicated; the result is an even more stark contrast between bright airiness and bold geology. While there is again a range of pen and brushwork, this is one of Haseltine's most controlled and intense graphic exercises, with a powerful abstraction of design and an acute realism of observed fact. Seldom does he exploit better the whiteness of his page to capture the brilliant midday sun of summer as it outlines the individual silhouettes, surfaces, and fissures of these formations. By deftly shifting from lighter lines and looser washes at the sides to greater tightness and tonal depth toward the center, he at once describes and heightens the riveting visual experience to be had

here. No doubt indebted to the imprint of Düsseldorf and Achenbach's teachings, and to Haseltine's first trips to the Italian coast, this drawing achieves a particularly powerful sense of location, capturing the face and personality of Thunder Hole.

A third drawing in this area is a more conventional shoreline view looking along a series of ledges receding into the distance (fig. 111), although for all its casual simplicity, carefully composed and orchestrated. Balancing the landscape on the right with open water to the left, beneath a relatively high horizon, Haseltine has our eye follow the piles of rocky fingers rhythmically into the background from lower right to upper left. Two tiny figures stand on the last point, echoed by a schooner seen faintly on the horizon line just above them, which ties together the entire space. Haseltine may not have had Ruskin's advice in mind, but the critic's influential guidelines for drawing water may have made themselves felt: "I need not, I should think, tell you that it is of greatest possible importance to draw the curves of the shore rightly. Their perspective is, if not more subtle, at least more stringent than that of any other lines in Nature. . . . The instinct of the eye can do it; nothing else."[19] Patience and effort were required to "take the greatest pains to get the curves of these lines true; the whole value of your careful drawing may be lost by your admitting a single false curve of ripple."[20] To Ruskin such passages of space and surface were among the most challenging yet expressive for an artist: "A piece of calm water always contains a picture in itself, an exquisite reflection of the objects above. If you give the time necessary to draw these reflections, disturbing them here and there as you see the breeze or current disturb them, you will get the effect of water."[21] In Haseltine's composition, with its combination of wash areas and repeated curved strokes under the darkened low-tide zone, the calm water surface effectively joins the gentle land masses under what seems to be a soft sunlight. The finished image is understated yet satisfying.

On 11 July 1859, Haseltine did a full-scale sketch of Great Head (fig. 112), a site frequented in preceding years by Church (compare fig. 69). Haseltine remains consistent in his concern with the rocky structure and massing of the headland, in contrast to Church's sense of its larger contour, especially as it relates to the beach and extended coastline nearby. Like Church, Haseltine made his way up and down a good portion of the island's coast facing Frenchman Bay, which resulted in another sequence of drawings just south of Bar Harbor, where he was staying (figs. 113 through 118). Some of these are beautifully balanced compositions of land and water, light and shadow, rocks and trees, while several are devoted to different angled views of the Porcupine Islands (figs. 113, 114). These represent vantage points as the artist moved closer to the subject, and in one related work (Ben Ali Haggin, New York) he filled the sheet with the lower corner of Bald Porcupine in a mirror-image composition of his Great Head drawing. Making use of this format of a cliff profile, Haseltine painted a small oil in the same vicinity as his Great Head drawing (fig. 115). From the eastern end of Sand Beach where the headland's ledges drop off into the water, this view looks slightly more westerly to include the large protruding rock offshore known as the Old Soaker, and the island's southern coastline receding in the far right background. In waiting for low tide, Haseltine could draw attention to the contrasts of the seaweed and darker rocks and the flat pools of water revealed by the ebbing sea. Such a study shows his central interest in both the special configurations of rock formations and their changing appearance over time.

His sketch of a lumber mill and sluice (fig. 116), like one of the panoramic island views, is dated 21 July, and with its faint profile of hills on the horizon (almost surely across Frenchman Bay), this setting is probably around Salisbury Cove, one of the productive lumbering sites on the island. Where Church tended to place his mills in context, and even hinted of human activity in the unobtrusive presence of a beached sailboat or wooden bridges crossing the scene, the strength of Haseltine's drawing is its stress on the contrasting geometries of wood forms and the more amorphous foliage around the periphery. The last dated work among these sheets is from 1 August (fig. 117), and characteristically, it is largely a reverse composition of a similar view looking the other way (compare fig. 118). Its open expanse of water also places it on the eastern coast, a scene not much different from that surveyed earlier by Cole and Church (see figs. 37, 74). The sailboat at the center seems to be more a scale-giving device than any agent of human presence or industry. The drawing's execution shows Haseltine at his best in combining economy and richness of texture, telling suggestiveness and finely drawn detail.

Moreover, it appears to be a rare instance in which a drawing led to an ambitious large canvas (fig. 119). Another painting showing Ironbound Island in Frenchman Bay (private collection) derived from other drawings (see figs. 113, 114), but Haseltine's Mount Desert paintings are unaccountably much more scarce than other New England or Italian subjects. One Mount Desert canvas successfully translates into the textures of paint and color the Maine character of hard stony ground, dense forest growth, and windswept views out to open seas. Painted in New York in 1861, a year after Church's monumental *Twilight in the Wilderness* (fig. 99), Haseltine's oil *Mount Desert* suggests a comparable summary of nature's sublime powers. This appears to be a synthetic view taken at no one exact spot, but combining elements of high cliffs, protruding shoreline ledges, irregular coves, forests in all stages of growth, and turbulent skies. Enlarging on and adjusting the configurations of the plein air drawing, the canvas also offers a fully expressive treatment of light and atmosphere worthy of his better-known Narragansett and Capri marines. His handling of the indirect sunlight, glazing the foreground rocks and bursting through the rain-laden clouds, is a tour de force. But the dark greens, cool blues, and bright, thin light unmistakably speak of a northern latitude, as his daughter recognized: "When he painted on the coast of Maine he realized the clear scintillating luminosity of American atmosphere, but observed that, although the country was impregnated with sun and warmth, it was a very different sunlight from that of Italy."[22]

Haseltine and his family spent much of their time from the mid-1870s on in Rome and traveling through Europe. Only in the 1890s did he return to America for an extended period and a nostalgic visit to "his old haunts. Rye beach, Maine." He had a number of friends in Northeast Harbor, and went there for the summer of 1895. He painted watercolors of local views and sold sixteen of them in a private exhibition there. Helen Haseltine Plowden describes that occasion:

Many of the residents of N. E. Harbour, the Bishop of Albany, the Gardeners, the Storys, the Forbes, the Huntingtons, Dr. Potter, Bishop of New York, were friends of many years' standing and he was glad to link up with them again. Pierpont Morgan was up in those waters with his yacht and, from entries in his diaries, we know Haseltine often joined him. Their friendship dated back to the days of the seventies in Rome.[23]

On this second trip his paintings of Mount Desert were different. "He realized that much time had gone by since the days of the peak of his fame in America between the sixties and eighties; he knew that younger artists and other schools of painting had superseded him."[24] In fact, his style had evolved with the changing tastes, and he showed a definite awareness of the pervasive impressionist aesthetic. Now he painted large-scale plein air watercolors in a lighter key and with a more fluid touch than had been displayed in his earlier work. For the most part he concentrated on the protected harbors and smaller islands rather than the rugged ocean coastline, though one example (fig. 120) recalls some of his earlier shoreline compositions (see figs. 117, 118). This view may well be located somewhere between Seal Harbor and Otter Cove on the southern coast, but this has a more intimate feeling than most of Haseltine's 1859 work. The viewpoint here is turned inward toward the shoreline, in contrast to the generally spacious compositions of the earlier visit. The coloring, too, is richer and warmer, and perfectly suited his new interest in the luminous effects of fog and the silvery summer light filtering through the trees by the shore. "Narrow, gravel beaches yellowed by iodized seaweed, diminutive deep blue and purple coves, young birches and aromatic shrubs, grey mossy rocks on the Beech Mount, the vivid rose of Sutton rocks and Asticon [Asticou] islands—these are the subjects of the sketches done during those months."[25]

Consistent in tone, format, and size, approximately fourteen by twenty-two inches, these watercolors (figs. 121 through 123) view Seal Harbor and Northeast Harbor from the rocky water's edge looking to the inner shore. Instead of the silhouetted evergreens that punctuate his earlier, strongly tonal graphic works, he places the white and gray trunks of birch and aspen at the center of these compositions, their gnarled roots growing over the banks and their delicate leaves making intricate patterns against the sky. His daughter refers to his being a "pre-Monet Impressionist . . . he was a lover of Monet's work."[26] Indeed, the cool palette of mixed light greens and blues, along with the occasionally stippled passages of brushwork, do suggest the French master's later works. One of these watercolors was traditionally titled *Seal Harbor* (fig. 121), likely because of the rounded, sloping shoreline and more intimate size, whereas the Northeast Harbor series, done from both the western and eastern

120. William Stanley Haseltine, *Ocean Coastline near Seal Harbor*, 1895

121. William Stanley Haseltine, *Seal Harbor*, 1895

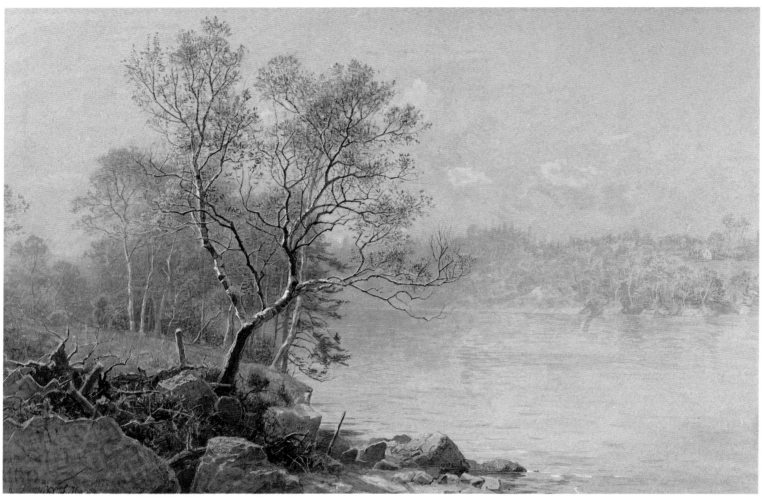

122. William Stanley Haseltine, *North East Harbor, Maine*, 1895

shores near its entrance, show a more distant expanse consistent with this long, deep inlet (figs. 122, 123). Yet another, unfinished sheet, called *North East Harbour in a Fog*,[27] depicts the faint lines of the mountain slopes just north of the village, while the related images indulge in the subtle nuances of light and atmosphere flickering across the water and veiling the details of the farther banks.

When Haseltine revisited Mount Desert Island in 1895, the community and the coast had greatly changed from his first trip. During the decades following the Civil War, travel by steamer and then railroad made distant areas increasingly accessible. Tourists and vacationers followed in the artists' footsteps in the sum-

mer months. During the "Gilded Age," resort areas became established from Newport to Bar Harbor. On Mount Desert in the second half of the nineteenth century, large hotels arose, and the prospering middle and upper classes built shingled summer cottages across the island. Several landowners were already beginning to think about setting aside key areas of the island for a park, a notion that came to fruition with the establishment of Acadia National Park early in the twentieth century. Mount Desert had evolved from a distant wilderness at midcentury to a playground by century's end, as Haseltine's friends who lived there in 1895 affirmed. As an artist, he came with different points of view: on his first trips he was among the last wave of artists

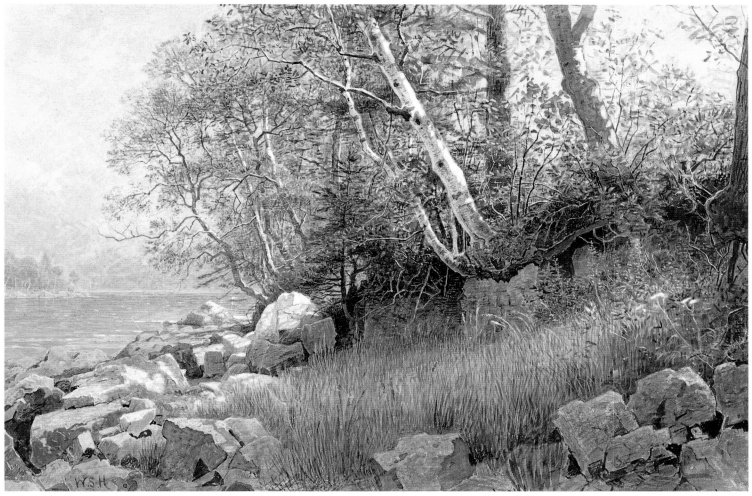

123. William Stanley Haseltine, *North East Harbor, Maine*, 1895

who explored nature as romantic scientists; two or more decades later he was another rusticator, looking less for the truths of geology than for the gentle comforts of social company and the island's recreational pleasures.

Haseltine completes an eminent trilogy of artists whose documentation of Mount Desert in the middle decades of the nineteenth century is unsurpassed in extent and quality. Fitz Hugh Lane created some of the purest and most compelling paintings of his age during the 1850s. Frederic Church produced a commanding series of works on paper and on canvas that are a towering achievement of his generation. Haseltine's drawings and watercolors represent a comparable accomplishment in their

realm. Taken together, his two groups of pictures form a convenient set of artistic parentheses around the late nineteenth century. The period between saw a flood of well-known and lesser-known painters come to the island, some to produce just an occasional drawing or oil, others to sketch over the course of several summers. Though none would create the sustained amount of work that Lane, Church, and Haseltine did, many made fascinating, revealing, and sometimes exceedingly beautiful images that mirror the island's changing allure for new generations.

VII.
The Late Nineteenth Century

I N T H E W A K E O F T H E P I O N E E R S, a flood of artists with diverse talents and interests visited Mount Desert during the second half of the nineteenth century. By midcentury the bold examples of Cole and Church were widely enough known to their colleagues and followers to stimulate others to try their hands at recording this dramatic scenery. So far as we know, some made only one visit, while others returned several times over the years, captivated by the artistic possibilities and the social life on the island. In a pattern that would carry over into the twentieth century, others merely paused in the area as they traveled to other parts of the coast east of Schoodic, notably the even more stark promontories they discovered at Grand Manan Island approaching the Bay of Fundy in Canada. As artistic styles began to diversify during the later decades of the nineteenth century, painters came with a variety of agendas and worked in various techniques and media, many sketching in pencil but also using pen and washes, gouache, and watercolor.

As one of the island's historians summarized around the turn of the century:

> The artists who were the earliest visitors did much to make the island famous. Church, Fisher, Cole, Gifford, Hart, Parsons, Warren, Bierstadt, and others of the older generations renowned in American art, painted the crags and the shining waters and gave fanciful names to some of the picturesque places, such as Eagle Lake [credited to Church], the Beehive, Echo Lake, and the Porcupine Islands.[1]

Today we know almost nothing about the visits of Charles Parsons (1821–1910), an accomplished marine painter who was also for many years a successful lithographer for the Currier and Ives

firm. Much better known is the German-born Albert Bierstadt (1830–1902), who emerged as one of the foremost figures in the second generation of Hudson River school painters, and who was a great interpreter of the American West. Though apparently no documentation or examples of his work at Mount Desert have survived, he had close connections in New York painting circles with a number of key figures lured to "the crags and the shining waters" of Maine, among them Frederic Church, Sanford Gifford, Aaron Draper Shattuck, and William Trost Richards.

After the Civil War, the phenomenon of tourism arose, and to accommodate it the summer hotel business developed.[2] About 1871 the first resort inns went up at Bar Harbor and Southwest Harbor, and others were built in the next few decades as business flourished. Two factors were influential: a changed work week as industrialization shortened working hours, and the cult of nature, with its appeal of physical and spiritual therapy. The concept of the weekend offered more leisure time, and with growing wealth Americans established summer resort communities up and down the East Coast.[3]

While Lane, Church, and Haseltine were devoting extensive time to sketching on Mount Desert during the 1850s, other artists were attracted to some of their favored artistic sites. John Henry Hill (1839–1922) was representative of the close-knit group of artists in New York championing the Pre-Raphaelite style in America. At about the time of his conversion to the aesthetic articulated by the English critic John Ruskin, Hill appears to have traveled to Mount Desert, probably in the company of his artist father, John William Hill. Both adhered to the principles of truth to nature set forth in Ruskin's pervasively influential books, *Modern Painters* (1843 and 1846; first American edition, 1847)

124. Otter Cliffs from Thunder Hole

and *The Elements of Drawing* (1857). The prominent American landscape painter Asher B. Durand, who had inherited the mantle of leadership of the Hudson River school after Cole's early death in 1848, became the major exponent of Ruskinian ideas with his "Letters on Landscape Painting" published in the *Crayon* in 1855 and 1856. There he argued that an artist should look at the ingredients of nature so as to "attain as minute portraiture as possible." One should seek "a knowledge of their subtlest truths and characteristics" and using pencil, "draw with scrupulous fidelity the outline or contour of such subjects as you shall select, and . . . choose the most beautiful or characteristic of its kind."[4]

In this mode, John William Hill executed a tight watercolor drawing recorded as *Rocks at Mount Desert* (location unknown), which was so meticulous in its scrutiny and technique that it was called worthy of the teachings of Louis Agassiz, Harvard's eminent natural scientist: "Agassiz could lecture to a class with this."[5] The younger Hill's style was largely indistinguishable from his father's at this time, and what must be one of the earliest encapsulations of the Ruskinian approach is John Henry Hill's drawing of rocks at Mount Desert (fig. 125) dated 1856. It concentrates on the "minute portraiture" of the particular rock formations, most likely along the Ocean Drive with its background of the open sea; it maximizes the use of pencil to capture "the outline or contour" of each massive boulder. Historians have pointed out that beginning in the 1850s American artists regularly exhibited works under the title "Study from Nature." An editorial in the *Crayon* of March 1865 proclaimed that "the true method of study is to take small portions of scenes, and thereto explore perfectly . . . every object presented. . . . To make a single study of a portion of landscape in this way, is more worth than a summer's sketching."[6] In contrast to Thomas Cole's earlier compositions based on identifiable locations, or Fitz Hugh Lane's panoramic outlines of observed scenery, here Hill has mastered the image of a *study*—as opposed to a "summer's sketching"—and this mode would reappear constantly in years following, as practiced by such artists as Aaron Draper Shattuck, William M. Hart, Sanford Gifford, William Trost Richards, and Samuel Lancaster Gerry (see figs. 131 through 135). This early practice prepared Hill for the rocky landscapes he would be painting by the mid-1860s of such diverse sites as the New Jersey meadows, Shoshone Falls in

125. John Henry Hill, *Rocks at Mt. Desert*, 1856

Idaho, and Lake George in upstate New York, each with its own special geological character.[7]

Just two years after Hill's visit to Mount Desert, Shattuck (1832–1928) arrived with a similar devotion to Ruskinian principles. He had exhibited a work entitled *Study of Rocks* in 1856 at the National Academy of Design and the Brooklyn Art Association, and received the admiring praise that "a geologist would know how to prize" his drawing.[8] In 1854 he had made his first visit to the Maine coast, drawing the rocky headlands of White Head Cliffs near Portland (private collection).[9] Shattuck's life and career were spent mostly in New England and New York. He studied first in Boston in 1857, and then at the National Academy of Design in New York. In 1859 he moved into the renowned Studio Building, where he knew Frederic Church and Albert Bierstadt as artists who were also interested in painting the northern landscape. Shattuck's biographers talk about his scientific approach to recording the facts of nature: he kept daily accounts of the weather and made extensive verbal notes and illustrations regarding cloud formations in many of his notebooks.[10] Most of his summers in the sixties found him in

126. Aaron Draper Shattuck, *Jordan Cliffs and the Bubbles, Mt. Desert,* 31 August 1858

127. Aaron Draper Shattuck, *Frenchman Bay, Mt. Desert,* 1858

128. Aaron Draper Shattuck, *Seawall and Cranberry Island*, late 1850s

New England, including Maine, and an important early cluster of works he did along the coast during the summer of 1858 survives.

Dated drawings from June to September of that year indicate that he first sketched around the Portland area, and then later at Peake's Island and Monhegan Island. By August he was working at Mount Desert and the nearby islands in the surrounding Penobscot and Frenchman bays.[11] Shattuck for the most part preferred to work on a small scale even when he was painting, and this intimate approach is evident in his sketches of this region (figs. 126 through 128). Stylistically, they combine an awareness of Lane's luminist sensibilities with the geological observations typical of Church's work, dating from the immediately preceding years. But Shattuck's fine sense of detail and controlled use of pencil, charcoal, and white chalk also reflect his allegiance to Pre-Raphaelite methods. His drawing dated 31 August, a view of Jordan Cliffs and the Bubbles of Jordan Pond, is close to Church's of a few years before (compare fig. 98). With a light touch Shattuck indicates the raw stone face of the mountainside, while in looser strokes he suggests the tree reflections in the surface of the water. The economical design of this panorama expresses a knowing grasp of luminist organization and clarity, what Henry Tuckerman described as the artist's ability to capture "the misty atmosphere of the distant shore."[12]

Tuckerman also observed that "this artist was one of the first of our landscape-painters to render foregrounds with care and fidelity. . . . He is exact, graceful, and often effective."[13] These thoughts might well apply to Shattuck's drawing of 25 August (fig. 127), a view along Frenchman Bay on the eastern side of the

129. William M. Hart, *Sunrise, Great Head, Mt. Desert*, c. 1860

island. His use of the contrasting central areas of heavy black graphite and white gouache for the angular rock faces is especially effective. In this instance the complex, random massings of limestone take primacy over the sketchy surroundings and barely hinted distance. At the same time Shattuck "often painted spirited sea-coast scenes,"[14] of which his small oil study of the nearby coastline is a good example (fig. 128). It was originally thought to have been done in the same area, but the low projecting ledges look more like the island's southern shore than the abrupt cliffs of Frenchman Bay. Such exposed slabs of variegated stone forms are found in the Seawall area along the Western Way; Shattuck was likely looking across the Cranberry shore toward the Duck Islands in the distance.[15] Although Shattuck was fully conscious of the broad sunlight flooding the scene, with the hint of summer clouds in the sky, his fluid brushwork stressed the distant textures and colors of his foreground "with care and fidelity."

Variations of the Hudson River school formulas continued uninterrupted during the 1860s. William M. Hart (1823–1894) was a competent follower of the Cole and Church precedents. He and his brother James, also an accomplished landscape painter, emigrated with their family from Scotland to Albany in 1831. In contrast to his brother's more academic training in Düsseldorf,

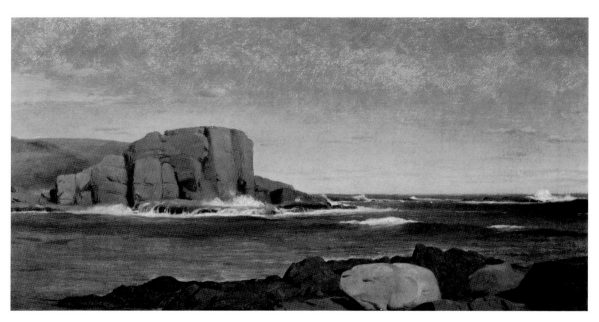

130. William M. Hart, *Great Head, Mount Desert, Maine*, c. 1860

William was a largely self-taught and itinerant painter in the eastern United States before settling in New York in 1854. Within a decade he was sufficiently well recognized to be named the first president of the Brooklyn Academy of Design.[16] The subjects and dates of his works indicate he was painting at Mount Desert from 1857 to 1860, with some pieces being finished and exhibited a few years later. Apparently, he gravitated to the area of Great Head for much of his inspiration, as evidenced by two of the small canvases he did there (figs. 129, 130). Tuckerman observed with customary astuteness of Hart that "many of his smaller landscapes are gems of quiet yet salient beauty."[17] While they do capture the mass of the rocks and a sympathy for the poetic effects of light, they do not match the imaginative power or technical ability we so admire in the first-rank artists of the period. Hart was clever in a modest way in his adaptations of his picture format to the vertical rise of these cliffs and the horizontal expanse of the ocean shoreline.

A younger artist and another fervent disciple of Cole's was Sanford Gifford (1823–1880), who emerged from the master's shadow into a radiantly lit reputation of his own. Virtually all of his biographers from his day to ours have spoken of light as the glory of his paintings. Tuckerman's assessment in 1867 was that "Gifford has a true eye for atmospheric effects . . . there is a scope, a masterly treatment of light and shade, full of reality and often poetically suggestive."[18] Two years later another critic asserted, "Few of our artists equal him in the expression of sunlight and warmth," while his painter friend Jervis McEntee used these words: "The poetic soul revels in the sunshine and air, seeking everywhere the expression of its serene joy."[19] On Gifford's death in 1880 the artist John F. Weir delivered a memorial address at the Century Association in New York, where he summarized: "Gifford loved the light. His finest impressions were those delivered from the landscape when the air is charged with an effulgence of irruptive and glowing light."[20] Modern writers have celebrated the same elements in his art, placing him firmly among the finest practitioners of the luminist mode; one writer described Gifford's style as "aerial luminism" and "subjective idealism."[21]

Gifford was born and raised in upstate New York; by his own admission and the testimony of others, he fell deeply under the influence of Cole's art and subject matter. Gifford took up similar

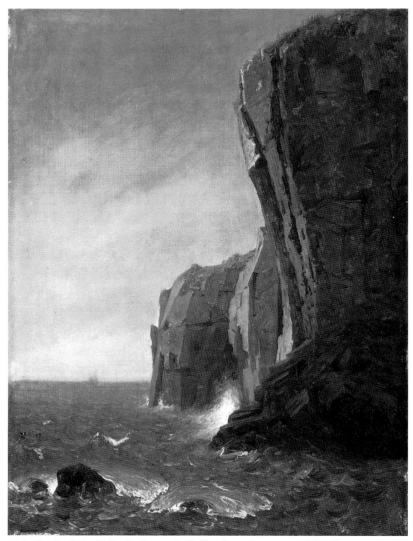

131. Sanford R. Gifford, *Otter Cliffs (Rocks at Porcupine Island Near Mt. Desert)*, c. 1860

woodland compositions, mountain prospects, and views of elevated wilderness promontories for much of his early work. He looked conscientiously at Cole's landscapes on canvas and in nature: "During the summer of 1846 I made several pedestrian tours among the Catskill Mts and the Berkshire hills, and made a good many sketches from nature. These studies, together with the great admiration I felt for the works of Cole developed a strong interest in landscape art, and opened my eyes to a keener perception and more intelligent enjoyment of Nature."[22] Tuckerman confirmed this admiration of Gifford's, which not only

set the latter on his course as an artist but shaped the choice of his subjects well into the 1850s: "Few of our landscape-painters have been more directly influenced in their artistic development by the example of Cole, than Gifford. It was the sight of his pictures which kindled the sympathy and emulation of the painter's instinct in the heart of his youthful neighbor."[23]

But like his colleague Frederic Church, Gifford was able to absorb the powerful precedents of the older master, and emerge with a clear personal vision in his maturity. As it had for Church, the example of Cole's own trip to Mount Desert in 1844 must have offered a seed of inspiration to Gifford as he began to emulate Cole a few years later. After an early trip to Europe in 1857, Gifford settled in New York, moving into the Studio Building, where he worked near Church, Shattuck, and Bierstadt, all of whom had an interest in Mount Desert. Perhaps Gifford made a first visit to the coast in 1859, for the following year he exhibited a picture titled *Indian Summer in Maine*.[24] Whatever his motive, he did undertake one major excursion to Mount Desert in the summer of 1864, which resulted in a series of pencil and oil sketches as well as one small painting (figs. 131, 132). The latter is one of the gems of Gifford's career and one of the single most beautiful images created of Mount Desert Island. Although he is more often associated with other regions of New England, the West, Europe, and the Near East, he distilled in this single experience of Maine a tender yet exhilarating tribute to nature and art.

His oil study *Otter Cliffs (Rocks at Porcupine Island Near Mt. Desert)* (fig. 131) exemplifies Gifford's compositional indebtedness to Cole; it looks like a near mirror image of the earlier artist's imaginative *Otter Cliffs* (fig. 34), though bearing the later generation's greater attention to geological structure and specificity of place.[25] Gifford prepared and executed more carefully his painting *The Artist Sketching at Mount Desert* (fig. 132), and while it too has distant echoes of Cole, it unmistakably belongs to another time. Gifford and his brothers had volunteered for the Union Army at the outbreak of the Civil War, and he was engaged with the movement of the Northern forces periodically, though he never did see frontline action. From time to time, he was able to set off on painting trips, which were probably a relief from the increasing turbulence of the war. What impelled him to undertake this singular trip to Mount Desert and complete such a

serene vision in the summer of 1864? His brother Charles was lost at the outset of the war in 1861, and his brother Edward was killed in service at New Orleans in 1863.[26] Perhaps the artistic stimuli of Cole, Church, and Shattuck joined with the wrench of recent family losses to prod him to escape into the unsullied and uplifting landscape. *Twilight in the Wilderness* (fig. 99) was Church's cry of the heart at the beginning of the war; Gifford remarkably produced a bright and reaffirming image in the face of his own and his nation's troubles.

Like Cole and Church before him, he spent several weeks climbing around the island's mountains (compare figs. 30 and 65) in search of different views. An acquaintance, Dr. S. Weir Mitchell of Philadelphia, may have facilitated Gifford's visit to the island. Mitchell had been a guest in the artist's New York studio, and had visited Mount Desert early in the sixties, returning there regularly for summers thereafter. Surviving drawings indicate that between 14 July and 5 August Gifford sketched near Northeast Harbor, Southwest Harbor, and Porcupine Island off Bar Harbor, as well as Eagle Lake inland. At least two drawings and an oil sketch done between 15 and 25 July appear to be preparations for his canvas looking out to sea from one of the island's highest elevations. Two were more panoramic views, *Green Mountain, Mt. Desert, July 15th '65* and *A Sketch at Mount Desert, Maine*, while a third depicts a small shelter, *Camp on Green Mt., Mt. Desert, July 21st 1864*.[27] (That summer he also followed in Church's footsteps by going on to sketch at Mount Katahdin.) The final painting is an explicit view south toward Otter Cove from just off the principal summit, on the easterly side of Green as it slopes down toward the gorge and nearby Dry (later renamed Dorr) Mountain. From his notations of color, light, and location on several drawings, it is evident that Gifford was seeking a final balance of near and far, specific fact and spacious effect. The drawings were made at different levels on the mountainside and survey alternate passages of the horizon.

As modest and effortless as this small painting seems, it is a subtle fusion of three striking elements, which together illustrate Gifford's homage to and independence from his colleagues. The elevated viewpoint, the seated artist, and the hazy expanse reveal to us that this is a picture about looking and recording what we see. We stand first before the scene of both the painter and his view; in turn we look over his shoulder to join in the act of

132. Sanford R. Gifford, *The Artist Sketching at Mount Desert*, 1864–65. (Color frontispiece)

observation; as he records his impressions, so do we. The artist's open paint box by his side holds up, in a clever conceit, a miniature version of the view before us, a canvas within the canvas that hints of the whole process as an act of contemplation and creation. To this end Gifford's inscription at the lower right includes on one line the faintly incised notation, "Mt. [Desert], July 22, 1864," and on another his signature, "S. R. Gifford/ 1865," indicating when he was there and fixed the image first in his mind, and later the following winter when he finished the image on canvas in his studio.

The elevated vista invites us to gaze into the distance, providing, as in Thoreau, a meditation on the future and the possible.[28] Gifford had already employed this compositional device several times for important views painted over the preceding decade, among them *Mountain Valley, North Conway,*

circa 1854, *Mansfield Mountain*, 1858, *Catskill Mountain House,* 1862, and *Kauterskill Clove*, circa 1863.[29] Knowing the artist's early admiration for Cole, one can trace these works back to the older painter's major achievement of 1836, *The Oxbow on the Connecticut River* (Metropolitan Museum of Art). There, too, the painter sits on the edge of the hillside with his painting umbrella and stool nearby. The figure joins foreground and background, as his silhouette does here, though significantly Gifford's umbrella points sharply and cleanly into the open sky above. This floodlit space expands outward and upward. By his critical placement, the sketching figure mediates between nature on one side and art on the other.

The presence of the artist in his own work was not unique to Cole; it appears frequently in Western romantic painting, from Casper David Friedrich abroad to Fitz Hugh Lane at home.[30] In

fact, Gifford had included an artist at work in the foreground of an earlier landscape painted on his first trip abroad, *Valley of the Lauterbrunnen,* 1857 (Brown University).[31] But he refines the image at Mount Desert by the prominent and legible addition of the self-referential painting within the painting. It is not just that the artist is seen at work here, actively engaged in his landscape, but that the image has already crystallized into art. We are at once looking in the paint box at a finished study of the scene, with the artist at work on another sketch in his hands, and at a visual emblem of the final painting resolved during the following months in the studio. The real work of art is no longer before the artist's eyes but before ours. By this compact imaginative conception, Gifford's vision seamlessly unites nature and art.

The hazy summer light that suffuses the whole work was praised by his contemporaries and biographers as his special creation: "Gifford has also been successful in the experiment, which, of late, has been tried by several American landscape-painters, to reproduce the effects of a misty atmosphere so often witnessed by summer travelers among the mountains."[32] Speaking of such pictures as *Mansfield Mountain* and *Catskill Clove,* though the comment is equally applicable to *The Artist Sketching at Mount Desert, Maine,* Tuckerman wrote that Gifford "has caught the very tint and tone of the hour, and bathed this sublime gorge therewith." Over these views "broods a flood of that peculiar yellow light born of mist and sunshine."[33] Another associate noted, "With Mr. Gifford landscape-painting is air painting; and his endeavor is to imitate the colour of air."[34] In his 1880 memorial tribute the painter, John F. Weir summed up: "For Gifford the key to the sentiment of the landscape always rested in its atmosphere. This gave it unity and expression. He plunged all the separate features of the landscape into a qualifying colored atmosphere."[35]

Gifford himself argued that "the really important matter is not the natural object itself, but the veil or medium through which we see it."[36] This golden radiance is as much a transforming agent as the artist in the foreground is. If we place ourselves in the landscape as the painter has done, we engage in an act equally physical and spiritual. On one of his preparatory drawings he added extensive notations about light and color that end, significantly, in a metaphor: "rocks & cleared land lighter than sea. . . . Gradation of sea same as that of a mountain

distance/Sails like constellations."[37] Indeed, the white dots of sailing vessels are visible in three primary clusters, off Schooner Head in Frenchman Bay at the left, in Otter Cove at the center, and inside Baker's Island in the right distance. Although it is a sunlit day at the height of summer, they sparkle as if in ether. Altogether, the whole is a magical statement about the restorative powers of landscape and of painting.

Few visitors in these years could approach such an intense combination of objective recording and private meditation. The New Bedford Gifford, Robert Swain Gifford (1840–1905), went to Maine a few years later, and painted *Bald Porcupine Island at Mt. Desert* in 1868.[38] This is a fresh but conventional view emphasizing the popular recreational sailing activities around Bar Harbor after the Civil War. This Gifford was born near New Bedford, Massachusetts, where he, like William Bradford, received early instruction from Albert van Beest, the marine painter from Holland. Lane had been briefly active in the region south of Boston during the mid-1850s, and through such associations may have come the appeal of painting coastal Maine.

Another marine artist who journeyed to Mount Desert at this time, William Trost Richards (1833–1905), was a far more significant figure. Though he was closely associated with Newport and the Rhode Island coast for much of his mature career, Richards first came to Maine in 1866, having already painted at Nantucket the previous summer. He was a Philadelphia native like Haseltine, trained in Germany during the mid-1850s, and profoundly influenced by the concurrent theories of Louis Agassiz on geology and John Ruskin on drawing. His earliest professional experience was as a designer of ornamental metalwork, a training soon reinforced by the precision of drawing inculcated by the German academy. By the time of Richards' return to Philadelphia in 1856, Durand's letters in the *Crayon* were at the peak of their influence in promoting the Ruskinian notion of intensively examining and capturing the smallest particulars of nature's physiognomy. The next year Richards saw his friend Church's recently completed masterpiece, *Niagara,* 1857 (Corcoran Gallery of Art, Washington, D.C.), which decisively introduced into American painting a new and powerful landscape format: an extended horizontal composition with an equally expansive spatial depth, all on a grand scale and meticulously executed.[39] The painting represented a fresh, compelling vision

133. William Trost Richards, *Rocks at Mount Desert*, c. 1866

for this generation. Richards wrote explicitly of his admiration for the Harvard natural scientist: "I almost envy your geological surveys with Prof. Agassiz. I have long been wishing to study in an Elementary Manner Geology."[40]

At the same time he fervently espoused the Ruskinian cause, joining the Pre-Raphaelite group of the Hills, Shattuck, and others under the banner of "The New Path." With his peers he read Ruskin's recent call to artists in *Modern Painters:* "Their duty is neither to choose, nor compose, nor imagine, nor experimentalize; but to be humble and earnest in following the steps of nature, and tracing the finger of God."[41] Given its care of execution and concentration on nature's terrain, Richards' drawing of a rocky coast, dated 30 July (fig. 133), was almost certainly done on his 1866 trip to Mount Desert. Like Haseltine's and Shattuck's drawings of a few years earlier (compare figs. 107 and 127), this pays primary attention to the variety and individuality of forms in the foreground. As a study of rocks this

was akin to his equally refined examinations of grasses, leaves, and woodland trees, which merited the observation that "we seem not to be looking at a distant prospect, but lying on the ground with herbage and blossom directly under our eyes. Marvelous in accurate imitation are the separate objects in the foreground of these pictures."[42]

This dedication to the facts of nature went hand in hand with the Ruskinian idea of working outdoors, and it remained a lifelong foundation of Richards' approach to art. The *Crayon*'s constant stress on the importance of sketching was advice he took to heart in the many dozens of his drawings, watercolors, and sketchbooks that survive from every period of his career: "The habit of fixing the mind intently on Nature to draw her minuter traits, enables us to see many things which are lost entirely in a first impression; it would be worth the while to every lover of Nature to set determinedly at drawing portions of landscape."[43] Richards made a specialty of painting coastal and marine

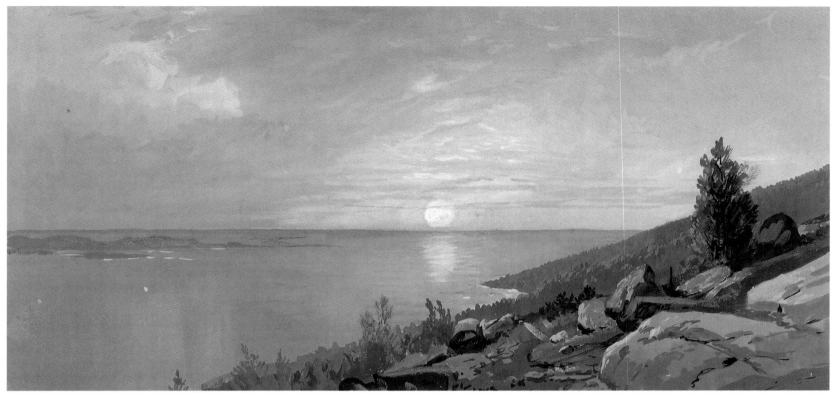

134. William Trost Richards, *Sunrise over Schoodic*, early 1870s

subjects through the 1870s; he traveled constantly in the summer months from the New Jersey shore to Maine, sketching his "combinations of Rock and beach and sea."[44] Until he settled permanently at Newport in 1874, he sought subjects throughout New England, and his small watercolor gouache *Sunrise over Schoodic* (fig. 134) probably dates from an excursion to Mount Desert in the early seventies. By this time he had taken up watercolor sketching, and in 1874 became a member of the American Society of Painters in Water Colors. During the preceding years he had undertaken a series of shoreline studies in pencil and watercolor, including *Rocks at Nantasket* and *Study of a Boulder* in 1869.[45] Richards joined other American artists, perhaps most notably Winslow Homer, in enthusiastically pursuing outdoor painting in watercolor by the mid-1870s. Although the sharp outlines and clean composition of his Maine sketch are grounded in his earlier Ruskinian principles of drawing, a new looseness and suggestiveness are apparent in his

textures and light effects. This is no longer solely a study of geology underfoot, but a broader and more poetic response to the cool hour of dawn witnessed from the eastern slope of Newport Mountain as we look calmly over Frenchman Bay and the open Atlantic.

Richards would perfect this manner of working through his subsequent years around Newport, and Maine was not to attract his attention again. But others who joined him there in the seventies were also moving toward a more luminous and fluid style of painting. Notable in artists' depictions of Mount Desert at this time is the appearance of human beings. At first they were diminutive presences resting on cliffs, but they soon assumed larger roles, participating in leisure activities on the waterfronts. This is seen in works by some lesser-known artists who were following the conventions established earlier by the major Hudson River luminist painters. These lesser-known artists included such figures as Samuel Lancaster Gerry (1813–1891), Andrew W.

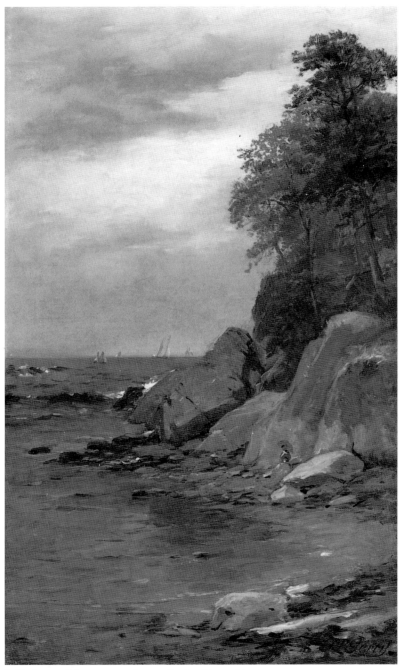

135. Samuel Lancaster Gerry, *Rocky Shore*, 1870s

Warren (?–1873), W. W. Brown (dates unknown), David Maitland Armstrong (1836–1919), F. O. C. Darley (1822–1888), and Henry W. Waugh (dates unknown). For this generation, in contrast to Church's of two decades before, it was no longer the case that "the roads were still rough tracks and the sea was still the highroad for dwellers on the island."[46] Now dirt roads and trails crossed the island, linking the villages with new hotels. On a pleasant summer day artists were no longer alone in walking the cliffs, mountain paths, and beaches. Likewise, the number and variety of sailing vessels increased in the harbors and adjacent waters, as cruising craft and day sailors joined the local commercial and fishing fleets around the island. Promenading, reading in the shade, exploring the striking rock formations, rowing, and canoeing began to fill Mount Desert's theatrical scenery. Now the place was less a sublime discovery or outdoor scientific laboratory than a benign place to relax, revive the spirit and body, or conduct a courtship. For many arriving artists, the narratives of genre subjects took as much of their attention as the landscape setting.

Gerry was a native Bostonian and spent much of his career in that city. He exhibited at the Boston Athenaeum at about the same time Lane did, and through the Gloucester artist's example he may have been encouraged to try a Maine subject himself. His view of the rocky shore (fig. 135) is in the traditional style of Gifford, Hart, Church, and Cole, though the group of sailing schooners near the shore and the woman seated on the beach under a parasol describe a different sort of tranquillity. Andrew Warren painted a young couple on the ledges, similarly relaxed, taking in his gentle ocean vista (fig. 136). This view is from one of the offshore islands, looking back to the silhouette of Mount Desert in the distance. Born in Coventry, New York, Warren was established in New York City by the end of the 1850s, and was soon recognized as an accomplished marine painter. Most of the few interesting biographical details we have about him come from Tuckerman:

> Taking a fancy to marine subjects, he shipped as a cabin boy on a vessel bound to South America, that he might see the sea in all its bearings. Since then he has lived at Mount Desert, and built his own boat to facilitate his travel over the watery highway to make studies of interest on islands adjacent to Schooner Head. He is now absent on a second visit to Central America (Nicaragua) in search of fresh

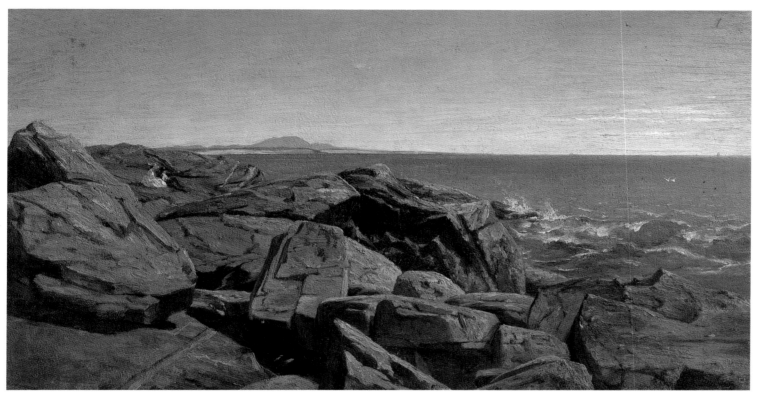

136. Andrew Warren, *Mount Desert Island, Maine,* 1869

137. W. W. Brown, *Bar Harbor,* 1870s

material. A work of his, "Rocky Shore, Mt. Desert," is in the gallery of the Brooklyn Institute, and has much vigor of drawing and handling.[47]

Tuckerman published these observations in 1867, two years before the oil study of the couple, which Warren inscribed in Spanish: "A Mi Querido Amigo A. C. Smith AWW 1869." Archibald Carey Smith was one of the finest yacht portraitists of his generation; based in New York, he painted a number of regattas and marine scenes around the New Bedford, Massachusetts, area at midcentury, and no doubt common interests led to his friendship with Warren. The latter's style seems most indebted to the New England work of Hart and Haseltine. Familiar here are the broadly painted ledges sloping diagonally down to the sea and the intense blue coloration for the broad expanses of water and sky.

We know even less about the artist who prominently signed the charming oil study entitled *Bar Harbor,* "W. W. Brown" (fig. 137). With the unmistakable contours of Dry Mountain and Green

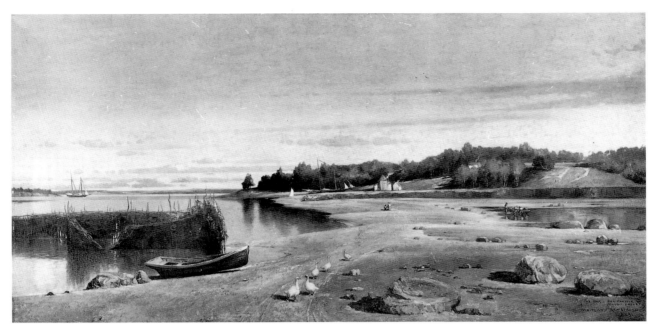

138. David Maitland Armstrong,
The Bar, Bar Harbor, 1877

139. F.O.C. Darley, *Rocks near
the landing at "Bald Porcupine
Island,"* Bar Harbor, 1872

140. Henry Waugh, *View from Cottage Window, Mt. Desert*, 1873

Mountain as a backdrop, the flourishing harbor town spreads across the sloping waterfront. Despite the economy of his sketch, telling details such as the sailing and rowing figures, the town pier, a schooner in dress flags, and several sizable inns are visible. A much larger and more finished canvas from about the same period is David Maitland Armstrong's painting *The Bar, Bar Harbor*, begun in 1877 and reworked in 1883 (fig. 138). When the tide was out, people would walk across the exposed bar of land to Bar Island, the one closest to the town, which helps create the harbor's anchorage area. Armstrong's scene is even more domesticated, with a rotting wooden hull suggesting a history, in contrast to activities of the moment: ducks on the path, a rowboat just pulled ashore, children playing in the temporarily shallow water, and smoke rising from cottage chimneys beyond. A New Yorker, Armstrong had spent a number of years in Rome and Paris, and the bright, spacious ambience of this work suggests a consciousness of European plein air painting. His settled and sociable landscape dramatizes the rapid social changes reshaping Mount Desert between the 1870s and the 1890s: "In twenty years, from a desolate tract of rough pasture land, bearing a few humble dwellings, Bar Harbor grew to be one of the most popular resorts on the New England coast. Gradually the exquisite beauty of the position of Bar Harbor, backed by the great hills and looking out on the island-gemmed bay and across to the Gouldsboro hills, began to be talked about."[48]

F.O.C. Darley, well known as a genre illustrator and a landscape painter, drew both kinds of images in the summer of 1872. With his Philadelphia background, he may have learned of Maine's possibilities for subject matter from visitors like Haseltine or Xanthus Smith. In small boats, paddling, rowing, or sailing, he made his way around the Porcupine Islands clustered off Bar Harbor just beyond Bar Island. These afforded tiny, protected coves, beaches, and rock formations, with constantly shifting views of Mount Desert's hills and stretches of Frenchman Bay all around. Darley inscribed one drawing *Rocks near the landing at "Bald Porcupine Island," Bar Harbor* (fig. 139), suggesting he made his way ashore, perhaps to relax or to draw. Another pencil sketch (private collection) shows a youthful couple fashionably dressed, the woman seated in the bow of a canoe shaded by a parasol, the man gallantly paddling, off a nearby point of an island. Such an image was typical of late-Victorian Bar Harbor, and led one island historian to conclude that the place was now "synonymous with a gay, unconventional, out-of-door existence, with merry courtships and happy, irresponsible days."[49] The scenes Darley observed at water's edge were also the subject of attention of another little-known figure, Henry Waugh, who filled sketchbooks with drawings of local views. He illustrates a panoramic prospect of the harbor activities and surrounding islands off Bar Harbor in his two-page sketch inscribed *View from Cottage Window, Mt. Desert* (fig. 140).

But perhaps the most prolific artist at Mount Desert in the 1870s was Alfred Thompson Bricher (1837–1908). A native New Englander, he was largely self-taught through careful study of Cole and Durand and travel in the Catskills. By 1859 he had a studio in Boston, where his artistic interests turned to coastal subjects and the examples of Church and Lane. That year marked

141. Alfred Thompson Bricher, *Maine Coast*, 1870s

142. Alfred Thompson Bricher, *Otter Cliffs, Mt. Desert Island, Maine*, 1870s

the important beginning of his artistic apprenticeship on Mount Desert Island, where he went to paint in the company of Church, Hart, Haseltine, and Charles Temple Dix.[50] Dix was a sophisticated, well-educated, well-traveled artist, who had already spent some time in Europe during the fifties before devoting himself to marine painting. Noted for having "executed several admirable coast and sea pieces," Dix, said Tuckerman, was a painter "of rare promise and no inconsiderable performance in the sphere of marine landscape."[51] This first summer trip to Maine must have been especially stimulating for Bricher in the company of such artists, for in the years directly following he

started exhibiting Mount Desert subjects at the Boston Athenaeum, and from the early seventies to the mid-nineties he revisited and repeatedly painted views from one end of the Maine coast to the other. For example, at the 1871 National Academy of Design exhibition in New York he showed *Sunset* and *Moonrise on Ironbound Island, Mt. Desert, Maine*. During the later seventies he paused to paint in the Portland and Cape Elizabeth area, and from the eighties to the end of his life, he sailed down the coast to find even more dramatic scenes at Grand Manan Island. But Mount Desert seems to have been a regular stopping point on these trips, for even in the nineties Bricher was showing pictures

143. Alfred Thompson Bricher, *Coastline near Otter Cliffs, Mt. Desert Island*, 1870s

titled *Sunset at Mount Desert* and *Under Schooner Head, Mt. Desert Island*.[52]

Bricher married and moved to New York in 1868; instead of locating himself in the more fashionable Studio Building, he took quarters downtown in the Association Building of the YMCA, and there worked in the company of Hart, George H. Smilie, and John La Farge, all of whom made their own excursions to Mount Desert (see figs. 154, 158). Little if any of Bricher's work on the island during the first summer trip can be firmly identified, and only occasionally did he date paintings in his maturity. Once his style was set, he remained consistent in working methods, media, and compositional formats. Like Richards and others of his generation, Bricher was a prolific drafter, sketching spontaneously and constantly on small pads. These works were primarily of two types, pen-and-ink and wash drawings (figs. 141, 142). Many of these bear alternate margin lines, as he sought the most appropriate shape for a picture. For example, the parallel lines at each side of the little drawing entitled *Otter Cliffs* seem intuitive

reinforcements of the sheer rock silhouette, as Bricher began to balance dark and light, space and solid, vertical form and horizontal expanse, even as he was responding to the scene on the spot. On another equally small sheet (fig. 142) he shows the cliffs from the other side, this time employing narrow strokes of gray and black wash. Still another watercolor sketch of the coastline, probably in the same area (fig. 143), makes use of blue washes applied with similar, relatively short brushstrokes. In these he managed to suggest both the liquid elements of water reflections and, through leaving parts of the white paper untouched, the bright effects of sunlit skies.

When Bricher turned to oils, he drew on this wide inventory of scenic effects and compositional possibilities to create carefully rendered canvases filled with glistening details of light and strong tonal contrasts. Many of the paintings of his maturity bear such generic titles as *Along the Maine Coast*, and are hard to locate with absolute precision, but this one (fig. 144) could well be a view of Frenchman Bay in the area of Hull's Cove or Salisbury

144. Alfred Thompson Bricher, *Along the Maine Coast*, 1870s

145. Alfred Thompson Bricher, *Sand Beach, looking towards Otter Cliffs*, 1870s

Cove. Probably based on more than one preliminary study, it condenses within this elongated luminist format the immediacy of a warm summer day. The result is the restful serenity of nature captured at high tide and high noon. Two related oils may be more confidently identified as images of Sand Beach viewed from different angles. The smaller (fig. 145) is an oil study closer in spirit to Bricher's plein air works on paper; it looks west along the island's bold southern shoreline toward Otter Cliffs in the distance. A more finely drawn studio piece is the larger canvas viewing Great Head at the eastern end of the beach (fig. 146). Here Bricher combines his particular command of the smooth nuances of soft, silvery clouds with the tighter rendering of

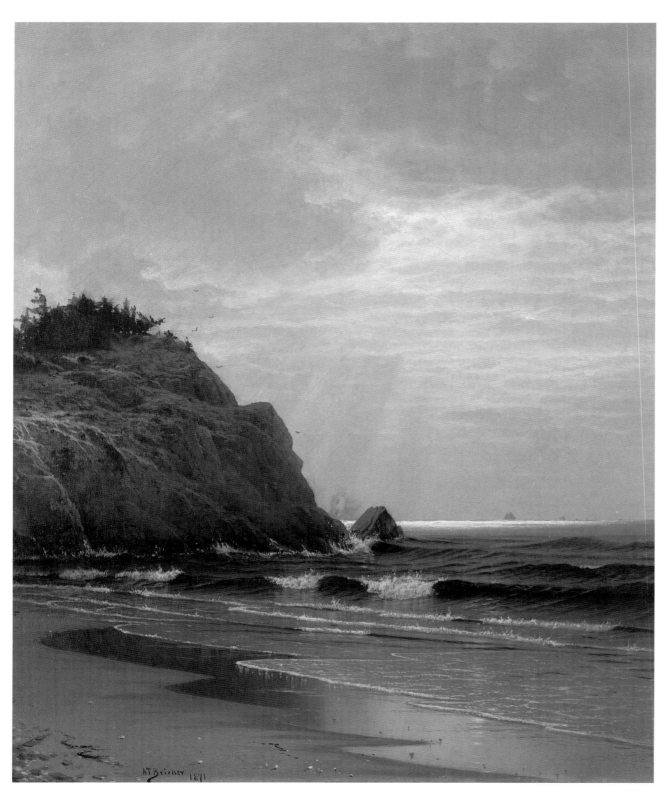

146. Alfred Thompson Bricher,
Cloudy Day, Great Head, 1870s

exposed rock highlights, foamy curls of breaking waves, and the mirror-clean patterns of receding water on the sand. Dated 1871, near the beginning of his long artistic romance with Mount Desert Island, this work was seldom surpassed in his career.

Bricher hit his stride during the 1870s at Mount Desert; Xanthus Smith (1839–1929) was almost an artist-in-residence on the island in the eighties and nineties. Another Philadelphian, he presumably heard of this coastal destination for artists from the growing number of his colleagues making visits throughout the last half of the century. He was the son of Glasgow-born Russell Smith, who emigrated early to Pennsylvania, and who himself became a highly successful landscape painter of the Hudson River school during the middle decades of the century. Xanthus studied at the Pennsylvania Academy and no doubt with his father, achieving a sufficient level of accomplishment to merit regular exhibition of his work from 1856 through the following decade. During the Civil War he began an extensive series of pictures documenting major combat vessels and naval engagements, in part stimulated by his own firsthand experiences in the navy and service under Admiral Farragut and Admiral DuPont.[53] Although he continued the rather conventional landscape formulas seen in his father's works, Xanthus was intensely enthusiastic about marine and coastal subjects, and seldom in the best work of his maturity is water not a major element. The Mount Desert region remained a natural passion throughout his later life.

Smith brought to his observations of the island the same accuracy of detail and location that characterized his maritime battle scenes. A few years after the war's end, he began his summer visits to Maine, which included stays first in Portland and then on Mount Desert. As early as 1867, when Tuckerman published his history of American artistic life, he could note in his paragraphs on Russell Smith that "the artist's son, Xanthus, has already exhibited much of his father's genius for landscape, and has achieved no ordinary degree of success in his profession as an artist."[54] The first year for which we have a substantial body of documented work done by Xanthus Smith at Mount Desert is 1877, when he spent the latter part of August exploring the eastern shoreline, where Church, Hart, and Gifford had been active. In a light, very fine pencil he did a sequence of silvery, delicate drawings of what he called "Peak of Otter & Sandy

Beach" (now known as the Beehive) and nearby Great Head, as well as Schooner Head and a view across to Ironbound Island (figs. 147, 148). With their tight lines, closely controlled gestures, and restricted range of shading, these are nonetheless works of great suggestiveness, for the sharp lines clearly evoke the solid structure of rocks, while the softer feathery marks effectively convey the organic textures of trees. Even when taking the distant view, Smith focuses his interest in a few important forms, as if seeing them under a microscope. His vision is intimate in both observation and execution, as may be seen in the tiny curling lines of his inscriptions and initials, rendered, it seems, by just the concentrated pressure of his fingertips.

Five years later Smith returned to sketch on the other side of the island, a quieter and more protected region that would hold his attention throughout the eighties. His drawing dated 2 September 1882, *Beech Mountain, Southwest Harbor* (fig. 149), shows the growing fishing village and its calm harbor, with a good-sized schooner anchored off a pier. His pencil work now seems slightly loosened from the controlled hand of 1877, and indeed, his drawings over the next few years became freer, more open, and more textured. In these years the large and handsome Claremont Hotel was constructed and opened in Southwest Harbor, close to where Smith had been sketching. Having boarded with a local family, he now took rooms in the newly opened hotel with its splendid view across the harbor toward the opening of Somes Sound, a prospect that had so transfixed Lane on his visits three decades earlier (compare figs. 48 through 53). The hotel's early registers indicate that Smith signed in alone or with his family each August in 1885, 1886, 1889, and 1890. From other dated drawings and watercolors it is evident he was there as well in 1883, 1884, 1887, and 1892 through 1895.[55]

As he became familiar with the surrounding area, he began to experiment with other media, notably pen, wash, and watercolor. In a change from his favorite shoreline scenes, in 1887 he sketched an inland view near Southwest Harbor in a combination of graphite and pen. An 1894 drawing of waves crashing off a promontory with a lighthouse (probably that on Bear Island) reveals a much broader and more expressive use of pencil shading and textures.[56] On the other side of the island the year before, Smith did a similarly fresh and quickly executed drawing, *Star Crevice, Salisbury Cove* (fig. 150), a notable split-rock

147. Xanthus Smith, *Peak of Otter and Sandy Beach, Mt. Desert, Maine*, 22 August 1877

148. Xanthus Smith, *Looking North West from Schooner Head, Mt. Desert, Maine*, 1877

149. Xanthus Smith, *Beech Mountain, Southwest Harbor*, 1882

150. Xanthus Smith, *Star Crevice, Salisbury Cove*, 1893

formation and a popular attraction along that part of the coast. Cursory as these drawings were, they exhibited a growing awareness of light, atmosphere, and the action of water. These interests also found an outlet in watercolor sketching, which Smith took up intensively in the mid-eighties and pursued actively over the next few decades. Usually on a small scale comparable to his pencil and pen studies, these sheets show many of the same subjects: coastal sailing vessels or wrecks and calm views within Somes Sound. Under the pervasive influence of European and American impressionism, artists generally were more attentive by century's end to the spontaneous effects of outdoor color and sunlight. Smith's rendering of the transparencies of water, the moisture of cloud formations, and reflected patterns is akin to Haseltine's brighter and more fluid palette in the mid-nineties (see figs. 122, 123). Typical of Smith's watercolor work at this time are two scenes most likely done on the island's gentler western side, somewhere near Pretty Marsh (figs. 151, 152).

151. Xanthus Smith, *Pretty Marsh*, 1890s

152. Xanthus Smith, *Pretty Marsh,*
Mt. Desert, Maine, 1890s

153. George H. Smilie, *Bar Harbor*, August 1893

One revealing index of the evolution in Smith's style and technique during the last decade of the century was his frequent reworking of pen or pencil drawings of the nineties with watercolor washes added a decade or more later. (One of a rocky headland is first dated 1893, and enhanced and redated 26 February 1910.)[57] By 1914 Smith was undertaking primarily pure watercolors in the studio, as indicated by their winter dating. Smith and George H. Smilie (1840–1921) represent the final stages of the venerable Hudson River school tradition, first articulated by Cole early in the century. No longer concerned with the image of the adventurous artist pioneering in the wild frontiers of nature, this last generation enjoyed leisure hours and pleasurable social conduct in a settled summer resort.

Smilie also came from an artistic family based in New York; he studied with James MacDougal Hart, whose brother William painted in Maine in the 1860s. An officer of the American Watercolor Society, Smilie favored use of the wash medium on his own visit to Mount Desert during August 1893. His watercolor

Bar Harbor and his chalk drawings *Newport Mountain from Bald Porcupine* and *Otter Cliffs* (figs. 153 through 155) show the now-familiar looseness of stroke, fascination with broad textures, and bright effects of color generally favored in this decade. The sailing vessels dotting Frenchman Bay are signs of wealth, recreation, and pleasure.

Finally, during this fin de siècle period, a few other idiosyncratic artists arrived and made the occasional personal recording of their travels. Some, such as Ralph Blakelock (1847–1919), Louis Comfort Tiffany (1848–1933), and John La Farge (1835–1910), we would hardly expect to find associated with this corner of Maine, though the first was at this time a constant traveler and landscape observer, and the second two with their devotion to work in stained glass must have loved the glowing colors of Maine light in the summer months. In Blakelock's case, we have only one drawing, done in the style of the early pen sketches from his better-known Western journeys (fig. 156). Its generic title, *The Nubble, Coast of Maine*, could place this almost

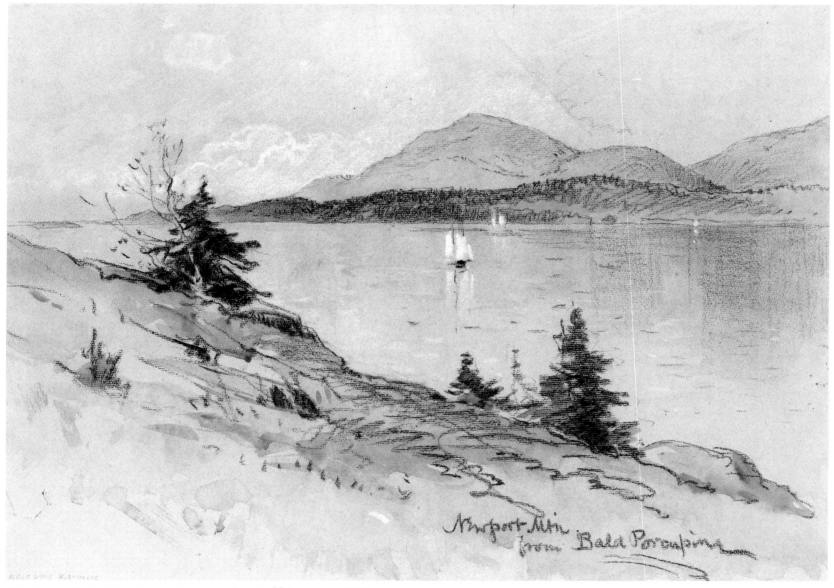

154. George H. Smilie, *Newport Mountain from Bald Porcupine*, 1890s

anywhere, but such outcrops are so named locally around Mount Desert. The nervous and austere penmanship of this drawing is characteristic of Blakelock, who is more familiar for his later visionary landscapes; this represents a rare and unexpected diversion in his career.

Likewise, we know virtually nothing of the circumstances that brought Tiffany, the cosmopolitan artist and master of decorative arts, to Maine. He is well recognized for his highly imaginative screens and translucent glass designs; he received a number of international awards and wide patronage from wealthy New

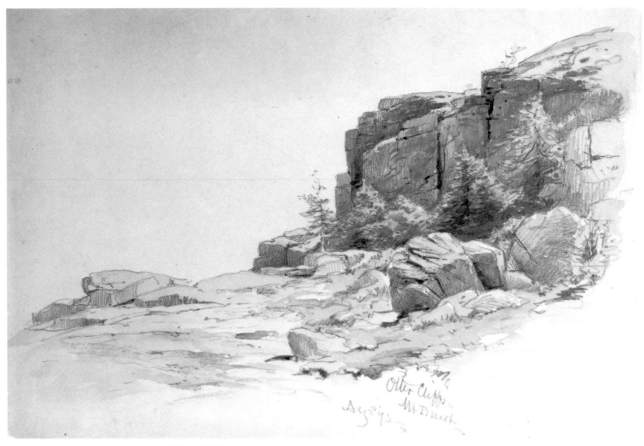

155. George H. Smilie, *Otter Cliffs*, 1890s

156. Ralph Blakelock, *The Nubble, Coast of Maine*, possibly 1890s

Yorkers and Newporters at the end of the century. Perhaps through one of these connections he was enticed to visit the resort communities on Mount Desert, it is thought, in the summer of 1888. His painting *My Family at Somesville* (fig. 157) is a domestic vignette set in a sunny meadow of summer flowers with the island's mountain slopes behind. The broad brushwork and bright palette bear the legacy of impressionism as it was widely practiced by its American interpreters during these years. Tiffany's familiarity with orientalism and his European experience put him comfortably in an international and social context. A decade or so later, Frank W. Benson brought a similar artistic style to his paintings of summer hillsides and family gatherings on North Haven Island in Penobscot Bay.[58] Unlike Benson, Tiffany found only passing interest in the Maine landscape,

157. Louis Comfort Tiffany, *My Family at Somesville*, c. 1888

though his picture was to represent Mount Desert in a classic American impressionist image.

John La Farge, also international in his training, artistic interests, and travel, seems an equally improbable visitor. After studying in Paris at midcentury, he worked for a time in Newport and later in Boston. He also moved in fashionable cultural and social circles, and collaborated in several architectural projects involving murals and stained-glass decoration. Like Tiffany, he admired orientalist taste and decoration, and had explored the possibilities of watercolor. La Farge was to find a perfect subject full of bright color and a range of light effects—reflected, transparent—when he reached Maine. During August 1896, he came at the invitation of a close friend, Mary Cadwalader Jones, who was the sister-in-law of the novelist Edith Wharton and the

mother of the prominent local landscape architect Beatrix Farrand. Their Bar Harbor estate was renowned for its extensive gardens and terraces designed by Farrand, and it offered the artist a focused view of nearby Porcupine Island, which inspired him to paint half a dozen watercolors during his stay that summer (fig. 158).[59] Their titles suggest that these are studies of the scene at different times of day and conditions of weather, from fog and rain to twilight and moonlight. One can sense their immediacy of observation in the quick execution and fluid passages of overlaid washes. This sheet has additional interest as an on-the-spot study with its sketchier, less-finished right side, where La Farge first tested the colors on his palette and later penciled out a tree to tighten the remaining composition.

Wharton also visited her sister-in-law during these years, as

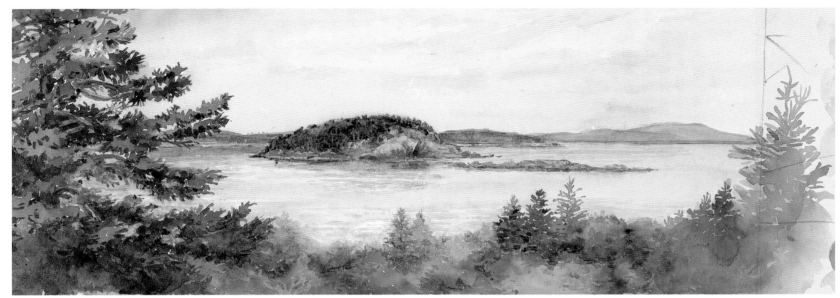

158. John La Farge, *Porcupine Island, Bar Harbor, Maine,* August 1896

Bar Harbor became a hub of social and cultural activity. Bishop William Doane of Albany and Harvard president Charles William Eliot were among the other leaders of a prosperous and distinguished summer community on the island. Benjamin Harrison, president of the United States in the early nineties, came to stay with his secretary of state, James G. Blaine, who was a summer resident. J. Pierpont Morgan came regularly on his yacht, and George Vanderbilt constructed a large estate surrounded by an impressive network of carriage roads in Bar Harbor.[60] The headmasters of two important private boarding schools, Dr. Samuel Drury of St. Paul's and Dr. Endicott Peabody of Groton, settled in Northeast Harbor as regular summer "rusticators." Dr. James Gilman, president of the Johns Hopkins University, was quoted as asserting that "there were three things which he always thought,—the air that he breathed, the views that he looked at, and the people that he met, . . . 'whichever way I put them, they make an ascending climax.'"[61] No wonder some of the country's most fashionable and well-established artists made the pilgrimage and felt at home as guests here while undertaking their artistic pursuits. It was natural that America's foremost portraitist, Thomas Eakins, should feel comfortable among the summer residents from Philadelphia and Baltimore when he came in the summer of 1897 to Seal Harbor to paint a portrait of Henry A. Rowland, professor of physics at the Johns Hopkins University.[62]

Possibly the most original and esteemed American impressionist to arrive was Childe Hassam (1859–1935), a Bostonian who studied in France during the 1880s, and mastered the garden and flower subjects favored by Claude Monet. Beginning in the mid-eighties, Hassam began visiting the Isles of Shoals at the southern end of the Maine coast on the border of New Hampshire, where Celia Thaxter cultivated her famous garden and salon on the island of Appledore. There through the early nineties, he painted many oils and watercolors of her elaborate flower beds set in the bright sunshine and against blue seas. This warm and sympathetic association with her equally creative personality and with the landscape grew over the years until her death in 1894.[63] That year also saw the publication of one of her best-known books, *An Island Garden,* with illustrations based on watercolors by the artist. Although Hassam returned at the end of the nineties, and painted the rocks at Appledore until 1916, he stayed away for several years after her death, which

159. Childe Hassam, *Looking over Frenchman Bay at Green Mountain*, 1896

likely explains his acceptance of an invitation to visit the Mount Desert region shortly thereafter.

John Godfrey Moore, prominent in the successful New York brokerage firm Moore and Schley, was a summer resident of Bar Harbor. But by the mid-nineties he felt the pace of activities and density of settlers were overtaking the quiet enjoyment of the island's beauty, and he decided to move his family across Frenchman Bay to Winter Harbor. There he purchased much of Grindstone Neck, and later sections of Schoodic Point, which he ultimately gave to Acadia National Park. Moore's sister Nellie was a New Yorker who summered in the big family cottage on Grindstone Neck, and the Hassams went to stay with her in the

160. Childe Hassam, *Sunset, Ironbound Island*, 1896

summer of 1896.[64] Like La Farge across the bay at Bar Harbor the same year, Hassam painted different views from his shoreline prospect. But instead of looking at the small array of islands off the edge of Mount Desert proper, Hassam had an opportunity to view the major slopes of the great island mass itself.

His canvas *Looking over Frenchman Bay at Green Mountain* (fig. 159) is a view from Grindstone Neck across Heron Island off the entrance to Winter Harbor, to the southern portion of Ironbound Island at the middle right and Green Mountain rising above Bar Harbor in the distance. In a related oil, *Sunset, Ironbound Island* (fig. 160), Hassam turned the angle of his view slightly northward, this time showing the broad outcrop of Egg Rock with its lighthouse in the middle of Frenchman Bay. It was in this region that Thomas Doughty had conflated his view of the island lighthouse and mainland exactly six decades earlier (compare fig. 10). Hassam's grasp of impressionist techniques is evident in his bright key, relatively short strokes of broken color, and sensitivity to the momentary effects of light. Whether or not painted as pendants, these views contrast times of day: one was painted with the cool greens and yellows of hazy midday, and the other with the more intense lavenders, blues, and oranges of evening.

One of Mount Desert's early historians, George Street, summarized the changes in mood and atmosphere from the vision of an earlier artistic generation to that at the close of the nineteenth century:

> The artists of a later generation do not find the landscape as interesting as did their comrades of an earlier school. It lacks "atmosphere." The typical Mount Desert day has a dry brilliancy which banishes the charm of mystery. The northwest wind is a tonic and the sunshine is vivifying, but on these characteristic days there are no soft horizons or shadowy distances such as the modern artists prefer. Every outline is sharp and defined, every hue is emphasized. . . . Only when the fog wreaths sail in from the sea, or a soft southerly haze occasionally shrouds the sharp horizons, do objects attain the relative values which nowadays tempt a painter.[65]

During the course of the late nineteenth century American artists had embraced a broad spectrum of approaches to recording the Mount Desert landscape, even as they gradually moved, as Street perceptively observed, from the sharp Ruskinian rendering of nature's details to the broader effects of enveloping light and atmosphere.

For his part, Hassam returned, after his one summer's sojourn in Frenchman Bay, to the Isles of Shoals, where he redirected his artistic attention from the flower gardens to the bold outcrops of rocks and open ocean. His biographers explain this by his new interest in Monet's later coastal subjects such as the cliffs at Etretat, but arguably his shift of focus when he went back to Appledore in 1899 was as much inspired by the fresh dramatic grandeur of scale and contrast of elements he saw looking across at Mount Desert Island from the cottage lawn at Grindstone Neck. After the turn of the century his images acquired a powerful new sense of abstract design, as he painted a series of nearly empty seascapes, marked off only by the horizon line, and filled with a rich pattern of color and brushwork, almost detached from observed experience.[66] These seem more personal evocations of mood, surfaces for nuances of texture, paintings of nature simplified and distilled. At Mount Desert, Hassam realized the culminating vision of an observed world in his impressionist manner, and at the same time glimpsed the coming artifices and abstractions of modernism.

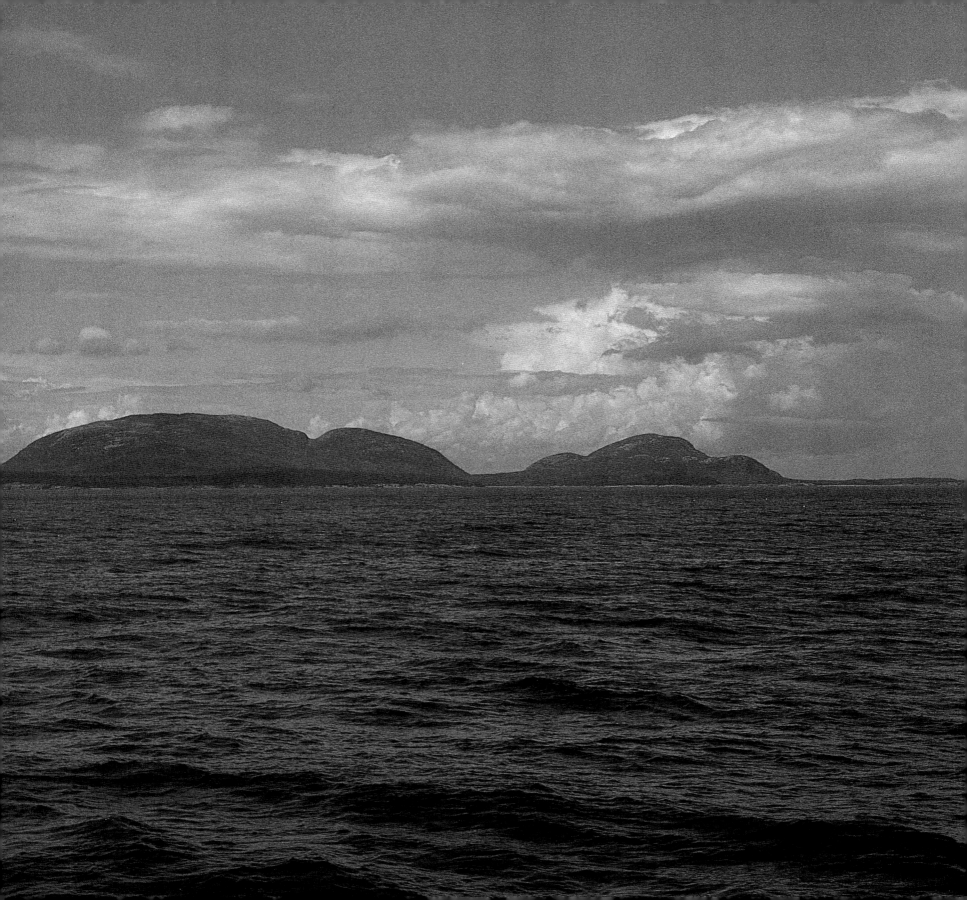

VIII.
The Early Twentieth Century

ONE MAY WONDER why two of the greatest landscape realists, Winslow Homer in the nineteenth century and Edward Hopper in the twentieth, both powerful and unforgettable painters of Maine, never journeyed to Mount Desert for subject matter. An explanation lies perhaps in the metaphorical rather than in the literal nature of their landscapes. Homer, after returning from his two-year stay on the north coast of England, when he settled in his family's compound at Prout's Neck on Maine's southern coast, turned increasingly to the elemental, even symbolic forces of nature. His great seascapes set along the headlands outside his studio began, during the late 1880s and in the following decade, to address two concurrent, almost paradoxical themes: on the one hand personal expressions of feeling, and on the other universalized essentials of nature. Although many of the locations around the ledges of Prout's Neck are recognizable, the specificity of place and the accurate recording of geology were not primary goals for Homer. His late oils transcend location, and the rocky terrain that happened to stretch out around his studio was sufficient for him to compose a vision of mortal forces beyond the immediate and the momentary.[1]

In the case of Hopper, who also painted extensively in southern Maine around the Portland region, we might similarly argue that the rocky terrain he found there satisfied his artistic need for strong pictorial designs and starkly lit forms. While we commonly think of Hopper as a supreme painter of twentieth-century American landscapes, he basically held throughout his career to the architectural forms and alienating spaces of modern city life. His three principal country regions for painting were Cape Cod, Gloucester, and Portland. But open rolling fields, headlands, and

seascapes were rare images in his art: at Truro he preferred to include a farmhouse or porch facade, in Gloucester the silhouetted forms of Victorian woodwork in early row houses, and near Portland the distinctive configuration of the Twin Lights lighthouse. His Maine landscapes did not vary greatly from his Massachusetts settings; perhaps they were a little bleaker and more angular. But like Homer before him, he did not require bold geology to make his art.

By the twentieth century Mount Desert was no longer an alluring destiny at the misty end of a rugged but romantic pilgrimage into the wilderness. Artistic issues of personal and formal expression overtook the faithful recording of the external physical world, and for all of Homer's and Hopper's realism, the power of their art could take shape almost wherever water crashed against rock, or a lighthouse rose above a headland. Not long into the first decade of the twentieth century, new concepts and examples of motion appeared: the theory of relativity, the "moving picture," the automobile, the airplane, and futurism. In his *Education*, published in 1906, Henry Adams saw a modern vision in the idea of "acceleration" and "velocity."[2] The emerging technologies of the modern age meant not only increased speed and efficiency of travel, but also new relationships between humans and the ground beneath them. Along the Maine coast, ferry steamer service reached many of the isolated islands offshore, while improved roadways and railroad lines made distant points like Mount Desert more accessible than ever. Now Philadelphians and New Yorkers might comfortably take an overnight train to Ellsworth and a spur connection to a ferry crossing at Trenton, making vacation travel to the island a regular and reliable routine.

As Mount Desert became more settled, numerous other islands

161. Mount Desert from the south

157

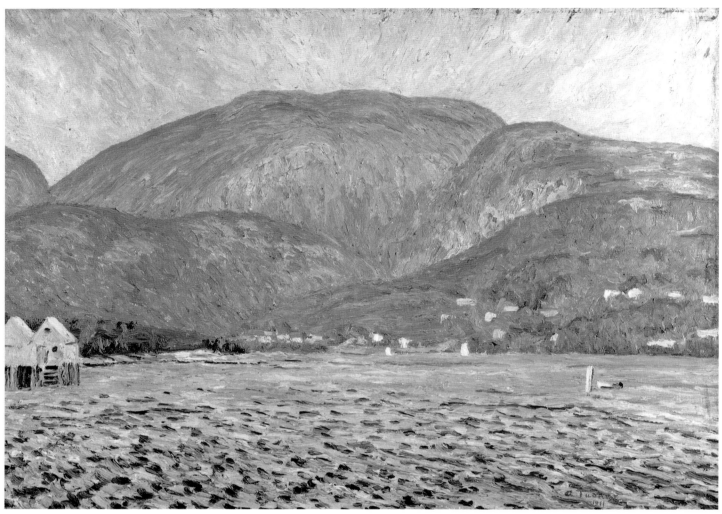

162. Allen Tucker, *Green Mountain*, 1911

gained appeal as picturesque spots for vacationers, tourists, and artists. Already noted is Childe Hassam's attraction to Appledore; early in the century the impressionist Frank Benson settled on North Haven, and the younger realists Leon Kroll, Rockwell Kent, and George Bellows discovered the raw beauty of Monhegan Island.[3] Indeed, travel and accessibility may well have been the two most critical factors in Mount Desert's transformation during the first quarter of the new century. Just as the nineteenth century saw the great changes wrought by the shift from sail to steam travel, so the early twentieth century brought to Mount Desert both the automobile and the promise of an

increasing number of visitors to the scenic and heretofore protected coastal wilderness. It was at once coincidental and imperative that the building of a causeway bridge across the Narrows at the head of the island, the introduction of cars, and the creation of a national park on Mount Desert should have all occurred about the same time, toward the end of the second decade. As pressure built to allow greater public access to the area's natural scenery and amenities, the visionary leadership of Charles William Eliot, George Dorr, and John D. Rockefeller, Jr., combined to effect the transfer of the most precious tracts of land (the major mountains and southeastern coastline) from private

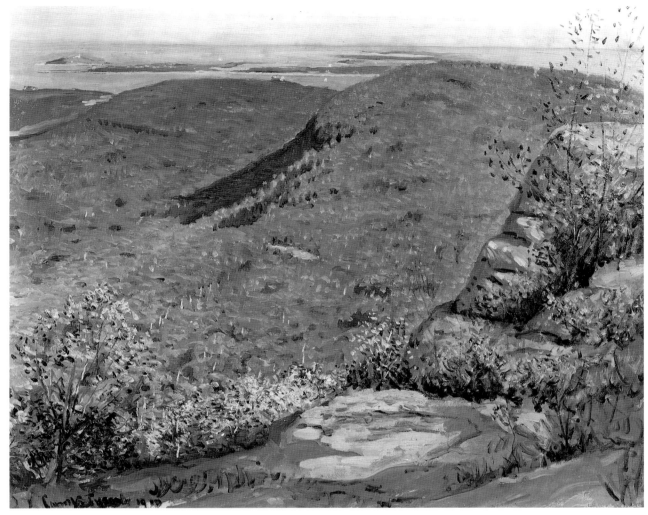

163. Carroll Tyson, *View from Cadillac Mountain*, 1910

trusts to federal ownership.[4] The paradox of this turning point in the island's history and identity is that Mount Desert was no less changed than it was preserved.

Many significant figures continued to visit or paint the island through the twentieth century. Their individual and varied styles represent extensions of earlier modes of expression and modernism's transforming points of view. Despite the social changes taking place, the distinctive scale and silhouette of the island still held visual inspiration. For the impressionist this was an ideal landscape of flickering color and strong light; for the expressionist the massive slopes and primal forces of water

against rock could be deeply evocative; for the modernist experimenting with aspects of abstraction, the sharp contrasts of shapes lent themselves to formal simplification and interplay. Like the nineteenth-century painters, each succeeding generation in the twentieth century was able to formulate its own artistic response to this enduring landscape.

One stylistic current that remained strong in America and at Mount Desert after the turn of the century was impressionism broadly defined. First developed in France more than a generation earlier, impressionism by the last decades of the nineteenth century had already dissolved into a variety of

subcategories and permutations, loosely gathered under the general term post-impressionism. Artists began to employ broken brushwork and patches of color independent of description, forming patterns and textures with almost a life of their own on canvas surfaces. Light and color no longer necessarily modeled form or defined space; they acquired emotional and psychological associations detached from momentary experience. Nature was often an armature for aesthetic issues, and both French and American painters freely pursued the many possibilities that were offered by making art, once they were liberated from literal documentation of a scene.

Two painters fully in command of the techniques of later impressionism, who carried on Hassam's legacy at Mount Desert after the turn of the century, were Allen Tucker (1866–1939) and Carroll S. Tyson (1878–1956). The former was admired as an early American disciple of van Gogh, though he trained in New York at the Art Students League with another American impressionist, John Twachtman. Tucker formally acknowledged his artistic indebtedness to his teacher in a later exhibition catalogue: "It was Twachtman who opened the door for me."[5] Tucker's subsequent travel to Europe exposed him to the pervasive influence of Claude Monet's later work. His synthesis of these several stylistic sources parallels the modernist adaptations by his contemporaries in "the Eight" and in the Stieglitz circle, who were looking to recent currents in European art. Most frequently compared to Tucker is William Glackens in his emulation of Renoir's late-impressionist brushwork and color.[6]

Tucker's painting *Green Mountain* (fig. 162), looking northward from Seal Harbor, exemplifies his generation's transformation of the European vocabularies. Painted on a visit in 1911, the scene depicts the island's highest summit, known as Green Mountain until its change by the National Park Service to Cadillac Mountain in the 1920s.[7] The mountain's looming slopes fill most of Tucker's canvas, contrasted with the dense pattern of thick brushwork describing the agitated water surface in the foreground. His hues are bright greens, warm yellows, blues, and pinks. While these colors, along with the choppy brushstrokes of pure pigments, loosely recall Monet's later impressionist techniques, Tucker's process has moved even further from trying to record direct visual sensations, and more toward conveying the sense of nature's different textures and energies, directly felt in

the manner of van Gogh. Van Gogh himself responded to Monet's more expressionist mode of painting in the later 1880s, when both began to adapt their brushwork and color application to each individual element of a landscape. Thus, instead of an even surface, the paint itself varied according to detail, not just describing forms but attempting to approximate and identify with the different physical textures of water, rock, foliage, and sky. In Tucker's painting, we come to see as well as feel the hulking mountain mass, the high, thin sky above, and the dappled harbor surface in the foreground.

The Philadelphian Carroll Tyson was equally a devotee of impressionism and Mount Desert, but unlike Tucker, who made a single visit, Tyson came to the island as a child, and he returned faithfully almost every summer for the rest of his life. Educated at the Pennsylvania Academy of the Fine Arts and in several European cities, he was well aware of his two Philadelphia predecessors, Thomas Eakins and Mary Cassatt, who had earlier made their artistic pilgrimages to Paris. But it was the later manifestations of impressionism and post-impressionism that influenced Tyson most, and he admiringly recalled his visits to the studios of Monet and Georges Seurat. His immersion in the French tradition also led Tyson to begin collecting important works by Cezanne, Manet, Renoir, and van Gogh.[8] His regard for these masters may be seen in his own art, which consistently present colorful landscapes containing people enjoying outdoor pleasures, almost always under benign skies and in gentle circumstances. Although he painted well into the fifties, his style was essentially set in the last golden years before World War I. Like his contemporaries Maurice Prendergast on the north shore of Boston, John Sloan at Gloucester, and Edward Potthast at Newport, Tyson created an art that in retrospect celebrated the end of an era, of a natural and social paradise, that culminated with the upheaval of the First World War, and the artistic watershed event of the Armory show.

But for several decades Tyson held unflaggingly to his cheerful vision of Mount Desert and the enduring physical beauties and pleasures of the region. On canvases of a consistent size he painted its hillsides, *Western Mountain* and *View from Cadillac Mountain* (fig. 163); its fishing and sailing communities, *John's Island, Bass Harbor, View from Manset, The Road to the Pier (Southwest Harbor)*, and *Beach at Seal Harbor* (fig. 164); its

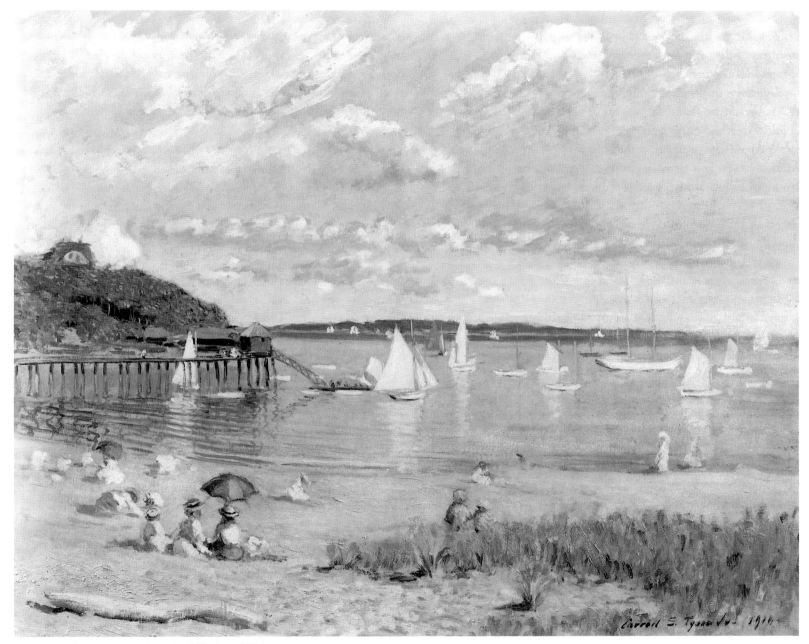

164. Carroll Tyson, *Beach at Seal Harbor*, 1910

eminent scenic locations, *Somes Sound* and *Otter Cliffs* (fig. 165); and its surviving commercial enterprises, most notably *Hall's Quarry* (fig. 166).[9] This last was a fond tribute to a great island industry extending back to the nineteenth century, when Maine's granite traveled in blocks on Fitz Hugh Lane's sturdy schooners to Boston and elsewhere to make possible the country's state houses and other classical buildings. The strong colors of this picture and the harmony between nature's beauty and modern machinery convey an image of unabashed energy and, ultimately, nostalgia. Tyson's views still exhibit a kinship with those observed

almost a century before by Cole and his followers (compare figs. 30 and 65). Like Tucker, he was able to draw from his palette intense, vibrant hues; his work went beyond description to embody personal feelings.

The appearance in the area of John Singer Sargent during the early 1920s should be noted in passing. Then in the twilight of his long and esteemed career, Sargent was the grand old man of fashionable American portraiture and master of the dazzling impressionist landscape. A cosmopolitan expatriate in England and Europe for much of his career, he maintained his American associations and patronage. Returning to Boston in his later years, he executed commissions to decorate the new McKim, Mead, and White Boston Public Library on Copley Square, the new Museum of Fine Arts in the Fenway, and the main staircase of the new Widener Library at Harvard. Possibly as a respite from these formal obligations, Sargent accepted an invitation to visit his friends, the Dwight Blaney family, on Ironbound Island in Frenchman Bay in 1921 and 1922. Blaney was an artist, and Sargent was relaxed in his company. Regrettably for our interests, he painted no landscapes of Mount Desert on these visits, but rather two affectionate pictures of his friends in the quiet setting

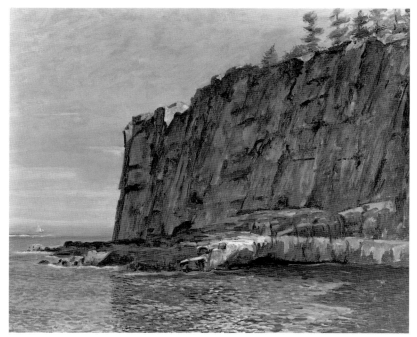

165. Carroll Tyson, *Otter Cliffs*, c. 1910

of their woodland property. One was a watercolor of Blaney with his wife and two daughters at ease on the veranda of their house, and the other an oil of his colleague seated with an easel in the woods nearby.[10] Both are fresh and intimate portraits, almost casual genre studies of a family's occupations, and we can only wish that while there, the great American master of oil and watercolor painting had turned his attention to the sweeping landscape on view around him from Ironbound. One can imagine what sparkling images he might have captured in the manner of his unsurpassed Alpine landscapes of a few years before. But in the last years of his life, Sargent perhaps appropriately chose the intimacy of figures on a shadowed porch and a painter at work in the darkened enclosure of a forest grove. Unlike Sanford Gifford's artist embracing the distant horizon (see fig. 132), the figure in Sargent's painting sits meditatively in an arboreal studio.

Realism was undergoing certain adjustments at the hands of many artists during the first quarter of the twentieth century, and other impulses toward modern subjects and techniques were emerging. Although still a distant location for many American artists to reach, Mount Desert nonetheless attracted its share of modernists, who readily found ways of abstracting the landscape without losing sight of it. Among the most prominent visitors in this category were William Zorach (1887–1966), Oscar Bluemner (1867–1938), John Marin (1870–1953), and Marsden Hartley (1877–1943).

Known primarily as a sculptor of human figures carved in wood and stone, Zorach became familiar with the modern tradition while studying and working in Paris during the second decade of the century. There he was exposed to fauvism and cubism, on both of which he drew for his landscape paintings during the 1920s.[11] The first movement provided him with examples of strong expressive colors independent of visual reality, while the latter showed how forms might be seen in their essential structures. In 1920 Zorach visited Yosemite Valley in California, where his landscapes incorporated these new styles, and six years later painted at Bar Harbor. His watercolors from that summer (figs. 167, 168) show the introduction of modern cruise ships, now visiting the area on a regular basis, set against a denser and busier harborscape. In the fauve manner Zorach manipulates his colors, pure blue washes for the distant mountains and patches of overlaid wash for the fused details of architecture and foliage.

The cubist vocabulary is evident in the angular edges of forms, overlapping planes of light, and the play of transparency versus solidity. While American cubism never reached the degree of fragmentation or abstraction seen in the work of European artists, Zorach makes good use of the modern styles to match his subject.

Oscar Bluemner seems an equally improbable observer of Mount Desert, coming from an early career as an architect followed by a productive trip to Europe in 1912. He, too, responded immediately to the creative possibilities of recent expressionist movements in France and Germany, and even more

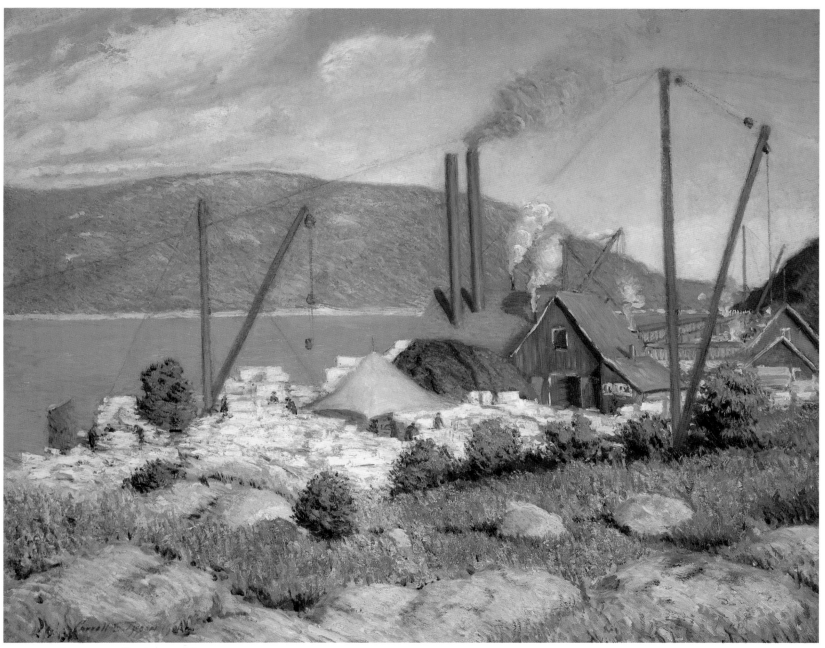

166. Carroll Tyson, *Hall's Quarry*, 1906

167. William Zorach, *Bar Harbor, Maine*, 1926

168. William Zorach, *Bar Harbor, Maine*, 1926

169. Oscar Bluemner, *Frenchman's Bay from Cadillac Mountain*, 1920s

to the agitated, fractured forms of cubism and futurism. The reduction to essentials and energetic sequences of forms helped shape his personal style of staccato patterned landscapes. He was a constant sketcher, and his notational style carried over into many of his larger works. Sometime in the twenties he probably made the mountainside drawing titled *Frenchman's Bay from Cadillac Mountain* (fig. 169), with its characteristic rhythms of rounded and scalloped shapes, first in pencil and then heightened with colored washes. The view itself and the process of quick observation recall the early precedents of Cole, Church, and Gifford (see figs. 30, 65, 132).

The two principal modernists who left some of the strongest images of Maine in the twentieth century were John Marin and Marsden Hartley. Both painted more extensively in the areas on either side of Mount Desert, but in each case important views of the island region itself indicate their periodic interest in this part of the coast. Marin conducted an artistic love affair with Maine through much of his long, prolific career. His first training was in mechanical engineering and drawing, which led to a brief career in architecture. When he subsequently turned to painting, this youthful experience was evident in his facility for drawing and the clear linear description of forms.[12] Almost all his art reflects an underlying consciousness of structure, plane, and cubic

essentials. One might say that Marin's landscapes, whether of the city or of the seacoast, always give knowing attention to the "architecture" not just of buildings but also of mountains and rocks.

At least three other factors contributed to the shaping of his artistic direction: further study at the Pennsylvania Academy of the Fine Arts and the Art Students' League in New York, sustained support from the pioneering photographer and avant-garde dealer Alfred Stieglitz, and a trip to Paris where Marin came to know the work of Cézanne and Matisse at a critical moment in European modernism. These combined experiences enriched his technical abilities immensely, such that (in addition to being able to paint with a brush in either hand) he mastered etching, drawing, watercolor, and oil. Like other Americans exposed directly to the new artistic movements in Europe, Marin found a fresh stylistic vocabulary in the strong cubic massings of form in Cézanne's late landscapes and in the daring boldness of Matisse's flat patterns of brilliant colors. Closely related to cubism, futurism came to be associated with the dynamic energies and shifting pulses of modern life. Marin drew on these precedents of active, unstable forms and rhythmically repeated lines or structures to capture first the pace and excitement of the urban landscape and later the sparkling flux and contrasts of the northern coastline.

While in Paris in 1910 Marin met Ernest Haskell, an artist, who invited the painter to visit Maine. Four years later, for the first of several summers, he took a house not far from Haskell in Casco Bay between West Point and Small Point.[13] Immediately he began doing watercolors of the area in a lyric shorthand that had a written parallel in the poetic notes he made at the time: "Big shelving, wonderful rocks, hoary with enormous hanging beards of seaweed, carrying forests of evergreen on their backs."[14] The following summer he ventured a little further east to paint in the Stonington (Deer Isle) area, where he moved in 1919 for the following few seasons, and produced many of his signature images. From the proliferation of bright and animated watercolors and oils that appeared in these years, it is clear that this picturesque fishing town, set along the rocky southern coast of Deer Isle and protected by a string of small islands, had captured the painter's eye and heart. He set his energetic lines down on paper, visually and verbally: "This place of mine, a village, where

170. John Marin, *Looking Towards Isle au Haut, Maine, from Deer Isle*, 1919

171. John Marin, *Looking Towards Mount Desert, Maine*, 1933

172. John Marin, *Vicinity Frenchman's Bay, Maine Coast*, 1933

clustered about you can see if you *look* dream houses of whiteness, of a loveliness of proportion, of a sparingness of sensitive detail, rising up out of the greenest grass sward."[15]

The summer of 1919 was the first time Marin cast his painter's glance in the direction of Mount Desert, still further to the east. Looking across from Deer Isle, he could see the rising contour of Isle au Haut, the one island with any height before Mount Desert itself. Along with the main island, much of Isle au Haut has now come under the protection of Acadia National Park. In Marin's first glimpse of it, he emphasized its domination of the horizon (fig. 170); his watercolor is a selective assemblage of a few basic shapes, bushes, grasses, paths, and water, set down in quick brushstrokes. As his words confirm, his view concentrates on spareness, proportion, colors, and detail. But the white areas of the page and the touches of reflections in the water also reveal his alertness to the immediate presence and particularity of light. His

many related images of sunsets, rain clouds, and fog banks indicate a broad attention to different conditions of weather and time of day, exemplified in such well known paintings as *Storm over Taos*, 1930 (National Gallery of Art) and *The Fog Lifts*, 1949 (Wichita Art Museum, Kansas).

During his years in Maine, Marin's style gradually evolved from a delicate and descriptive linework to a bolder and more reductive manner. He also seemed drawn slowly eastward until 1933, when he summered with his family at Cape Split, to the east of Frenchman Bay and Schoodic Point. Here the coast was more stark and sparsely populated, the essential elements of the environment more confrontational and unmediated. He bought a cottage built at the edge of the sea; on the ground floor it was surrounded with a broad, windowed porch giving a full panorama of the coast and open ocean. The latter now became the principal focus of his paintings.[16] Also critical to his later style and choice of subject matter was his travel along the coast by boat. Earlier Marin had gone sailing with Haskell, who recalled that they "sailed to Ragged island and Wallace Head—all over Casco Bay we sailed. He believed in sailing. . . . And now I see sailing, in his pictures of the sea—the very essence of sailing."[17]

To reach Cape Split from Stonington by boat, one must cross the southern ends of Penobscot Bay, Mount Desert Island, and Frenchman Bay, a passage Marin must have made several times. En route he would have seen the rising hills of the island, much as Samuel de Champlain had three centuries before, across the open water. The Marin literature makes virtually no mention of his Mount Desert work, but the prospect did engage his observation.[18] Two unusual watercolors from 1933 show us the island's hills silhouetted on the horizon (figs. 171, 172). One assumes an elevated vantage point in the foreground, perhaps viewing Mount Desert across lower Jericho Bay from Deer Isle. The second combines the abstraction of a compass in the upper left with a more conventional seascape across the center and the mountain outlines above, in a maplike recording almost like a Coast and Geodetic Survey rendering. This last is the artistic heir to Fitz Hugh Lane's water-level drawings of the island sketched from his approaching vessel (compare figs. 40 and 41). But Marin's inner oval or corner frames, shifting viewpoints, and reductive visual shorthand all reflect his modern transformation of what he sees into a pictorial artifice.

173. John Marin, *Schoodic Point*, 1941

Observing Mount Desert from offshore, or the open ocean from his cottage at Cape Split, he found that "here the Sea is so damned insistent that houses and land things won't much appear in my pictures."[19] That charged and ever-changing emptiness came to dominate his late images, and a 1941 drawing titled *Schoodic Point* (fig. 173) shows the end of the peninsula barely noted at the upper left. Marin is clearly on a boat heading east from Mount Desert, and just entering the swirling tide pools and rougher water off Schoodic where Frenchman Bay opens out into the Gulf of Maine. His biographers describe his late style as calligraphic; this is evident here in the rich variety of length, width, intensity of pressure, and direction of his pencil strokes. But his oil paintings were also becoming slates of grafitti in oil, whether from the brush or, at the end, squeezed directly out of tubes or even hospital syringes. He titled one of his last canvases *The Written Sea*, 1922 (private collection).[20] Such works evolved into personal abstractions of experience, with the internal energy and excitement of the pure creative process. Marin asserted that they "have the music of themselves—so that they do stand of themselves as beautiful—forms—lines—paint on beautiful paper or canvas."[21]

The sense of isolation and the stern face of the sea at Schoodic Point were also the focus of Marsden Hartley's attention at this time. A native of Maine (born in Lewiston in 1877), Hartley also came to this part of the coast after a number of years of travel. When he returned to Maine, he knew and admired Marin's work, and was doubtless conscious of Marin's association with Maine when he painted in the Schoodic area.[22] But as their biographers have pointed out, and as we may readily observe in comparing their work on the coast, Marin favored attention to water over rock, and with Hartley it was the reverse. Even pictures like *The Wave* (Worcester Art Museum) or *Evening Storm, Schoodic Point* (fig. 174) treat water as a massive geometric solid in a composition of colored building blocks and pigments thick and immobilized. Painted near the end of a tormented and restless career, this work reflects Hartley's constant search for stability and permanence in the midst of loneliness and change.

This quest began early and most likely unconsciously. The youngest child of nine, he faced neglect at age eight after the death of his mother, and by the early nineties he undertook the first of many moves that would continue for the rest of his life. Conflicted emotionally and sexually, Hartley sought for reassurance in personal relations, in the world about him, and in his artistic forms. For much of his life he could not settle in one place for long; so too his art, for a long while at least, shifted in style and technique as he found temporary sustenance in different aspects of European modernism. A selective recitation of his travels will testify to the unsettled course of his life: in 1893 his family moved to Cleveland, and six years later he went to New York for art school. Then in the next decade he traveled to Boston and back to New York. In 1913 Hartley began his first European trip, which included stays in Paris, London, and Berlin, before returning to New York in 1915. Almost immediately he set off for Provincetown and then Bermuda, and between 1918 and 1921 went to the southwest to paint, then back to Germany until 1930. This decade took him to New Hampshire; Gloucester, Massachusetts; Mexico; Germany; Gloucester again; and Nova Scotia. Hartley at last returned to settle in Maine in 1937 for most of his final seven years. Even then, he spent about nine months a year in Maine, with trips away the other three months.[23]

When he first came east as a young man, Hartley learned about post-impressionism, notably from the work of the Italian Giovanni

Segantini and the American Maurice Prendergast. In New York, thanks to the modernist aspirations of the Eight and the groundbreaking exhibitions of Alfred Stieglitz, Hartley soon encountered the visionary simplifications of Albert Ryder's painting and the fauve expressionism of Henri Matisse. Finally, even before leaving for Paris, he was emulating the proto-cubist work of late Cézanne and early Picasso. Once in Germany, Hartley responded warmly to the musical associations and color expressionism of Wassily Kandinsky.[24] With each discovery, his painting technique and style changed, not so much in slavish imitation as in passionate absorption, seeking personal liberation. However uneven the first half of his career may have seemed, with artistic peace always elusive, Hartley gradually found subjects and powerful ways of painting them that reveal his particular freedom and reach of imagination.

Among the subjects to which he repeatedly turned, no matter where he was painting, were bold and singular mountains, or their equivalents in feeling and scale to be found in oversized boulders and massive rock formations. So he took on both Cézanne's blocky structures and the specific imagery of Mont Saint Victoire. In New Hampshire he concentrated on the Franconia Mountains, in Mexico on Mount Popocatapetl, and in Germany on the Alps. Even when he painted still lifes and portraits, they were stolid, immobile forms often filling much of the canvas. Other favorite subjects were the prehistoric glacial boulders he discovered in the area outside Gloucester known as Dogtown. There in 1931 and again in 1934 he painted the eerie shapes, a mountainscape in a field, which in one case he tellingly titled *Mountains in Stone, Dogtown*, 1951 (private collection).[25] On the reverse of another canvas Hartley inscribed three lines from T. S. Eliot's poem "Ash-Wednesday": "Teach us to care and not to care/Teach us to sit still/Even among these rocks."[26] Finding stillness and the suspension of concern in the enduring landscape was a deeply felt hope for Hartley.

This was his state of mind as he identified two compelling images for his art in the Maine landscape, the great peak of Mount Katahdin and Schoodic Point. Hartley had spent his first summer in Maine when he was thirteen years old, and returned there for the summer of 1917. Like Marin, each time he went back, he settled further east, first visiting Ogunquit, then Georgetown on the midcoast in 1937, and then West Brookville

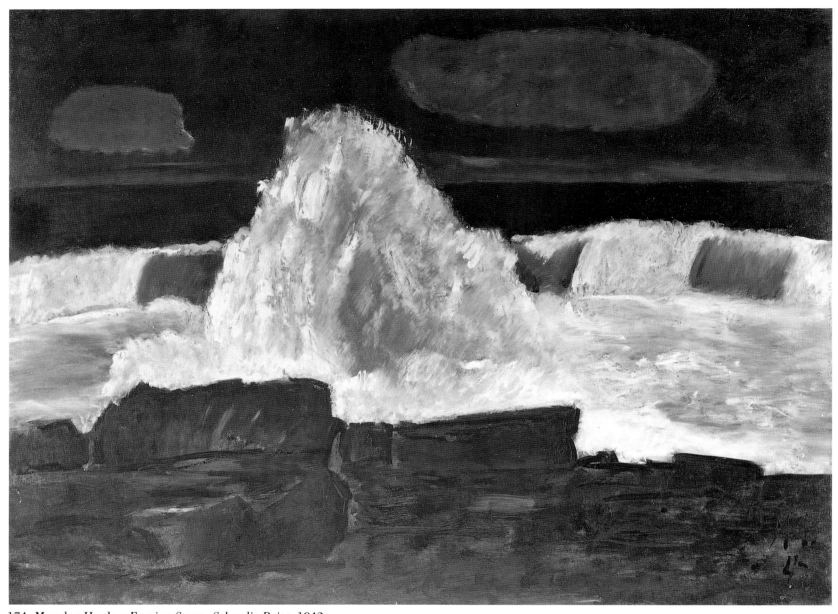

174. Marsden Hartley, *Evening Storm, Schoodic Point*, 1942

two years later. With Thoreau's essays in mind, like Frederic Church a century before, Hartley now determined he must make the pilgrimage to Mount Katahdin. He climbed up to its base in 1939, and over the following three years painted at least eighteen versions of the looming summit.[27] "I have achieved the 'sacred' pilgrimage to Katahdin Mt—exceeding all my expectations so far that I am sort of helpless with words. I feel as if I had seen God for the first time, and find him nonchalantly solemn."[28]

Empathizing with the sustaining power of nature, Hartley drew for inspiration on Emerson and Whitman as well as on Thoreau. He sought the spiritual presence within the natural world and exulted in the great strengths to be found in America's geography,

which in an echo of Thomas Cole he called "savage."[29] During his last three years, Hartley lived with a fisherman's family in Corea, not far from the region of Cape Split where Marin had settled. In this final period Hartley brought to bear in his Schoodic images many of his earlier sources of inspiration: the distillation of forms to their essentials from Cézanne and Picasso, the flat decorative instincts of Matisse, the somber rhythms of color and shapes recalling German expressionism, and the celebration of the American wilderness landscape. At Schoodic, as at Mount Katahdin, we feel Hartley continuing to evoke the solemn chant of T. S. Eliot, along with Thoreau's mythic descriptions of the mountain region as "vast, Titanic, inhuman Nature."[30] On this stern headland confronting the force of water and the infinite unknown, Hartley joined in his transcendentalist predecessor's incantation: "I stand in awe of my body, this matter to which I am bound has become so strange to me. I fear not spirits, ghosts, of which I am one,—*that* my body might,—but I fear bodies, I tremble to meet them. What is this Titan that has possession of me?"[31]

For his part, Hartley recognized this intensity in his last paintings: "My work is getting stronger & stronger and more intense all the time. . . . I have such a rush of new energy & notions coming into my head, over my horizon like chariots of fire that all I want is freedom to step aside and execute them."[32] Schoodic Point has the same general silhouette as nearby Mount Desert Island across Frenchman Bay, and its geology is a relatively consistent fine-grained granite, rather similar to a stretch along the southwest coast of the main island. Running through the neck where it drops off into the open ocean are large basaltic dikes, visible as rows of huge rectangular blocks of stone.[33] Of differing color, heaved upward at the shore's edge, they present a massive physical foreground for the visitor. In this area Hartley completed at least one pencil drawing, three oils, and a related picture of a nearby lighthouse.

His drawing was characteristic of a process Hartley had long used, in which he set down in firm lines, silhouettes, and tonal contrasts the structure of a landscape.[34] Here he was consciously following the tradition of such graphic masters as Rembrandt: "Monochrome . . . is the keynote of the greatest painting that has been done. . . . We see how perfectly the great masters

understood how to swell their crescendos out of dark surroundings."[35] That same sensibility of tonal force carried over into the oil paintings, which are nearly monochromatic in their interlocking zones of whites and dark blue-blacks. Dated to this period and almost certainly done nearby was a large charcoal drawing and an oil painting called *The Lighthouse,* 1941–1942 (Burden Collection, New York).[36] Set at the edge of a cliff with turbulent breakers at its base, the light tower leans slightly off vertical, an emblem of anxiety and instability, as if seeking support from the wall of boulders beside it. Hartley had painted a lighthouse in the distance in *Fox Island, Georgetown* (Addison Gallery, Andover, Massachusetts) a few years earlier, but that building was set in the middle of a smooth, curved island. Both the location and the shape of the lighthouse in his later oil suggest it could be either the Winter Harbor Light or the Prospect Harbor Point Light.[37] The first is on little Mark Island at the entrance of Winter Harbor and directly visible from the Schoodic Peninsula, and the second is near the road leading from Schoodic to Corea.

Significantly, in Hartley's Schoodic Point landscapes, buildings are no longer essential. First in *The Wave,* 1940 (Worcester Art Museum), and then in a paired sequence of oils, *Evening Storm, Schoodic Point, No. 1* (fig. 174) and *No. 2* (private collection) two years later, clouds and waves become as thick and impenetrable as stone or brick.[38] The massive white breaker now literally and metaphorically "towers" in the composition's center. We witness with the artist, in Thoreau's words, the titanic battle between the liquid and solid of modern physics and the light and dark of the modern spirit.

Together, Hartley and Marin bring us decisively into the artistic language and imagery of the twentieth century, from the literalism and idealism of an earlier age to the uncertainties and skepticism of modern times. Remarkably, more than almost any other region of America the grand island of Mount Desert has sustained and inspired devoted, even passionate, attention from its occasional and recurring visitors over an unprecedented span of time. The light on its rocks, the reflections on its waters, its stillness and its storms, the shape of its slopes, and the beacon marks at its ledges and towers remain a site for observation and contemplation today.

Epilogue

PERHAPS THE MOST felicitous artistic continuity today centers on Richard Estes (b. 1936), one of the country's foremost photorealist painters, who in the 1970s acquired the Carroll Tyson house in Northeast Harbor, reaffirming the island's ongoing welcome for America's most notable artists. Born in the Midwest and trained at the Art Institute of Chicago, Estes moved to New York in the late 1950s, just as a groundswell of new forms of realism was rising in the wake of abstract expressionism. During the following decade the exuberance of pop art flourished, as did the ingenious and challenging forms of illusionism, soon linked under the rubric of photorealism. Photorealists not only chose the contemporary subjects of urban and commercial landscape but, even more, they exploited the technical processes, such as photomechanical reproduction, of industrial society in a way reminiscent of the precisionist imagery and techniques of such painters of the 1930s as Charles Sheeler, Morton Schamburg, and Charles Demuth.

For much of his career, Estes passed the winter months in New York City and more than half of each year at Mount Desert. He developed a now familiar and celebrated inventory of urban images, usually street and park scenes, mirrored surfaces of windows, buildings, and automobiles. During the eighties and nineties he ventured farther afield in his artistic enterprise, to Germany, Italy, and Japan, always scrutinizing the force of light on our postmodern environment of glass and steel. A photographer of the highest professionalism, Estes not only emulates and transforms the camera's eye in his art, he also makes extensive use of photographic studies and details in the process of visual collage and synthesis that underlies his painted canvases. While a finished work may have all the seeming precision of photography—seeming, because on close exam-

ination certain passages prove to be surprisingly painterly and intentionally blurred as in peripheral or selectively focused vision—his painted image is never an exact replica or enlargement of any single view he has recorded on film.

For all its encompassing serenity and beauty, Mount Desert has not provided Estes with any direct subject matter. It is rather a place of detachment where he can translate his images of the urban world into the language and substance of art. Seldom have water and rock, seen all around at Mount Desert, had roles in his work. Yet remarkably, in one unusual work of 1990, a portrait titled *Clare* (fig. 176), posed before the panorama of Cadillac Mountain and the gorge adjoining Dorr, the island landscape dominates the image. Estes had only twice previously painted portraits: one in 1985 of Marguerite Yourcenar, the distinguished author and longtime resident of Northeast Harbor, on the occasion of her election to the French National Academy, and the second of the wife of a prominent collector of Estes' work.[1] The former shows Madame Yourcenar standing in the corner of her study before a desk laden with papers and books. The latter portrait was completed the following year and also shows the sitter in the corner of a room, but this time with glass windows behind which open out to a framed view of the open ocean horizon.

One might say that the portrait of Clare Stone, wife of the artist's dealer, is as much a portrait of the landscape. To pose the figure in this setting, Estes characteristically took numerous photographs on the spot, blending them in the painting and manipulating his viewpoint as well as the spatial relationships between foreground and background. Moreover, inspired by the example of Frederic Church's 1851 painting of the same view (fig. 82), he went to the approximate location selected by Church, paying homage to the earlier painting in his background while greatly transforming the foreground. In a nice visual pun on the sitter's name, he places her like a figural stone on the large cubic

175. Otter Cove and Cadillac Mountain Gorge

173

176. Richard Estes, *Clare*, 1990

boulder in the center of the composition. Church took a more distant view of the scene, with the foreground spreading across the lower half of the picture and the figure anonymously turned away and small in size to give scale to the vista beyond.

Coincidentally, the working methods of both artists painting at the site almost a century and a half apart are not dissimilar. Where Church made multiple sketches and studies in pencil, pen, and oil (see figs. 66 through 74), Estes employs his camera to note details, angles of view, and selective elements for compositional purposes later in the studio. The one area to which Estes gives far greater attention in his vertical format is the sparkling surface of blue water in Otter Cove, a tour de force of fragmented and frozen reflections. This wilderness glass is not only a worthy foil for its New York City storefront counterparts, but a worthy successor to Church's impeccable water studies at Mount Desert (compare fig. 79). Estes' painting adds a new dimension both to his own career and to the picturing of Mount Desert Island.

For almost two centuries this favored place has met the aspirations of painters, whether they came out of religious or aesthetic or social impulse, scientific imperative, or personal mission. Some have been pilgrims and some dreamers. As the later twentieth century yields to the twenty-first, the Mount Desert landscape remains an enduring presence, with a power no less spiritual than physical.

Notes

I. THE TIMELESS PLACE

1. Useful summaries of the geological history of the Mount Desert Island area are given in Russell D. Butcher, *Field Guide to Acadia National Park, Maine* (New York, 1977), 28–37, and Carleton A. Chapman, *The Geology of Acadia National Park* (New York, 1970), 11–32.
2. See Butcher, *Field Guide*, 29, and Chapman, *Geology of Acadia National Park*, 28.
3. See Butcher, *Field Guide*, 34, and Chapman, *Geology of Acadia National Park*, 29.
4. *Northeast Harbor, Reminiscences, by an Old Summer Resident* (Hallowell, Maine, 1930), 12.
5. See Samuel Eliot Morison, *The Story of Mount Desert Island* (Boston, 1960), 3–4, and Butcher, *Field Guide*, 11. Today there is a similar flow and ebb of summer inhabitants, likewise attracted by the native delicacies of lobster, crab, and wild raspberries and blueberries.
6. Morison, *Mount Desert Island*, 7.
7. See Samuel Eliot Morison, *Samuel de Champlain, Father of New France* (Boston, 1972), 27–46. This biography is a full and sympathetic account of Champlain's life and achievements, and provides the basis for the précis of his encounter with Mount Desert related here.
8. Quoted in Samuel Adams Drake, *Nooks and Corners of the New England Coast* (New York, 1875), 29. A slightly different free translation appears in Morison, *Mount Desert Island*, 9. A facsimile of the relevant pages from Champlain's original published narrative is included in Charles Savage, *Mount Desert: The Early French Visits* (Northeast Harbor, Maine, 1973), 6–7.
9. Morison, *Champlain*, 46.
10. Ibid., 233.
11. Quoted in ibid., 54–55.
12. Quoted in George E. Street, *Mount Desert: A History*, rev. ed. (Boston, 1926), 108–9.
13. Quoted in ibid., 110.
14. Henry David Thoreau, *The Maine Woods* (New York, 1966), 111.
15. Ibid., 108.
16. Ibid.
17. Ibid., 107.
18. Ibid., 92.
19. Ibid., 84–85.
20. Ibid., 93.
21. Drake, *Nooks and Corners*, 30. See also Morison, *Mount Desert Island*, 61, and *Northeast Harbor, Reminiscences*, 45. The *Ulysses* sank in 1878, and all side-wheelers were replaced by the *Mount Desert* until 1894, when the larger *J. T. Morse* covered the route to Mount Desert. During the late nineteenth century, steamers operated by the Maine Central Railroad connected with train service to Hancock Point at the head of Frenchman Bay. Local steamers operated among Bangor, Bar Harbor, and most of the villages around the coast of the island. See Morison, *Mount Desert Island*, 63. In the first quarter of the twentieth century, ferry service operated from Trenton on the mainland, taking those who had arrived in Ellsworth by train, until a causeway was constructed across the narrows with the advent of the automobile.
22. See Street, *Mount Desert*, 295–96. Tracy's manuscript is now in The Pierpont Morgan Library, New York.
23. Quoted in ibid., 271.
24. See Wally Welch, *The Lighthouses of Maine* (Orlando, Fl., 1985), 8–45.
25. See ibid., 49–59. Morison noted the construction of a lighthouse on Mount Desert Rock as early as 1830, and the subsequent erection of the East Bunker's Ledge daymark, but believed that there were no other aids to navigation in the area before the Civil War.
26. See ibid., 64.
27. See Morison, *Mount Desert Island*, 33.
28. See Street, *Mount Desert*, 281, 296.
29. Drake, *Nooks and Corners*, 49.
30. See Morison, *Mount Desert Island*, 45.
31. Street, *Mount Desert*, 296.
32. See Drake, *Nooks and Corners*, 42, and Butcher, *Field Guide*, 13.
33. Quoted in Street, *Mount Desert*, 32.
34. See Drake, *Nooks and Corners*, 48, and Lloyd Goodrich, *Thomas Eakins*, 2 vols. (Cambridge, Mass., and Washington, D.C., 1982), 2:137. John Singer Sargent also visited the area in 1921–1922, and painted a portrait of his artist friend Dwight Blaney sketching deep in the woods on Ironbound Island in the upper part of Frenchman Bay. He also did an oil, *On the Verandah*, showing the Blaney family on the porch of their summer home on Ironbound. But these are essentially portraits; neither is really concerned with the panoramic vista of Mount Desert nearby. See Gertrud A. Mellon and Elizabeth Wilder, eds., *Maine and Its Role in American Art, 1740–1963* (New York, 1963), 108–9. In addition, a few prominent photographers have produced a body of images in the Mount Desert region; for example, Seneca Ray Stoddard and Henry L. Rand at the end of the nineteenth century, and George A. Tice in the early 1970s. See John Wilmerding et al., *American Light: The Luminist Movement, 1850–1875* (Washington, D.C., 1980), 138–45, and Martin Dibner, *Seacoast Maine: People and Places* (New York, 1973), 2, 8, 82, 122, 126, 128, 156, 178, 199, 202, and 206. In the late 1960s, Walker Evans visited the painter John Heliker and photographed his kitchen, but no landscapes, on Great Cranberry Island off the Mount Desert coast.
35. Moving toward greater abstraction in their responses to the island region since World War II have been such resident painters as William Thon, John

Heliker, and William Kienbush. Today, one of the island's best-known painters, in residence for much of the year, is Richard Estes, whose precise style of photorealism serves not wilderness scenes but the street landscapes of New York and other cities. One unusual exception concludes this book (fig. 176).

36. Much of this chapter was published in somewhat altered form in John Wilmerding et al., *Paintings by Fitz Hugh Lane* (Washington, D.C., 1988), 106–26 (courtesy of the Trustees of the National Gallery of Art, Washington, D.C.), and in John Wilmerding, *American Views: Essays on American Art* (Princeton, N.J., 1991), 3–15 (courtesy of Princeton University Press).

II. THE EARLY NINETEENTH CENTURY

1. Ralph Waldo Emerson, *The Complete Essays and Other Writings of Ralph Waldo Emerson*, ed. Brooks Atkinson (New York, 1950), 47.
2. Ibid., 11, 14.
3. Ibid., 5, 6.
4. Quoted in F. O. Matthiessen, *American Renaissance: Art and Expression in the Age of Emerson and Whitman* (London and New York, 1941), 62.
5. Henry David Thoreau, *The Major Essays*, ed. Jeffrey L. Duncan (New York, 1972), 205.
6. Thomas Cole, "Essay on American Scenery," *New England Monthly Magazine*, n. s. 1 (January 1836): 1–12, quoted in *American Art, 1700–1960: Sources and Documents*, ed. John W. McCoubrey (Englewood Cliffs, N.J., 1965), 100.
7. Ibid., 103, 107.
8. For summary information, see Mellon and Wilder, *Maine and Its Role*, 40, and Charles E. Clark et al., eds., *Maine in the Early Republic: From Revolution to Statehood* (Hanover, N.H., 1988), 194–246.
9. See Richard Moss, "Jonathan Fisher and the 'Universe of Being,'" in Clark et al., *Maine in the Early Republic*, 215.
10. Collection of the Jonathan Fisher Memorial, Blue Hill, Maine, reproduced in Mellon and Wilder, *Maine and Its Role*, 35.
11. *Self-Portrait*, oil on panel, collection of the Jonathan Fisher Memorial. See Dorsey R. Kleitz, "Jonathan Fisher's Emblematic Mind," in Clark et al., *Maine in the Early Republic*, 210–11.
12. See the excellent analyses of this painting by Dorsey R. Kleitz, Richard Moss, and David Waters in Clark et al., *Maine in the Early Republic*, 211, 222, and 244.
13. Quoted in ibid., 244.
14. For summary biographical information, see William H. Gerdts, *Thomas Birch*, exhibition catalogue, Philadelphia Maritime Museum (Philadelphia, 1966), 10–17, and John Wilmerding, *American Marine Painting*, 2d ed. (New York, 1987), 74–85.
15. See Gerdts, *Thomas Birch*, 14, and Wilmerding, *American Marine Painting*, 80.
16. See Welch, *Lighthouses of Maine*, 15–17.
17. See Morison, *Mount Desert Island*, 31–32.
18. Quoted in Frank H. Goodyear, Jr., *Thomas Doughty, 1793–1856: An American Pioneer in Landscape Painting*, exhibition catalogue, Pennsylvania Academy of the Fine Arts (Philadelphia, 1973), 11.
19. Ibid., 15.
20. See ibid., 17, and James M. Carpenter et al., *Landscape in Maine, 1820–1970: A Sesquicentennial Exhibition*, exhibition catalogue, Colby College Art Museum (Waterville, Maine, 1970), 8.
21. Nathaniel Parker Willis, *American Scenery* (London, 1840), 2: 36, quoted in Goodyear, *Thomas Doughty*, 30.
22. Ibid. A painted version was sold at auction by Barridoff Galleries, Portland, Maine, in August 1989.
23. Ibid.
24. Ibid.
25. N. P. Willis et al., *Picturesque American Scenery. A Series of Twenty-five Beautiful Steel Engravings, from Designs by W. H. Bartlett, George L. Brown, and Thomas Moran. With Text by N. P. Willis and Others. Including Illustrative Poems by American and English Authors* (Boston, 1883).
26. "Letter to the Editor," *Crayon* 3 (1856): 349, quoted in Fred B. Adelson, "Alvan Fisher in Maine: His Early Coastal Scenes," *American Art Journal* 18 (1986): 72. See also Carpenter et al., *Landscape in Maine*, introduction.
27. On the painting's verso, Fisher inscribed: "View of Bear Island/A reminiscence of pleasant/days in the year 1848 and/a token of friendship and slight/return for past favors." Collection of the Shelburne Museum, Shelburne, Vermont.
28. Letter to J. G. Bowen, Boston, 28 August 1849. Washburn Papers, box 22: 57, Massachusetts Historical Society, Boston, quoted in Adelson, "Alvan Fisher in Maine," 69.
29. See Sandra K. Feldman, *The Drawings of Edward Seager (1809–1886)*, exhibition catalogue, Hirschl and Adler Galleries (New York, 1983), 7–8.
30. Ibid., 22.

III. THOMAS COLE

1. Cole, "Essay on American Scenery," 101–2.
2. Ibid., 103.
3. Ibid., 105.
4. Louis Legrand Noble, *The Life and Works of Thomas Cole*, ed. Elliot S. Vesell (Cambridge, Mass., 1964), 270.
5. Ibid., 270–71.
6. The Art Museum, Princeton University, gift of Frank J. Mather, 1940; acquired from Thomas Cole's granddaughter, Florence H. Cole-Vincent. For a discussion of the sketchbook, see Louis Hawes, "A Sketchbook by Thomas Cole," *Record of the Art Museum, Princeton University* 15, no. 1 (1956): 2–23. In the most recent comprehensive monograph on Cole, by Ellwood Parry, no mention of this sketchbook or its drawings is made, and only passing commentary is given to the Maine trip. See Ellwood C. Parry III, *The Art of Thomas Cole: Ambition and Imagination* (Newark, Del. 1988), 304–8.
7. See discussion of this theme in Cole's art by Charles C. Eldredge, "*Torre dei Schiavi*: Monument and Metaphor," *Smithsonian Studies in American Art* 1, no. 2 (Fall 1987): 14–33.

8. See Howard S. Merritt, *Thomas Cole*, exhibition catalogue, Memorial Art Gallery of the University of Rochester (New York, 1969), nos. 23, 30, 33, 34, 48, and 50.

9. Morison, *Mount Desert Island*, 38.

10. For the original names of Mount Desert's mountains, their sources, and current nomenclature, see ibid., 75–76.

11. Noble, *Life and Works*, 270.

12. See Morison, *Mount Desert Island*, 44. It is quite possible that his painting illustrated here (fig. 34), traditionally titled and exhibited as *Otter Cliffs*, is a view inspired more by the cliffs at Schooner Head.

13. McCoubrey, *American Art*, 109.

14. Probably Henry C. Watson, review of the "Twentieth Annual Exhibition of the Academy of National Design [*sic*]," *Broadway Journal*, 3 May 1845, 275, quoted in Parry, *Art of Thomas Cole*, 308.

15. Parry, *Art of Thomas Cole*, 304.

16. Ibid., 305.

17. Quoted in Hawes, "Sketchbook by Thomas Cole," 8.

18. J. L. Stevens, Jr., in the *Gloucester Daily Telegraph*, 11 September 1850, quoted in John Wilmerding, *Fitz Hugh Lane* (New York, 1971), 54.

19. This chapter was previously published in slightly different form in John Wilmerding, "Thomas Cole in Maine," *Record of the Art Museum, Princeton University* 49, no. 1 (1990): 3–23 (courtesy of the Art Museum, Princeton University), and in Wilmerding, *American Views*, 16–34 (courtesy of Princeton University Press).

IV. FITZ HUGH LANE

1. Joseph L. Stevens, letter to Samuel Mansfield, Boston, 17 October 1903, in the Cape Ann Historical Association, Gloucester, quoted in Wilmerding, *Fitz Hugh Lane*, 50–51.

2. *Castine Homestead*, 1859 (private collection), reproduced in Wilmerding et al., *Paintings by Fitz Hugh Lane*, 124.

3. Susan Babson, "C.A.S. & L.A. Weekly Column on Matters of Local History," *Authors and Artists of Cape Ann* (album of undated miscellaneous clippings), Cape Ann Historical Association.

4. Stevens, letter to Mansfield, 17 October 1903.

5. Mary B. Cowdrey and Theodore Sizer, *American Academy of Fine Arts and American Art-Union Exhibition Record, 1816–1852* (New York, 1953), 221. See also Franklin Kelly, "Lane and Church in Maine," in Wilmerding et al., *Paintings by Fitz Hugh Lane*, 132–34.

6. Drawings in the collection of the Cape Ann Historical Association.

7. Joseph L. Stevens, Jr., *Gloucester Daily Telegraph*, 11 September 1850. The full account is reprinted in Wilmerding, *Fitz Hugh Lane*, 53–54, and in Wilmerding et al., *Paintings by Fitz Hugh Lane*, 120.

8. Ibid.

9. Ibid.

10. Ibid.

11. Ibid.

12. See *Paintings and Drawings by Fitz Hugh Lane at the Cape Ann Historical Association* (Gloucester, Mass., 1974), nos. 109ff.; and Wilmerding, *Fitz Hugh Lane*, fig. 63.

13. Joseph L. Stevens, letter to Lane, 29 January 1851, in the Cape Ann Historical Association, quoted in Wilmerding, *Fitz Hugh Lane*, 57–58.

14. William Howe Witherle, "A Cruise with Fitz Hugh Lane," *Wilson Museum Bulletin*, Castine Scientific Society 2, no. 2 (Winter 1974–1975): 2–4. Reprinted in full in Wilmerding et al., *Paintings by Fitz Hugh Lane*, 125–26.

15. Ibid.

16. Ibid.

17. Ibid. It is not certain whether the oil derived from this trip or another was the one titled *Mount Desert Light House* that Lane submitted for exhibition at the Boston Athenaeum in 1855.

18. Ibid.

19. Ibid.

20. Ibid.

21. See Matthiessen, *American Renaissance;* James McPherson, *Battle Cry of Freedom: The Civil War Era* (New York, 1988), chap. 1; and John Wilmerding, "Bingham's Geometries and the Shape of America," in Michael Shapiro et al., *George Caleb Bingham* (New York, 1990), 175–81.

22. Street, *Mount Desert*, 227–32, 241, 250–53.

23. George E. Wasson, *Sailing Days on the Penobscot: The Story of the River and the Bay in the Old Days* (New York, 1932), 25.

24. Ibid., 29–34, 229.

25. See Henry Adams, "A New Interpretation of Bingham's *Fur Traders Descending the Missouri*," *Art Bulletin* 65, no. 4 (December 1983): 675–80, and Barbara Groseclose, "The 'Missouri Artist' as Historian," in Shapiro et al., *George Caleb Bingham*, 53–91.

26. Clarence Cook, "Letters on Art.—No. IV," *Independent*, 7 September 1854, quoted in William H. Gerdts, "'The Sea in His Home': Clarence Cook Visits Fitz Hugh Lane," *American Art Journal* 17 (1985): 48. Although the more vivid sunset Lane painted in another canvas, *Off Mount Desert Island* (Brooklyn Museum, fig. 59), has also led to its association with the Cook commentary, that work was not finished and dated until 1856, after the critic's visit to Gloucester.

27. Dorothy L. Stevens, letter to Lane, 9 February 1853, in the Cape Ann

28. See Frederic A. Sharf, "Fitz Hugh Lane: Visits to the Maine Coast, 1848–1855," *Essex Institute Historical Collections* 98 (April 1962): 111–20.

29. Witherle, "Cruise with Fitz Hugh Lane."

30. Ibid.

31. Drawings in the collection of the Cape Ann Historical Association.

32. Wasson, *Sailing Days on the Penobscot*, 33.

33. See ibid., 51, 68, 155, and Street, *Mount Desert*, 253.

V. FREDERIC EDWIN CHURCH

1. Quoted in Parry, *Art of Thomas Cole*, 300.

2. Ibid., 307.

3. Henry D. Thoreau, *The Illustrated Maine Woods*, ed. Joseph J. Moldenhauer (Princeton, 1974), xviii, xv.

4. Ibid., 65.
5. See Franklin Kelly, *Frederic Edwin Church and the National Landscape* (Washington, D.C., 1988), 35.
6. "Chronicles of Facts and Opinions: American Art and Artists," *Bulletin of the American Art-Union* (August 1850): 81, quoted in Kelly, "Lane and Church in Maine," 134.
7. See Franklin Kelly, "A Passion for Landscape: The Paintings of Frederic Edwin Church," in Kelly, *Frederic Edwin Church* (Washington, D.C., 1989), 44–45.
8. See Parry, *Art of Thomas Cole*, 300.
9. Stevens, *Gloucester Daily Telegraph*, 11 September 1850.
10. For argument's sake these would be *Beacon, off Mount Desert Island*, 1851; *The Wreck*, 1852; *Mount Ktaadn (Katahdin)*, 1853; *Twilight (Sunset)* and *Sunset*, both 1856; *Twilight in the Wilderness*, 1860; and *Coast Scene, Mount Desert*, 1863.
11. Quoted in Kelly, *Church and the National Landscape*, 36.
12. See Drake, *Nooks and Corners*, 4: "And while *en route* I should not forget the Lynam Homestead, to which Cole, Church, Gifford, Hart, Parsons, Warren, Bierstadt, and others renowned in American art have from time to time resorted to enrich their studios from the abounding wealth of the neighborhood." See also Street, *Mount Desert*, 281: "The Higgins homestead, where Church, the artist, boarded, stood near what is now the corner of Main and Cottage streets." And Morison, *Mount Desert Island*, 45: "In 1844 Thomas Cole, a leader of the school, came to the Island to sketch. He stayed at the Lynam farm at Schooner Head, became enraptured with the scenery, and spread the word. Presently other members of the school, such as Thomas Birch, Frederick [*sic*] E. Church, Charles Dix and William Hart, came to paint and sketch. They stayed in Somesville at the Somes Tavern, in Bar Harbor with Tobias Roberts or Albert Higgins." Church lodged in Somesville on his 1855 visit, but the body of his 1850 drawings would indicate that he based himself at Schooner Head on the first trip.
13. Quoted in Kelly, *Church and the National Landscape*, 36.
14. *Bulletin of the American Art-Union* (November 1850): 131, quoted in ibid.
15. Quoted in David C. Huntington, *The Landscapes of Frederic Edwin Church: Vision of an American Era* (New York, 1966), 30.
16. Collection of the Cooper-Hewitt Museum, New York.
17. Collection of the Olana State Historic Site, Hudson, New York: OL.1977.118.
18. Collection of the Olana State Historic Site: OL.1980.1449, OL.1980.1447, and OL.1980.1458.
19. Collection of the Olana State Historic Site: OL.1980.1453. See also OL.1980.1456, OL.1980.1441, and OL.1977.116.
20. Collection of the Olana State Historic Site: OL.1977.52. See also OL.1978.22.
21. See Butcher, *Field Guide*, 29.
22. Collection of the Olana State Historic Site: OL.1989.1443 and OL.1977.108. See also OL.1980.1507.
23. Thoreau, *Illustrated Maine Woods*, xiii.
24. Ibid., 121. See the discussion of mills in Kelly, *Church and the National Landscape*, 14–16. On Church's drawings of this subject, see Franklin Kelly and Gerald L. Carr, *The Early Landscapes of Frederic Edwin Church, 1845–1854* (Fort Worth, Tex., 1987), 143, 153.
25. Thoreau, *Illustrated Maine Woods*, 5.
26. Street, *Mount Desert*, 235, 252–53.
27. *Bulletin of the American Art-Union* (November 1850): 131, quoted in Kelly, *Church and the National Landscape*, 36.
28. George William Curtis, *New York Tribune*, 10 May 1851, 5, quoted in Kelly and Carr, *Early Landscapes*, 114.
29. See Kelly and Carr, *Early Landscapes*, 111–12.
30. See ibid., 64.
31. Quoted in Huntington, *Landscapes*, 31.
32. Ralph Waldo Emerson, "Nature," in Emerson, *Complete Essays*, 5.
33. Quoted and discussed in Matthiessen, *American Renaissance*, 62.
34. "The Fine Arts," *International Magazine* 3 (June 1851): 327, quoted and discussed in Kelly and Carr, *Early Landscapes*, 116.
35. "Twenty-Sixth Exhibition of the National Academy of Design," *Bulletin of the American Art-Union* (May 1851): 23, quoted and discussed in Kelly, *Church and the National Landscape*, 40.
36. "The National Academy of Design, III," 5, quoted in Kelly, *Church and the National Landscape*, 40.
37. *New-York Tribune*, 10 May 1851, 5, and "Fine Arts," *Literary World*, 19 April 1851, 320, both quoted in Kelly, *Frederic Edwin Church*, 45.
38. "Twenty-Sixth Exhibition," 45.
39. For example, a controlled and delicate view of the island from the eastern side of Frenchman Bay, done perhaps while visiting the Sullivan area; collection of the Olana State Historic Site: OL.1977.115. See also the chronology of this period in Kelly, *Frederic Edwin Church*, 160.
40. "The Fine Arts: Exhibition of the National Academy," 5, quoted in Kelly, *Church and the National Landscape*, 61–62.
41. Theodore Winthrop, *Life in the Open Air and Other Papers* (Boston, 1863), 50–55, quoted in Kelly and Carr, *Early Landscapes*, 70.
42. Ibid., 40.
43. Emerson, "Nature," 5. See also the discussion of this painting in Kelly and Carr, *Early Landscapes*, 73, and Kelly, *Church and the National Landscape*, 67–74.
44. Theodore Winthrop, quoted in Kelly, "Lane and Church in Maine," 145.
45. Collection of the Cooper-Hewitt Museum; see also collection of the Olana State Historic Site: OL.1980.1468.
46. Street, *Mount Desert*, 295–96.
47. Winthrop, *Life in the Open Air*, 50, quoted in Kelly, "Lane and Church in Maine," 149.
48. Winthrop, quoted in Huntington, *Landscapes*, 74.
49. Ibid.
50. Winthrop, quoted in Kelly, *Church and the National Landscape*, 89.
51. Ibid.
52. Winthrop, quoted in Huntington, *Landscapes*, 74.
53. Winthrop, quoted in Kelly, *Church and the National Landscape*, 89, 91.
54. Winthrop, quoted in Huntington, *Landscapes*, 74–75.
55. Ibid., 73–74.
56. See the discussion of this in ibid., 76–78, and Kelly, *Church and the National Landscape*, 90–94.
57. Winthrop, quoted in Huntington, *Landscapes*, 78.
58. Louis Legrand Noble, *After Icebergs with a Painter: A Summer Voyage to*

Labrador and around Newfoundland (New York, 1861), 139–40, quoted in Kelly, *Church and the National Landscape*, 108.

59. Herman Melville, *Moby Dick; or, The Whale* (New York, 1950), 166.
60. Walt Whitman, *Leaves of Grass* (New York, 1954), 255, 400.
61. For example, see Kelly, *Church and the National Landscape*, 102–4ff.
62. For example, *Clouds with Green Cool Light*, collection of the Cooper-Hewitt Museum, New York.
63. Quoted in Huntington, *Landscapes*, 82.
64. Introduction to Charles Darwin, *On the Origin of Species*, facsimile ed. (Cambridge, Mass., 1964), vii.
65. Ibid., 79. For a fuller discussion of Darwin's impact on Church's world, see Stephen Jay Gould, "Church, Humboldt, and Darwin: The Tension and Harmony of Art and Science," in Kelly, *Frederic Edwin Church*, 94–107.
66. Darwin, *Origin of Species*, 466–67.
67. Ibid., 130.
68. See Kelly and Carr, *Early Landscapes*, 132.
69. For example, see the collection of the Olana State Historic Site: OL.1977.313.
70. Huntington, *Landscapes*, 62.
71. Kelly, *Church and the National Landscape*, 126.
72. See Kelly and Carr, *Early Landscapes*, 115–17, and Kelly, *Frederic Edwin Church*, 166.

VI. WILLIAM STANLEY HASELTINE

1. See Huntington, *Landscapes*, 30.
2. See Wilmerding, *Fitz Hugh Lane*, 54.
3. See Drake, *Nooks and Corners*, 49; Morison, *Mount Desert Island*, 45; Andrea Henderson, "Haseltine at Mount Desert," brochure, Wingspread Gallery (Northeast Harbor, Maine, 1990); and Helen Haseltine Plowden, *William Stanley Haseltine, Sea and Landscape Painter (1835–1900)* (London, 1947), 80.
4. Plowden, *William Stanley Haseltine*, 28.
5. Ibid., 36.
6. Ibid., 37.
7. Ibid., 104.
8. Ibid., 83, 167.
9. Darwin, *Origin of Species*, 302, 310–11.
10. Ibid., 487.
11. Henry T. Tuckerman, *Book of the Artists: American Artist Life* (New York, 1965), 556–57.
12. Plowden, *William Stanley Haseltine*, 167.
13. John Ruskin, *The Elements of Drawing; in Three Letters to Beginners*
14. Ibid., 50, 54.
15. Ibid., 92, 130–31.
16. Ibid., 131.
17. See Butcher, *Field Guide*, 29.
18. See Morison, *Mount Desert Island*, 21.
19. Ruskin, *Elements of Drawing*, 180–81.
20. Ibid., 179.
21. Ibid., 178.
22. Plowden, *William Stanley Haseltine*, 170. The painting originally known as *Iron-Bound, Coast of Maine* (private collection) is reproduced in color (plate 15) in Marc Simpson et al., *Expressions of Place: The Art of William Stanley Haseltine*, exhibition catalogue, Fine Arts Museums of San Francisco (San Francisco, 1992), 88. The large 1861 canvas called *Mt. Desert Island* is believed to be that exhibited at the National Academy of Design in 1862. See Simpson et al., *Expressions of Place*, 19, and Marc Simpson, "The Early Coastal Landscapes of William Stanley Haseltine," *Antiques* 142, no. 2 (August 1992): 204–13.
23. Plowden, *William Stanley Haseltine*, 171, 182–83.
24. Ibid., 182.
25. Ibid.
26. Ibid., 83. Another watercolor, titled *Seal Harbor, Mount Desert*, is in the collection of the Georgia Museum of Art, the University of Georgia, Athens; it is reproduced in color (plate 71) in Simpson et al., *Expressions of Place*, 149. Because it is so close to the view of Northeast Harbor included here (fig. 123), with its sense of a much deeper and narrower harbor, there may be understandable confusion in the definitive locations depicted in each of these watercolors. One more in the series, titled *Northeast Harbor, Maine*, is in the collection of the Nelson-Atkins Museum of Art, Kansas City, Missouri (gift of Mrs. Helen Haseltine Plowden). It is reproduced and discussed in Henry Adams et al., *American Drawings and Watercolors from the Kansas City Region*, exhibition catalogue, Nelson-Atkins Museum of Art (Kansas City, Mo., 1992), 162–63.
27. Location unknown; reproduced in Plowden, *William Stanley Haseltine*, 170. For information and advice I am grateful to Sally Mills, coauthor of *Expressions of Place*. This chapter was published in slightly abbreviated form in *Master Drawings* 31, no. 1 (1993), 3–20.

VII. THE LATE NINETEENTH CENTURY

1. Street, *Mount Desert*, 273.
2. Ibid., 254.
3. Ibid., 283. Among the fashionable hotels built between 1869 and 1880, primarily in Bar Harbor, were the Bay View House, Grand Central, the Atlantic, Louisburg, Saint Sauveur, Rockaway, Deering, Marlboro, Ocean House, Belmont, and West End.
4. Asher B. Durand, "Letters on Landscape Painting, No. V," *Crayon* 1 (1855): 145; see also McCoubrey, *American Art*, 110, and Linda A. Ferber and William H. Gerdts, *The New Path: Ruskin and the American Pre-Raphaelites*, exhibition catalogue, Brooklyn Museum (New York, 1985), 13–14.
5. Quoted in Ferber and Gerdts, *New Path*, 92.
6. Quoted in ibid., 41.
7. See *A Study of Trap Rock (Buttermilk Falls)*, 1863, *Shoshone Falls*, 1868, and *Lake George*, 1873; catalogue nos. 17, 22, and 25 in ibid., 170–78.
8. Quoted in ibid., 57.
9. See Charles B. Ferguson, *Aaron Draper Shattuck, N.A., 1832–1928: A*

Retrospective Exhibition, exhibition catalogue, New Britain Museum of Art (New Britain, Conn., 1970), plate 4.

10. Ferguson, *Aaron Draper Shattuck,* n.p.; Ferber and Gerdts, *New Path,* 275.

11. Ferguson, *Aaron Draper Shattuck,* n.p. Plate 10, *Granite Rocks by the Sea,* is almost certainly a Mount Desert scene. Two additional 1858 Maine drawings were in the collection of E. Maurice Bloch, auctioned at Christie's in June 1990 and January 1991.

12. Tuckerman, *Book of the Artists,* 560.

13. Ibid.

14. Ibid.

15. *Cranberry Island from Seawall* was sold at auction in 1990 under the title *Frenchman's Bay—Near Bar Harbor, Maine* at Barridoff Galleries, Portland.

16. See George C. Groce and David H. Wallace, *The New-York Historical Society's Dictionary of Artists in America. 1564–1860* (New Haven, 1957), 296–97.

17. Tuckerman, *Book of the Artists,* 547.

18. Ibid., 527.

19. Quoted in Nicolai Cikovsky, Jr., *Sanford Robinson Gifford, 1823–1880,* exhibition catalogue, University of Texas Art Museum (Austin, Tex., 1970), 16, and Ila Weiss, *Poetic Landscape: The Art and Experiences of Sanford R. Gifford* (Newark, Del., 1987), 20.

20. John F. Weir, "Address," in *Gifford Memorial Meeting of the Century* (New York, 1880), 23, quoted in Weiss, *Poetic Landscape,* 20.

21. See Weiss, *Poetic Landscape,* 20, 45. She contrasts Gifford's suffused luminosity to the sharp clarity and transcendental impulses of Fitz Hugh Lane's luminism. See also Wilmerding et al., *American Light.*

22. Quoted in Cikovsky, *Sanford Robinson Gifford,* 9.

23. Tuckerman, *Book of the Artists,* 526.

24. See Cikovsky, *Sanford Robinson Gifford,* 9, and Weiss, *Poetic Landscape,* 81–88.

25. Exhibited in *A Memorial Catalogue of the Paintings of Sanford Robinson Gifford, N.A.,* Metropolitan Museum of Art (New York, 1881), 29; sold at auction, no. 23, *American Paintings from the Collection of Mrs. George Arden, Part I,* Christie's, 22 May 1991 (New York, 1991), 30.

26. Weiss, *Poetic Landscape,* 52–53, 81–82, 91–100.

27. Ibid., 100–101, 245–48. The oil study, *A Sketch at Mount Desert, Maine,* was formerly known as *Hunter in a Mountain Landscape;* see Cikovsky, *Sanford Robinson Gifford,* no. 25. Weiss suggests this is "possibly the view from near Eagle Lake that includes Turtle Lake and Stony Brook Cove," but it is more likely the Green Mountain Gorge leading eventually into Otter Creek, showing a protruding boulder somewhat further down the slope than the prospect in the final painting.

28. See John Wilmerding, "The Luminist Movement: Some Reflections," in Wilmerding et al., *American Light,* 97–152.

29. See Cikovsky, *Sanford Robinson Gifford,* nos. 5, 12, 22, 23, and 25, and Weiss, *Poetic Landscape,* 186, 209, 230–33, and 245.

30. Weiss says the artist depicted at Mount Desert is presumably Gifford's close friend and painting companion, Jervis McEntee; Weiss, *Poetic Landscape,* 246. But the nature of the work suggests more that this is a surrogate for the author himself.

31. See ibid., 196, 246.

32. Tuckerman, *Book of the Artists,* 526.

33. Ibid., 527.

34. [George W. Sheldon], "How One Landscape Painter Paints," *Art Journal* 3 (1887): 284, quoted in Weiss, *Poetic Landscape,* 20.

35. John F. Weir, "Sanford Gifford, Artist and Man," *New York Daily Tribune,* 12 September 1880, quoted in Weiss, *Poetic Landscape,* 20.

36. Quoted in Cikovsky, *Sanford Robinson Gifford,* 16.

37. Quoted in Weiss, *Poetic Landscape,* 16.

38. Private collection; reproduced in color in the *Annual Report* of the Maine Coast Heritage Trust (Brunswick, Maine, 1987).

39. For biographical information, see Linda S. Ferber, *William Trost Richards, American Landscape and Marine Painter, 1833–1905,* exhibition catalogue, Brooklyn Museum (New York, 1973), 14–31, and Ferber and Gerdts, *New Path,* 214, 227.

40. Quoted in Ferber, *William Trost Richards,* 23.

41. John Ruskin, *Modern Painters* (New York, 1886), 422, quoted in Ferber, *William Trost Richards,* 24.

42. Tuckerman, *Book of the Artists,* 524.

43. "Elementary Drawing," *Crayon* 1 (1855): 305; see also Linda S. Ferber, "Luminist Drawings," in Wilmerding et al., *American Light,* 237–65.

44. Quoted in Ferber, *William Trost Richards,* 31.

45. Both reproduced in Ferber and Gerdts, *New Path,* 227–28.

46. Street, *Mount Desert,* 296.

47. Tuckerman, *Book of the Artists,* 552.

48. Street, *Mount Desert,* 282.

49. Ibid., 284.

50. For biographical information, see Jeffrey R. Brown, *Alfred Thompson Bricher, 1837–1908,* exhibition catalogue, Indianapolis Museum of Art (Indianapolis, 1973); also Simpson et al., *Expressions of Place,* 18–19, 29.

51. Tuckerman, *Book of the Artists,* 552.

52. For exhibition record, see Brown, *Alfred Thompson Bricher,* 14–15, 93–98.

53. For biographical information, see *The First Exhibition in Fifty Years of Oil Paintings by Russell Smith and His Son Xanthus Smith,* exhibition catalogue, Vose Galleries (Boston, 1977), and Xanthus Smith, "An Unvarnished Tale" (autobiographical manuscript), Archives of American Art, Washington, D.C.

54. Tuckerman, *Book of the Artists,* 521.

55. Information about the Claremont Hotel registers courtesy of Linda Lewis, formerly of the West Side Gallery, Southwest Harbor, Maine, August 1991.

56. Drawings with the West Side Gallery, Southwest Harbor, courtesy of Frank O'Rourke, August 1991.

57. With the West Side Gallery, Southwest Harbor, August 1991.

58. A closely related painting by Tiffany, titled *Family Group with Cow,* gouache and watercolor, was placed at auction at Christie's on 23 September 1992 (no. 91), and almost certainly depicts the same family grouping in a nearby part of the Somesville meadow at Mount Desert. See also John Wilmerding, "Benson and Maine," in *Frank W. Benson: The Impressionist Years,* exhibition catalogue, Spanierman Gallery (New York, 1988), 11–15.

59. Information courtesy of William Vareika Fine Arts, Newport, Rhode Island. As originally exhibited, the titles of his known Bar Harbor watercolors are *Porcupine Island, Bar Harbor, Maine. Fog and Rain, Morning Study*

(private collection); *Bar Harbor, Twilight* (Metropolitan Museum of Art); *Porcupine Island, Bar Harbor, Maine. Evening Study* (location unknown); *Sheep, Porcupine Island, Bar Harbor, Maine. Evening Study* (Metropolitan Museum of Art); *Porcupine Island, Bar Harbor, Maine* (private collection); *Moonlight, Bar Harbor (Study from Nature.)* (location unknown); and *Porcupine Island, Bar Harbor, Maine. Evening Study* (location unknown).

60. For a summary and analysis of Mount Desert's summer community at this time, see Judith S. Goldstein, *Crossing Lines: Histories of Jews and Gentiles in Three Communities* (New York, 1992), 151–69.

61. Street, *Mount Desert*, 289.

62. See Goodrich, *Thomas Eakins* 2: 137.

63. For a full account of Hassam's Appledore work, see David Park Curry, *Childe Hassam: An Island Garden Revisited*, exhibition catalogue, Denver Art Museum (Denver, 1990).

64. Information courtesy of Orton P. Jackson, Northeast Harbor and Philadelphia, in whose family one of the Hassam oils of Mount Desert descended from Moore's sister.

65. Street, *Mount Desert*, 273–74.

66. See especially *Moonlight*, 1907 (Shaklee Corporate Art Collection, San Francisco); *Sunset at Sea*, 1911 (Rose Art Museum, Brandeis University); *West Wind, Isles of Shoals*, 1904 (Bienecke Rare Book and Manuscript Library, Yale University); *Isles of Shoals, Sunset*, 1907 (private collection); *Red Sky, Sunset*, ca. 1907 (private collection); and *Sunset Sky*, 1908 (private collection); color plates 81, 85–87, 89–91, in Curry, *Childe Hassam*, 165–75.

VIII. THE EARLY TWENTIETH CENTURY

1. See John Wilmerding, "Homer's Maine," in *Winslow Homer in the 1890s: Prout's Neck Observed*, ed. Patricia A. Junker, exhibition catalogue, Memorial Art Gallery of the University of Rochester (New York, 1990), 86–96.

2. See John Wilmerding, "The Art of George Bellows and the Energies of Modern America," in *The Paintings of George Bellows*, ed. Michael Quick et al. (Fort Worth, Tex., and New York, 1992), 1–7.

3. See Franklin Kelly, "'So Clean and Bold': Bellows and the Sea," in Quick et al., *Paintings of George Bellows*, 135–69.

4. See the full account and discussion of these interrelated developments in Goldstein, *Crossing Lines*, 170–90.

5. Allen Tucker, *John H. Twachtman*, exhibition catalogue, Whitney Museum of American Art (New York, 1931), 7; information courtesy of Donelson S. Hoopes, guest curator, High Museum of Art, Atlanta, Georgia, 1992.

6. See Judy L. Larson, *The Advent of Modernism: Post-Impressionism and North American Art, 1900–1918*, exhibition catalogue, High Museum of Art (Atlanta, 1986), 171.

7. Morison, *Mount Desert Island*, 18–21, 75–76. The modern name honors a landowner and settler of Mount Desert from the early seventeenth century.

8. Biographical information in Louis C. Madeira IV, "Homage," in *Carroll S. Tyson, 1878–1956: A Retrospective Exhibition*, exhibition catalogue, Hirschl and Adler Galleries (New York, 1974), n.p.

9. Paintings with Hirschl and Adler Galleries, New York, 1974.

10. Both in private collections; reproduced in Mellon and Wilder, *Maine and Its Role*, 108–9.

11. For biographical information, see John I. H. Baur, *William Zorach* (New York, 1959).

12. For comprehensive biographical and critical information, see Ruth E. Fine, *John Marin* (Washington, D.C., and New York, 1990).

13. See ibid., 75, 166.

14. Quoted in ibid., 165.

15. Quoted in ibid., 180.

16. See ibid., 229.

17. Quoted in ibid., 185.

18. For example, see ibid., the definitive and comprehensive publication accompanying the 1990 Marin exhibition at the National Gallery of Art, Washington, D.C., 1990, which makes no mention of any Mount Desert images.

19. Quoted in ibid., 229.

20. Reproduced in color in ibid., 253.

21. Quoted in ibid., 271.

22. See Gail R. Scott, *Marsden Hartley* (New York, 1988), 125.

23. See the full biographical discussion and chronology in ibid., 165–69.

24. See the artistic discussion in ibid., 12–34.

25. Reproduced in color in ibid., 91.

26. Quoted in ibid., 90.

27. Ibid., 120.

28. Quoted in ibid., 130.

29. Ibid., 87.

30. Thoreau, *Maine Woods*, 84.

31. Ibid., 93.

32. Quoted in Scott, *Marsden Hartley*, 147.

33. See Chapman, *Geology of Acadia National Park*, 87–102, and Butcher, *Field Guide*, 30–31.

34. *Rock Coast, Sea and Sail*, 1940 (Museum of Art, Bates College, Lewiston, Maine), reproduced in Scott, *Marsden Hartley*, 153.

35. Quoted in ibid., 152.

36. Reproduced in ibid., 125; drawing formerly with Hirschl and Adler Galleries, New York.

37. See Welch, *Lighthouses of Maine*, 52.

38. See Barbara Haskell, *Marsden Hartley*, exhibition catalogue, Whitney Museum of American Art (New York, 1980), 101, 129–31, 173. Almost certainly, the paintings titled *Off to the Banks at Night*, 1942 (Phillips Collection, Washington, D.C.) and *Northern Seascape, Off the Banks*, 1936–1937 (Milwaukee Art Center) are also inspired by the Schoodic Point landscape; see Haskell, *Marsden Hartley*, plates 63 and 98.

EPILOGUE

1. For information on Richard Estes, see John Arthur, *Richard Estes*, exhibition catalogue, Isetan Museum of Art (Tokyo, 1990), especially 71–72, where *Yourcenar*, 1985, and *Portrait*, 1986, are reproduced in color.

Illustrations

Wherever possible, original titles (with original spelling and punctuation) have been used, based on artists' inscriptions or exhibition records. Secondary titles following in parentheses are those given by museums or owners. Note that while Frenchman Bay is the official modern designation, many artists freely used the alternative Frenchman's Bay. Photographs are by the author.

Frontispiece: Sanford R. Gifford, *The Artist Sketching at Mount Desert*, 1864–65. Collection of Jo Ann and Julian Ganz, Jr.

1. Mount Desert from Baker's Island
2. Schoodic Point from Great Head
3. Mount Desert Rock
4. Thunder Hole
5. Otter Cliffs
6. Beacon, East Bunker's Ledge
7. Bear Island, Northeast Harbor
8. Jonathan Fisher, *A Morning View of Blue Hill Village*, 1824. Oil on canvas, 25⅝ × 52¼ in. Museum purchase, 1965, William A. Farnsworth Library and Art Museum
9. Thomas Birch, *The U.S.S. Pennsylvania off Mount Desert*, 1810. Oil on canvas, 18 × 29½ in. Private collection, courtesy of Schutz & Co., New York
10. Thomas Doughty, *Desert Rock Lighthouse, Maine*, 1836. Oil on canvas, 27½ × 34¼ in. Collection of Mrs. Gustav D. Klimann
11. Thomas Doughty, *Maine Coast*, 1828. Oil on canvas, 25 × 30 in. Gerold Wunderlich & Co., Inc.
12. Thomas Doughty, *Mount Desert Lighthouse* (*Desert Rock Lighthouse*), 1845. Oil on canvas, 41 × 27 in. Collection of The Newark Museum, gift of Mrs. Jennie E. Mead, 1939
13. Currier and Ives, *American Coast Scene, Desert Rock Light House, Maine*, 1860s. Lithograph, 20 × 26 in. Shelburne Museum
14. Alvan Fisher, *View of Bear Island looking North*. Pencil on paper, 6½ × 9 in. Private collection
15. Alvan Fisher, *View from E. End of Bear Is. 13 August 1848. Fog*. Pencil on paper, 9¾ × 13½ in. Private collection
16. Alvan Fisher, *Bear Island Light & N.E. Harbour*, 6 August 1848. Pencil on paper, 6¼ × 9 in. Private collection
17. Alvan Fisher, *Bear Island*, 1851. Oil on canvas, 18 × 24 in. Shelburne Museum

18. Alvan Fisher, *Sutton Island, Mount Desert* (*Mount Desert Island*), c. 1848. Oil on canvas, 22 × 27 in. Museum purchase, 1968, William A. Farnsworth Library and Art Museum
19. Edward Seager, *Penobscot Bay, Maine*. Pencil on paper, 10⅜ × 16½ in. Private collection
20. Bar Island, Somes Harbor
21. Thomas Cole, *Old Bastion, Old Fort at Castine*, 1844. Pencil on two sheets of paper, 11⅛ × 17 in. each. Thomas Cole Sketchbook, 8v–9, The Art Museum, Princeton University, gift of Frank Jewett Mather, Jr.
22. Thomas Cole, *Old Fort at Castine*, 1844. Pencil on paper, 11⅛ × 17 in. Thomas Cole Sketchbook, 9v, The Art Museum, Princeton University, gift of Frank Jewett Mather, Jr.
23. Thomas Cole, *Long Island, Penobscot Bay*, 1844. Pencil on paper, 11⅛ × 17 in. Thomas Cole Sketchbook, 7v, The Art Museum, Princeton University, gift of Frank Jewett Mather, Jr.
24. Thomas Cole, *Pond Between Ellsworth & Bucksport, Maine*, 1844. Pencil on paper, 11⅛ × 17 in. Thomas Cole Sketchbook, 15, The Art Museum, Princeton University, gift of Frank Jewett Mather, Jr.
25. Thomas Cole, *View of Mt. Desert from Trenton on the Main Land*, 1844. Pencil on paper, 11⅛ × 17 in. Thomas Cole Sketchbook, 14v, The Art Museum, Princeton University, gift of Frank Jewett Mather, Jr.
26. Thomas Cole, *Mt. Desert Island in the distance seen from the Main Land*, 1844. Pencil on paper, 11⅛ × 17 in. Thomas Cole Sketchbook, 15v–16, The Art Museum, Princeton University, gift of Frank Jewett Mather, Jr.
27. Thomas Cole, *View in Somes Sound, Mt. Desert*, 1844. Pencil, white highlights on blue paper, 11⅛ × 17 in. The Art Museum, Princeton University, gift of Frank Jewett Mather, Jr.
28. Thomas Cole, *View from Mt. Desert looking inland Westerly*, 1844. Pencil on paper, 11⅛ × 17 in. Thomas Cole Sketchbook, 10v, The Art Museum, Princeton University, gift of Frank Jewett Mather, Jr.
29. Thomas Cole, *Mt. Desert looking South by east*, 1844. Pencil on paper, 11⅛ × 17 in. Thomas Cole Sketchbook, 11v, The Art Museum, Princeton University, gift of Frank Jewett Mather, Jr.
30. Thomas Cole, *Scene in Mt. Desert looking South*, 1844. Pencil on paper, 11⅛ × 17 in. Thomas Cole Sketchbook, 10v, The Art Museum, Princeton University, gift of Frank Jewett Mather, Jr.

31. Thomas Cole, *House, Mt. Desert, Maine*, c. 1845. Oil on canvas, 17½ × 23½ in. Courtesy of The Fogg Art Museum, Harvard University Art Museums, bequest of Edward Charles Pickering

32. Thomas Cole, *Mt. Desert*, 1844. Pencil on paper, 11⅛ × 17 in. Thomas Cole Sketchbook, 11v, The Art Museum, Princeton University, gift of Frank Jewett Mather, Jr.

33. Thomas Cole, *Sand Beach Mountain, Mt. Desert Island*, 1844. Pencil on paper, 11⅛ × 17 in. Thomas Cole Sketchbook, 12v, The Art Museum, Princeton University, gift of Frank Jewett Mather, Jr.

34. Thomas Cole, *Frenchman's Bay, Mt. Desert Island, Maine*, 1845. Oil on panel, 13½ × 22⅞ in. Albany Institute of History and Art, New York

35. Thomas Cole, *Otter Cliffs*, c. 1844. Oil on paper, 5¼ × 8 in. Collection of Lee Koehler and Brian Ward

36. Thomas Cole, *Hull's Cove, Mt. Desert*, 1844. Pencil on paper, 11⅛ × 17 in. Thomas Cole Sketchbook, 12v, The Art Museum, Princeton University, gift of Frank Jewett Mather, Jr.

37. Thomas Cole, *Islands in Frenchmans' Bay from Mt. Desert*, 1844. Pencil on two sheets of paper, 11⅛ × 17 in. each. Thomas Cole Sketchbook, 13v–14, The Art Museum, Princeton University, gift of Frank Jewett Mather, Jr.

38. Thomas Cole, *View Across Frenchman's Bay from Mt. Desert Island, After a Squall*, 1845. Oil on canvas, 38¼ × 62½ in. Cincinnati Art Museum, gift of Miss Alice Scarborough

39. Looking towards entrance of Somes Sound

40. Fitz Hugh Lane, *North East Harbor, Mount Desert*, August 1850. Pencil on paper, 9½ × 20¾ in. Cape Ann Historical Association

41. Fitz Hugh Lane, *Somes Sound, Looking Southerly*, August 1850. Pencil on paper, 9½ × 19¾ in. Cape Ann Historical Association

42. Fitz Hugh Lane, *Mount Desert Mountains, from Bar Island, Somes Sound*, August 1850. Pencil on paper, 8 × 21½ in. Cape Ann Historical Association

43. Fitz Hugh Lane, *View of Bar Island and Mount Desert Mountains, from the bay in front of Some's Settlement*, 1850. Pencil on paper, 9 × 20 in. Cape Ann Historical Association

44. Fitz Hugh Lane, *Bar Island and Mount Desert Mountains from the Bay in Front of Some's Settlement*, 1850. Oil on canvas, 20⅛ × 30⅛ in. Collection of Erving and Joyce Wolf

45. Fitz Hugh Lane, *Duck Harbor, Isle Au Haut, Penobscot Bay, Me.*, August 1852. Pencil on paper, 10¼ × 31 in. Cape Ann Historical Association

46. Fitz Hugh Lane, *North Westerly View of Mt. Desert Rock*, August 1852. Pencil on paper, 10¼ × 16 in. Cape Ann Historical Association

47. Fitz Hugh Lane, *Northwesterly View of Mt. Desert Rock*, 1855. Oil on canvas, 20 × 33 in. Courtesy of Ira Spanierman Gallery, New York

48. Fitz Hugh Lane, *Southwest Harbor, Mount Desert*, 1852. Pencil on paper, 10½ × 31¾ in. Cape Ann Historical Association

49. Fitz Hugh Lane, *West Harbor & Entrance of Somes Sound*, August 1852. Pencil on paper, 10½ × 16 in. Cape Ann Historical Association

50. Fitz Hugh Lane, *Entrance to Somes Sound from Southwest Harbor*, 1852. Oil on canvas, 23¾ × 35¾ in. Private collection

51. Fitz Hugh Lane, *Off the Coast of Maine, with Desert-Island in the Distance*, 1850s. Oil on canvas, 20 × 33 in. Shelburne Museum

52. Fitz Hugh Lane, *Entrance of Somes Sound from back of the Island House at South West Harbor*, September 1855. Pencil on paper, 10¼ × 15¾ in. Private collection

53. Fitz Hugh Lane, *Looking Westerly from Eastern Side of Somes Sound near the entrance*, September 1855. Pencil on paper, 8¾ × 26¼ in. Cape Ann Historical Association

54. Fitz Hugh Lane, *Bear Island from western side of N. East Harbour*, 1855. Pencil on paper, 10½ × 21½ in. Cape Ann Historical Association

55. Fitz Hugh Lane, *Bear Island from the South*, September 1855. Pencil on paper, 10½ × 16 in. Cape Ann Historical Association

56. Fitz Hugh Lane, *Near South East View of Bear Island*, September 1855. Pencil on paper, 10¾ × 22¾ in. Cape Ann Historical Association

57. Fitz Hugh Lane, *Bear Island, Northeast Harbor*, 1855. Oil on canvas, 14 × 21 in. Cape Ann Historical Association

58. Fitz Hugh Lane, *Sunrise on the Maine Coast*, 1856. Oil on canvas, 17¼ × 27 in. Private collection

59. Fitz Hugh Lane, *Off Mount Desert Island*, 1856. Oil on canvas, 24³⁄₁₆ × 36⁷⁄₁₆ in. The Brooklyn Museum, Museum Collection Fund

60. Fitz Hugh Lane, *Lumber Schooners at Twilight on Penobscot Bay*, 1863. Oil on canvas, 24⅝ × 38⅛ in. Andrew W. Mellon Fund and gift of Mr. and Mrs. Francis W. Hatch, Sr., National Gallery of Art, Washington

61. Sunset at Mount Desert

62. Frederic E. Church, *Little Long Pond and Jordan Cliffs (Penobscot Mountain and the Bubbles)*, 1850. Pencil on paper, 11⅞ × 15 in. New York State Office of Parks, Recreation, and Historic Preservation, Taconic Region, Olana State Historic Site

63. Frederic E. Church, *Mount Desert, Sky Study (Sunset, Bar Harbor)*, 13 September 1850. Pencil on paper, 6³⁄₁₆ × 11¼ in. New York State Office of Parks, Recreation, and Historic Preservation, Taconic Region, Olana State Historic Site

64. Frederic E. Church, *Mount Desert, View Towards Frenchman Bay (Mount Desert Island from Dorr Mountain)*, 1850. Pencil on paper, 9⅞ × 14⅞ in. New York State Office of Parks, Recreation, and

Historic Preservation, Taconic Region, Olana State Historic Site

65. Frederic E. Church, *Mt. Desert, Looking Southerly* (*View from Jordan Ridge, Mount Desert Island*), early 1850s. Pencil on paper, 12 × 15⅜ in. New York State Office of Parks, Recreation, and Historic Preservation, Taconic Region, Olana State Historic Site

66. Frederic E. Church, *Schooner Head, Mt. Desert,* early 1850s. Pencil on paper, 10⁹⁄₁₆ × 14¹³⁄₁₆ in. New York State Office of Parks, Recreation, and Historic Preservation, Taconic Region, Olana State Historic Site

67. Frederic E. Church, *Schooner Head and Lynam Farm,* 1850–51. Pencil on paper, 12⅞ × 16⅞ in. New York State Office of Parks, Recreation, and Historic Preservation, Taconic Region, Olana State Historic Site

68. Frederic E. Church, *Schooner Head, Red Rocks* (*Mount Desert Island from Halfway Mountain*), early 1850s. Pencil and gouache on paper, 11⅝ × 15⅝ in. New York State Office of Parks, Recreation, and Historic Preservation, Taconic Region, Olana State Historic Site

69. Frederic E. Church, *Near Great Head* (*Coast at Mt. Desert Island, Maine*), early 1850s. Oil with pencil on composition board, 12¹⁄₁₆ × 16¹⁄₁₆ in. Courtesy of Cooper-Hewitt, National Museum of Design, Smithsonian Institution (Art Resource, NY)

70. Frederic E. Church, *Otter Cliffs,* early 1850s. Pencil on paper, 10¹³⁄₁₆ × 15 in. New York State Office of Parks, Recreation, and Historic Preservation, Taconic Region, Olana State Historic Site

71. Frederic E. Church, *Cliff Wall Near Great Head,* early 1850s. Pencil on paper, 11⁹⁄₁₆ × 15⁹⁄₁₆ in. New York State Office of Parks, Recreation, and Historic Preservation, Taconic Region, Olana State Historic Site

72. Frederic E. Church, *Mt. Desert, Frenchman Bay* (*Stone Pillar, Mt. Desert*), September 1850. Pencil on paper, 11¼ × 14½ in. New York State Office of Parks, Recreation, and Historic Preservation, Taconic Region, Olana State Historic Site

73. Frederic E. Church, *Mount Desert, Frenchman Bay* (*Cliffs on one of the Porcupine Islands*), early 1850s. Pencil and gouache on paper, 11¼ × 14⁹⁄₁₆ in. New York State Office of Parks, Recreation, and Historic Preservation, Taconic Region, Olana State Historic Site

74. Frederic E. Church, *Porcupine Islands* (*Cliffs on the Porcupine Islands*), early 1850s. Pencil on paper, 9⅞ × 25³⁄₁₆ in. New York State Office of Parks, Recreation, and Historic Preservation, Taconic Region, Olana State Historic Site

75. Frederic E. Church, *Mt. Desert From a Distance,* mid-1850s. Pencil and guoache on colored paper, 9³⁄₁₆ × 15 in. New York State Office of Parks, Recreation, and Historic Preservation, Taconic Region, Olana State Historic Site

76. Frederic E. Church, *Lumber Mill, Sullivan, Maine,* 1850. Pencil on paper, 10 × 15¹⁄₁₆ in. New York State Office of Parks, Recreation,

and Historic Preservation, Taconic Region, Olana State Historic Site

77. Frederic E. Church, *Lumber Mill, Mt. Desert,* early 1850s. Pencil, gouache and chalk on paper, 10¼ × 15 in. New York State Office of Parks, Recreation, and Historic Preservation, Taconic Region, Olana State Historic Site

78. Frederic E. Church, *Rough Surf, Mt. Desert Island, Maine,* 1850. Oil on paper mounted on wood, 12½ × 16¼ in. Thomas and Barbara Lee, Brookline, Massachusetts

79. Frederic E. Church, *Fog off Mount Desert,* 1850. Oil on academy board, 12 × 15½ in. Private collection

80. Frederic E. Church, *The Old Boat* (*Abandoned Skiff*), 1851. Oil on board, 11 × 17 in. Thyssen-Bornemisza Collection

81. Frederic E. Church, *Lake Scene in Mount Desert* (*Little Long Pond and Jordan Cliffs*), 1851. Oil on canvas, 20¾ × 30⅞ in. Alexander Gallery, New York

82. Frederic E. Church, *Otter Creek, Mount Desert,* c. 1850. Oil on canvas, 17¼ × 24¼ in. Seth K. Sweetser Fund, Tompkins Collection, Henry H. and Zoë Oliver Sherman Fund and gift of Mrs. R. Amory Thorndike, Courtesy, Museum of Fine Arts, Boston

83. Frederic E. Church, *Newport Mountain, Mount Desert,* 1851. Oil on canvas, 21¼ × 31¼ in. Private collection

84. Frederic E. Church, *New Port Mountain, Mt. Desert Island,* 1850. Pencil on paper, 12¾ × 20 in. New York State Office of Parks, Recreation, and Historic Preservation, Taconic Region, Olana State Historic Site

85. Frederic E. Church, *Newport Mountain, Mt. Desert Island* (*Mount Desert Island from Great Porcupine Island*), 1850. Pencil on paper, 11⅜ × 14¾ in. New York State Office of Parks, Recreation, and Historic Preservation, Taconic Region, Olana State Historic Site

86. Frederic E. Church, *Newport Mountain, Mt. Desert Island* (*Mount Desert Island from Sheep Porcupine Island*), 1850. Pencil and gouache on paper, New York State Office of Parks, Recreation, and Historic Preservation, Taconic Region, Olana State Historic Site

87. Frederic E. Church, *Beacon, off Mount Desert Island,* 1851. Oil on canvas, 31 × 46 in. Private collection

88. Frederic E. Church, *Study of Schooners and Beacon Day Marker,* c. 1850. Pencil and gouache on cardboard, 9¹³⁄₁₆ × 7⅛ in. Courtesy of Cooper-Hewitt, National Museum of Design, Smithsonian Institution (Art Resource, NY)

89. Frederic E. Church, *Fleet of Mackerel Fishers,* August 1850. Pencil on paper, 9 × 13⅝ in. Courtesy of Cooper-Hewitt, National Museum of Design, Smithsonian Institution (Art Resource, NY)

90. Frederic E. Church, *Mt. Desert,* c. 1850. Oil on paper, 8¹⁵⁄₁₆ × 14¹⁄₁₆ in. Courtesy of Cooper-Hewitt, National Museum of Design, Smithsonian Institution (Art Resource, NY)

91. Frederic E. Church, *Sunset, Bar Harbor,* 1854. Oil on paper

mounted on canvas, 10⅛ × 17¼ in. New York State Office of Parks, Recreation, and Historic Preservation, Taconic Region, Olana State Historic Site

92. Frederic E. Church, *Part of Frenchmans Bay near Sullivan*, 1854. Pencil with white and black gouache on paper, 10¾ × 17⁵⁄₁₆ in. New York State Office of Parks, Recreation, and Historic Preservation, Taconic Region, Olana State Historic Site

93. Frederic E. Church, *Road at Somesville*, 1854. Pencil and gouache on paper, 12⅛ × 17⁹⁄₁₆ in. New York State Office of Parks, Recreation, and Historic Preservation, Taconic Region, Olana State Historic Site

94. Frederic E. Church, *Twilight, Bar Harbor (Sunset, Bar Harbor)*, 1854. Pencil on paper, 9¹¹⁄₁₆ × 16¹³⁄₁₆ in. New York State Office of Parks, Recreation, and Historic Preservation, Taconic Region, Olana State Historic Site

95. Frederic E. Church, *One Hour After Sunset (Moonrise, Mount Desert Island)*, mid-1850s. Pencil and gouache on paper, 11⅞ × 14¾ in. New York State Office of Parks, Recreation, and Historic Preservation, Taconic Region, Olana State Historic Site

96. Frederic E. Church, *Sunset Over Eagle Lake*, 1850s. Oil and pencil on cardboard, 11⁷⁄₁₆ × 17⁹⁄₁₆ in. Courtesy of Cooper-Hewitt, National Museum of Design, Smithsonian Institution (Art Resource, NY)

97. Frederic E. Church, *Sunset*, 1856. Oil on canvas, 24 × 36 in. Munson-Williams-Proctor Institute, Museum of Art, Utica, New York, Proctor Collection

98. Frederic E. Church, *Lake at Mt. Desert*, mid-1850s. Pencil on paper, 10⁷⁄₁₆ × 15 in. New York State Office of Parks, Recreation, and Historic Preservation, Taconic Region, Olana State Historic Site

99. Frederic E. Church, *Twilight in the Wilderness*, 1860. Oil on canvas, 40 × 64 in. The Cleveland Museum of Art, Purchase, Mr. and Mrs. William H. Marlatt Fund

100. Frederic E. Church, *Study for Storm at Mt. Desert (Surf Pounding Against the Rocky Maine Coast)*, mid-1850s. Oil on cardboard, 11¾ × 20 in. Gift of Louis P. Church, courtesy of Cooper-Hewitt, National Museum of Design, Smithsonian Institution (Art Resource, NY

101. Frederic E. Church, *Storm at Mt. Desert (Coast Scene, or Sunrise off the Maine Coast)*, 1863. Oil, 37 × 47 in. The Wadsworth Atheneum, Hartford

102. Frederic E. Church, *Mt. Desert Island, Maine*, 1865. Oil on canvas, 31¼ × 48½ in. Collection, Washington University, St. Louis

103. Dancing Rocks, Baker's Island

104. William Stanley Haseltine, *Eagle Cliff (from Northeast Harbor, Mount Desert)*, 1859. Pen and black ink, gray wash, over pencil,

15 × 21¾ in. The Art Museum, Princeton University, Museum purchase, gift of Miss Dorothy Willard by exchange

105. William Stanley Haseltine, *Eagle Cliff, Somes Sound*, 1859. Pen and ink, gray wash, 15 × 21½ in. Private collection

106. William Stanley Haseltine, *North Bubble, Eagle Lake, Mt. Desert*, 1859. Ink on paper, 15 × 21½ in. Ben Ali Haggin, New York

107. William Stanley Haseltine, *Rocky Coast, Mount Desert Island*, 20 July 1859. Pencil, pen and black ink, gray wash, 15¼ × 21½ in. Ben Ali Haggin, New York

108. William Stanley Haseltine, *Rock Wall, Near Otter Cliffs*, 25 July 1859. Pen and black ink, watercolor, graphite on heavy off-white wove paper, 21¹⁵⁄₁₆ × 15 in. Gift of Helen Haseltine Plowden, courtesy of Cooper-Hewitt, National Museum of Design, Smithsonian Institution (Art Resource, NY)

109. William Stanley Haseltine, *Otter Cliff, Mount Desert (Looking towards Sand Beach and Great Head)*, 1859. Pencil and white chalk on blue paper, 13⅞ × 21½ in. Private collection

110. William Stanley Haseltine, *Thunder Hole, Mount Desert Island*, 1859. Pencil and grey wash on paper, 15⅛ × 21⁹⁄₁₆ in. Private collection

111. William Stanley Haseltine, *Near Otter Cliffs*, 1859. Pen and ink, 15¼ × 22⅛ in. Ben Ali Haggin, New York

112. William Stanley Haseltine, *Great Head, Mount Desert*, 1859. Pencil, ink and wash on paper, 15 × 21¾ in. Berry-Hill Galleries, New York

113. William Stanley Haseltine, *View of Frenchman Bay from Mount Desert Island*, 1859. Pen and ink, gray wash, 15 × 21¾ in. Private collection

114. William Stanley Haseltine, *Study: Porcupine Islands, Bar Harbor*, 1859. Graphite on gray wove paper mounted on illustration board, 14⅛ × 20⅞ in. Gift of Helen Haseltine Plowden, courtesy of Cooper-Hewitt, National Museum of Design, Smithsonian Institution (Art Resource, NY)

115. William Stanley Haseltine, *Sand Beach and the Old Soaker off Great Head*, c. 1860. Oil on canvas, 8¾ × 14¾ in. Private collection, courtesy Keny Galleries, Inc., Columbus, Ohio

116. William Stanley Haseltine, *Lumber Mill, Mt. Desert*, 21 July 1859. Pen and ink, gray wash, 14¾ × 22 in. Ben Ali Haggin, New York

117. William Stanley Haseltine, *Near Schoodic Head*, 1859. Pen and ink, gray wash, 14⅞ × 22 in. Ben Ali Haggin, New York

118. William Stanley Haseltine, *Wooded Coast, Frenchman Bay*, 1859. Pencil and grey wash on paper, 13⅝ × 19⅜ in. Private collection

119. William Stanley Haseltine, *View of Mount Desert*, 1861. Oil on canvas, 30 × 50 in. Private collection, courtesy D. Wigmore Fine Art, Inc., New York, N.Y.

120. William Stanley Haseltine, *Ocean Coastline near Seal Harbor,* 1895. Watercolor and gouache, 15 × 22 in. Ben Ali Haggin, New York

121. William Stanley Haseltine, *Seal Harbor,* 1895. Water and gouache on blue gray paper, 15 × 22¼ in. M. and M. Karolick Collection, courtesy Museum of Fine Arts, Boston

122. William Stanley Haseltine, *North East Harbor, Maine,* 1895. Gouache on paper, 13¼ × 21½ in. Private collection

123. William Stanley Haseltine, *North East Harbor, Maine,* 1895. Watercolor and Chinese white, 14¾ × 21¾ in. Private collection

124. Otter Cliffs from Thunder Hole

125. John Henry Hill, *Rocks at Mt. Desert,* 1856. Pencil on paper, 9⅝ × 9¼ in. Private collection

126. Aaron Draper Shattuck, *Jordan Cliffs and the Bubbles, Mt. Desert,* 31 August 1858. Pencil on pale buff paper, 10⅝ × 17¼ in. The Art Museum, Princeton University, gift of Mr. and Mrs. Stuart P. Feld

127. Aaron Draper Shattuck, *Frenchman Bay, Mt. Desert,* 1858. Pencil and colored chalks on paper, 10 × 16 in. Private collection

128. Aaron Draper Shattuck, *Seawall and Cranberry Island,* late 1850s. Oil on canvas, 9 × 17 in. Barridoff Galleries, Maine

129. William M. Hart, *Sunrise, Great Head, Mt. Desert,* c. 1860. Oil on canvas, 12½ × 10¼ in. Private collection, photo courtesy of The Crane Collection, Boston

130. William M. Hart, *Great Head, Mount Desert, Maine,* c. 1860. Oil on canvas, 9⅝ × 18¼ in. Collection of Jeffrey W. Cooley

131. Sanford R. Gifford, *Otter Cliffs (Rocks at Porcupine Island Near Mt. Desert),* c. 1860. Oil on canvas, 12½ × 9⅛ in. Collection of Mrs. Patricia Arden

132. Sanford R. Gifford, *The Artist Sketching at Mount Desert,* 1864–65. Oil on canvas, 11 × 19 in. Collection of Jo Ann and Julian Ganz, Jr.

133. William Trost Richards, *Rocks at Mount Desert,* c. 1866. Pencil on paper, 6 × 9¾ in. Private collection

134. William Trost Richards, *Sunrise over Schoodic,* early 1870s. Gouache on paper, 6½ × 13 in. Private collection

135. Samuel Lancaster Gerry, *Rocky Shore,* 1870s. Oil on canvas, 19 × 11¼ in. Private collection, courtesy of Christie's, New York

136. Andrew Warren, *Mount Desert Island, Maine,* 1869. Oil on canvas, 9 × 16 in. Hirshl and Adler Gallery, New York

137. W. W. Brown, *Bar Harbor,* 1870s. Oil on canvas, 10¾ × 13¾ in. Museum purchase, 1968, William A. Farnsworth Library and Art Museum

138. David Maitland Armstrong, *The Bar, Bar Harbor,* 1877. Oil on canvas, 24⅛ × 47⅛ in. Layton Art Collection, Milwaukee Museum, gift of Frederick Layton

139. F. O. C. Darley, *Rocks near the landing at "Bald Porcupine Island," Bar Harbor,* 1872. Pencil and colored chalks on paper, 9¾ × 13½ in. Private collection

140. Henry Waugh, *View from Cottage Window, Mt. Desert,* 1873. Pencil on paper, 5 × 14¾ in. Private collection

141. Alfred Thompson Bricher, *Maine Coast,* 1870s. Black ink on paper, 6¼ × 4¼ in. Collection of Natalie Fielding, New York

142. Alfred Thompson Bricher, *Otter Cliffs, Mt. Desert Island, Maine,* 1870s. Watercolor, 4¼ × 3¼ in. Collection of Natalie Fielding, New York

143. Alfred Thompson Bricher, *Coastline near Otter Cliffs, Mt. Desert Island,* 1870s. Watercolor, 3⅜ × 7¾ in. Private collection

144. Alfred Thompson Bricher, *Along the Maine Coast,* 1870s. Oil on canvas, 18 × 39 in. Collection of Elma Shoemaker

145. Alfred Thompson Bricher, *Sand Beach, looking towards Otter Cliffs,* 1870s. Oil on canvas, 8 × 16 in. Private collection, photo courtesy of Peter F. Fagley Fine Arts

146. Alfred Thompson Bricher, *Cloudy Day, Great Head,* 1870s. Oil on canvas, 24 × 20 in. Collection of Joseph and Barbara Schwarz, New York, photo courtesy of Thomas Colville, Inc., New Haven, CT

147. Xanthus Smith, *Peak of Otter and Sandy Beach, Mt. Desert, Maine,* 22 August 1877. Pencil on paper, 10 × 15 in. Private collection

148. Xanthus Smith, *Looking North West from Schooner Head, Mt. Desert, Maine,* 1877. Pencil on paper, 10 × 15 in. Private collection

149. Xanthus Smith, *Beech Mountain, Southwest Harbor,* 1882. Pencil on paper, 8 × 12 in. Collection of Mr. and Mrs. Donald Straus

150. Xanthus Smith, *Star Crevice, Salisbury Cove,* 1893. Pencil on paper, 7 × 10 in. Collection of Franklin H. Epstein

151. Xanthus Smith, *Pretty Marsh,* 1890s. Watercolor, 8 × 12 in. Hirshl and Adler Galleries

152. Xanthus Smith, *Pretty Marsh, Mt. Desert, Maine,* 1890s. Watercolor, 8 × 12 in., Hirschl and Adler Galleries

153. George H. Smilie, *Bar Harbor,* August 1893. Watercolor, gouache, and pencil on paper, 10 × 14 in. Private collection, courtesy of Christie's, New York

154. George H. Smilie, *Newport Mountain from Bald Porcupine,* 1890s. Black and white chalk and watercolor on blue paper, 14 × 19¼ in. The John Davis Hatch Collection, National Gallery of Art, Washington

155. George H. Smilie, *Otter Cliffs,* 1890s. Black and white chalk, 10 × 13¾ in. Private collection

156. Ralph Blakelock, *The Nubble, Coast of Maine,* possibly 1890s. Pen and pencil on paper, 4¾ × 7½ in. Private collection

157. Louis Comfort Tiffany, *My Family at Somesville,* c. 1888. Oil on

canvas, 24 × 36 in. Collection of The Charles Hosmer Morse Museum of American Art, Winter Park, Florida

158. John La Farge, *Porcupine Island, Bar Harbor, Maine,* August 1896. Watercolor and gouache over pencil on paper, 5¼ × 13¼ in. Courtesy of William Vareika Fine Arts, Newport

159. Childe Hassam, *Looking over Frenchman Bay at Green Mountain,* 1896. Oil on canvas, 26⁷⁄₁₆ × 36⅛ in. Courtesy of the Pennsylvania Academy of Fine Arts, Philadelphia, gift of Orton P. Jackson in memory of Emily Penrose Jackson

160. Childe Hassam, *Sunset, Ironbound Island,* 1896. Oil on canvas, 26 × 30 in., Berry-Hill Galleries, New York

161. Mount Desert from the south

162. Allen Tucker, *Green Mountain,* 1911. Oil on canvas, 25 × 34 in. Collection of High Museum of Art, Atlanta, Georgia, gift of the Allen Tucker Memorial

163. Carroll Tyson, *View from Cadillac Mountain,* 1910. Oil on canvas, 25 × 30 in. Hirschl and Adler Galleries

164. Carroll Tyson, *Beach at Seal Harbor,* 1910. Oil on canvas, 25 × 30 in. Hirschl and Adler Galleries

165. Carroll Tyson, *Otter Cliffs,* c. 1910. Oil on canvas, 25 × 30 in. Hirschl and Adler Galleries

166. Carroll Tyson, *Hall's Quarry,* 1906. Oil on canvas, 25⅛ × 30⅛ in. The White House, Washington, D.C.

167. William Zorach, *Bar Harbor, Maine,* 1926. Watercolor, 15 × 21½ in. Hirschl and Adler Galleries

168. William Zorach, *Bar Harbor, Maine,* 1926. Watercolor, 15 × 21½ in. Hirschl and Adler Galleries

169. Oscar Bluemner, *Frenchman's Bay from Cadillac Mountain,* 1920s. Pencil and gray wash, 5³⁄₁₆ × 6½ in. Gift of R. and Mrs. Stuart Feld, William A. Farnsworth Art Museum

170. John Marin, *Looking Towards Isle au Haut, Maine, from Deer Isle,* 1919. Watercolor and charcoal over graphite on wove paper, 14 × 16⁹⁄₁₆ in. Gift of John Marin, Jr., National Gallery of Art, Washington

171. John Marin, *Looking Towards Mount Desert, Maine,* 1933. Watercolor, 15 × 21½ in. Kennedy Galleries, Inc.

172. John Marin, *Vicinity Frenchman's Bay, Maine Coast,* 1933. Watercolor, 15 × 21½ in. Courtesy of Kennedy Galleries, Inc., New York

173. John Marin, *Schoodic Point,* 1941. Crayon on paper, 10½ × 13½ in. Kennedy Galleries, Inc.

174. Marsden Hartley, *Evening Storm, Schoodic Point,* 1942. Oil on composition board, 30 × 40 in. The Museum of Modern Art, New York, acquired through the Lillie P. Bliss Bequest

175. Otter Cove and Cadillac Mountain Gorge

176. Richard Estes, *Clare,* 1990. Oil on canvas, 47½ × 25 in. Collection of Clare and Allan Stone

Index

Endpapers: details of U.S. Department of Commerce charts, "Frenchman and Blue Hill Bays" and "Frenchman Bay and Mount Desert Island"